名刺ワールド Ⓡ

名刺ワールド ®

Nicetomeetyou

visual greeting from business cards

viction:ary™

key to <u>symbols</u>

⬈ = size
▯ = materials
⚲ = colour
✳ = finishing

名刺ワールド Ⓡ

Edited by Viction:ary

viction:ary™

Published and distributed by
viction:workshop limited
URL: www.victionary.com Email: we@victionary.com

Concept and Art direction by Victor Cheung
Book design and produced by viction:design workshop

ISBN 978-988-98228-4-2
Printed and bound in China

content
目次

about the book
はじめに

Business cards for any kind of business, plays a vital role in connecting and reaching out with clients or customers. It works as a tool to communicate, like an advertisement. It is just like how people wearing different kinds of clothes would give different impression. It tells you how a person or a company is like, and brings credibility to what the person does because that small piece of paper represents years of planning and effort and hard work and dreams. If a person shows only his mobile phone number on his card, he might work on the road; if he shows his full address and website on his card, you will know if he is located in a high-rise office building of a corporate or if he works at home.

Other than the physical and most minimal information, a business card can have a lot more to say about the owner. In which, the most important task is to tell you the personality and image of a person or a company. Some are tacky, some are striking. They amaze you with astonishing colours and phrases. They suggest good taste, formality, and confidence. However, no matter it uses UV spot varnishing or any other printing methods; plastic or any other special materials; whether via photograph or illustration, business cards always tell you what a person or a company can offer. Would it be an traditional corporate service from downtown, or a friendly, flexible and approachable business from next door? An 85 x 55 mm piece of artwork would say it all.

There are lots of business card solutions out there. It is easy to understand that unusual business card designs get noticed, kept, filed, and actually used when a prospect needs a product or service. However, this book is not just about showing how attractive a business card can be, or how a business card can catch your eyes or how designers manipulate the little piece of artwork, but reveals the message behind each business card on top of the effectiveness i.e. the memorability and accessibility. It brings forward with what designers like to show to their audience.

While some business cards choose to use the most inventive way with just black ink on white card, many others have a much more complex consideration with design: from the usage of colour and fonts, the arrangement of spacing and size, to the option of printing techniques. However, whether a name card is just a foil blocking of

the company's name in the middle with nothing else, or a fully illustrated card printed in different colours as a set; whether it is a $10 Xerox set of cards, or a part of the $10,000 identity package, all good business card design has a meaning behind it. In fact, all good design should bear with a visual statement.

It is, however, often hard to understand the concept or to define the personality through a business card design by only reading it visually. An architect might want to suggest his orderly structure and mind through his business card by using concrete colour and geometric forms, while a mechanic might show complexity and dimensions with 3D images, or a photographer would use his personal portfolio to represent his uniqueness. It could also be as imaginative as yellow would imply light, or a mushroom would suggest happiness! That is the fun part of creative design.

In this comprehensive collection, you will find business cards that are all different: some formal, some informal, some corporate, some funky and some even do not appear to be business cards at all. Every card has a different story behind them. So let's not just say "wow, that looks cool", but try to reveal and appreciate the idea behind, which has been discovered and represented here by the use of photography. With pictures taken by the designers of the cards themselves, this book shows you how they were inspired. Why would they use the particular colour and image? What was on their mind when they design the card? What would they like to say with their card? Things that a designer wants to speak through their business card design, "Nice To Meet You" tells you all about it.

about the book
はじめに

名刺はあらゆる業種においてクライアントや顧客への架け橋として重要な役割を果たし、広告と同様に、情報を伝えるツールとして機能しています。この機能は、自分の服装次第で他人に与える印象が変わることにも似ています。名刺を見れば人や企業の様子がわかると同時に何ができるのかを推測することができます。なぜなら、その小さな紙切れに、持ち主がどれだけの時間を計画に費やしたのか、どんな努力と作業を重ねてきたのか、そして、どんな夢を抱いているかが詰まっているからです。また、携帯電話の番号しか記載されていない名刺を渡されれば、その人物が外で働いていることが想像でき、住所とウェブ・アドレスが載っているなら、高層オフィス・ビルや自宅など、屋内で働いていることもわかるでしょう。

名刺では具体的情報やごくシンプルな情報以外の要素からも、持ち主に関して知ることができます。そんな名刺の機能のなかでも最も重要なのは、人や企業の個性やイメージを伝えてくれることでしょう。名刺には悪趣味なものもあれば、素敵なものもあり、斬新な色彩やメッセージで人を感動させるものもあれば、品の良さ・几帳面さ・信頼性が滲み出ているものもあります。UV部分ニス加工をはじめとした印刷技術、ビニールなどの特殊素材、エンボス加工、シルクスクリーン印刷、色々な裁断法といった技法、写真やイラスト…何が使われているにしろ、名刺は、その人物や企業が何を提供できるかをあなたに教えてくれるのです。例えば、秩序と伝統のある企業サービスなのか、それとも、親しみやすく、融通がきき、しかも迅速なサービスなのか。サイズ85×55ミリメートルの一枚がすべてを物語っているといっても過言ではありません。

現在は名刺の作成方法も非常に多様化していますが、おもしろいものの方が注意を引き、捨てられずにファイルされ、製品やサービスが必要になったときに実際に利用される可能性が高いことは明らかでしょう。本書は名刺がどこまで魅力的になれるのかはもちろん、どうやって人の目を捉えるかや、デザイナーがこの小さな作品をどのくらい巧みに表現できるのかを紹介しています。しかし同時に、名刺によって残る記憶や親しみやすさといった効果面ばかりでなく、それぞれの名刺が内包するメッセージも紹介し、デザイナーたちが受け手に対し何を訴えようとしたかも明らかにしているのが特徴です。

本書には、非常に独創的なものや白い紙に黒インクを使ったシンプルなものに加え、色、スペース使い、フォント、サイズ、印刷技法などの点でデザインにかなり複雑な工夫を凝らしている作品も多数収録しました。しかし、箔押し印刷した社名を中央に置いただけのものであろうが、全体にカラフルなイラストが描かれているものであろうが、100円程度のコピーで作られたものであろうが、あるいは、100万円をかけたCIプロジェクトの一環であろうが、良質な名刺デザインというものは"意味"を内包しています。実際、よいデザインとは、方向性が何であれ、自ずと視覚的メッセージを放つものなのです。

とはいえ、名刺デザインには視覚面からだけではコンセプトや持ち主の個性を理解し、定義することが難しいものも少なくありません。自分が設計した整然とした建築物とそのコンセプトを実際の色や幾何学形で表現しようとする建築家がいれば、複雑さとサイズを立体イメージで表そうとする機械工がいたり、自分の作品を使うことで

自らのオリジナリティを示そうとする写真家もいるように。また、例えば黄色で光を暗示してみたり、キノコで幸せを象徴してみたりと想像力豊かにできる点も、クリエイティブ・デザインの楽しい側面といえるでしょう。

本書には多岐にわたる作品が収録され、きちんとしたもの、カジュアルなもの、企業用のもの、奇想天外なもの、まったく名刺に見えないものなど、ひとつとして同じ顔はありません。業種もデザイナー、企業、金融関係、レストランなど様々。そして、どの名刺にもそれぞれに物語があります。ですから、ただ「わあ、かっこいい！」で終わらせてしまうのではなく、本書のために発掘され、写真で紹介された各作品に凝らされた意匠を読み解き、味わってみてください。今回は、名刺を制作したデザイナー自身が撮影した写真を使うことにより、彼らがどうやってデザインを発想したかを表現してみました。なぜこの色や画像を使ったのか。この名刺をデザインしたとき、デザイナーは何を考えていたのか。この名刺で何が伝えたかったのか。本書「名刺ワールド Nice To Meet You」は、デザイナーたちが名刺デザインを通じて語りたかったことをあなたに教えてくれるでしょう。

say it in "alphabets"

タイポグラフィーで見せる名刺

Mike

Designer:
Michael Perry
Client:
Michael Perry

A personal business card
with no consistent address,
in which the back is left
blank to be filled in if it is
needed. The distinctive
handmade aesthetic and the
image capturing a natural
scene as a tool to reflect the
designer's personality.

89 x 51 mm
n/a
CMYK
n/a

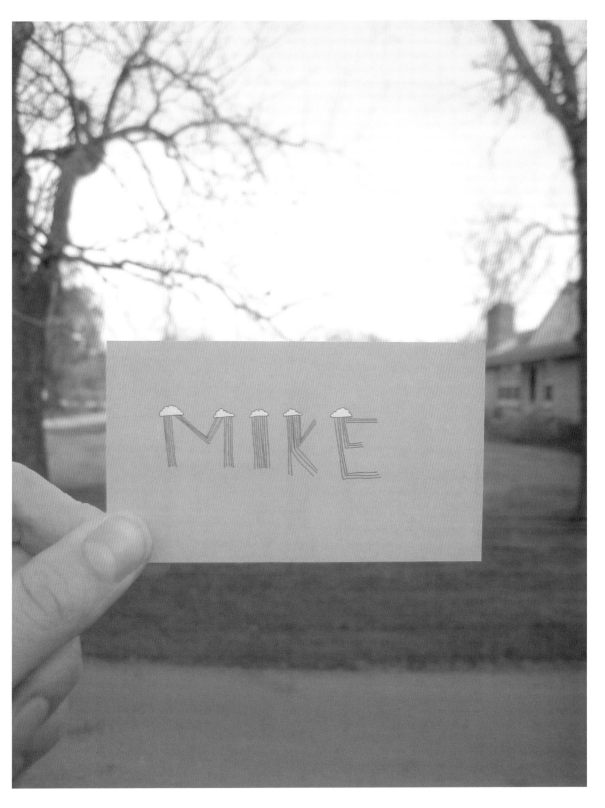

Nuno Martins

Designer:
Nuno Martins
Client:
Nuno Martins

As you can see on the back of this card 'You can write in my card... No problem!', it gives a unique and informal touch to this business card and brings you the personality of the designer himself.

85 x 55 mm
Revive uncoated
2 PMS uncoated
Silver

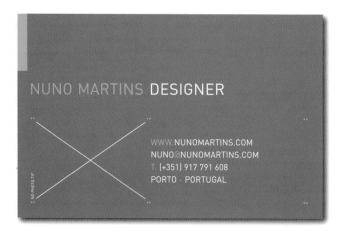

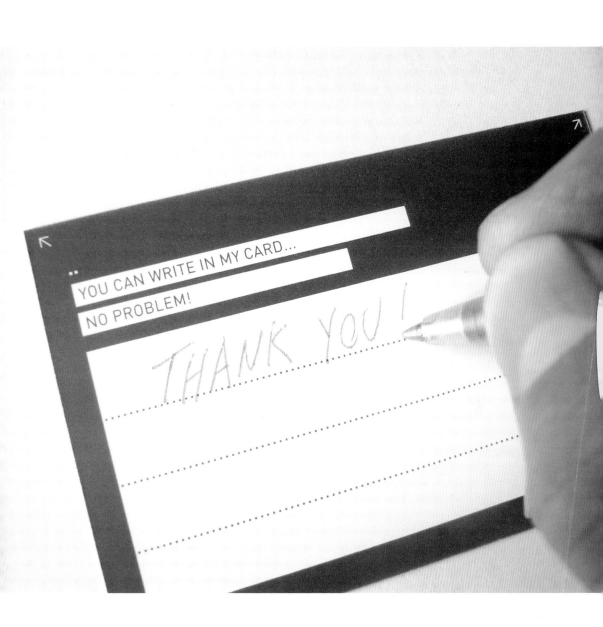

Edwin Lucas

Designer:
Kummer & Herrman
Client:
Edwin Lucas

This business card is designed for an Utrecht based independent publicist/journalist. Idea of the card is developed based on the publicist/journalist's stationery which is closely related to his profession. The use of form and colour i.e. the use of a number of yellow lines representing different text lines. The wider left margin accentuates this feel while the yellow colour refers to the highlighted areas during reading.

95 x 54 mm
Emotion 300 gsm
PMS Black, 106
n/a

drs. edwin lucas
teksten

vondelparc II vondellaan 148
3521 gh utrecht

t 030 252 28 51 f 030 252 33 46
edwin.lucas@wxs.nl

Rijksakademie 200?

Een h... landing...

Drie kern-functies

Kummer & Herrman

Designer:
Kummer & Herrman
Client:
Kummer & Herrman

The love for typography is visible within the stationary for the designers themselves, where Simple (Lineto), one of the many font types is always their choice. The dashes and slashes have also been an inspiration for the shading of the backside of the card which usually remain re-used in the layout of their correspondence. The use of colour is modest here in relation to their office interior.

95 x 50 mm
Silken 330 gsm
PMS Black, 4505
n/a

kummer & herrman / graphic designers
kromme nieuwegracht 88 / 3512 hm utrecht (nl)
t 31 (0)30 2343824 / f 31 (0)30 2380770
www.kummer-herrman.nl / studio@kummer-herrman.nl

jeroen kummer / jeroen@kummer-herrman.nl

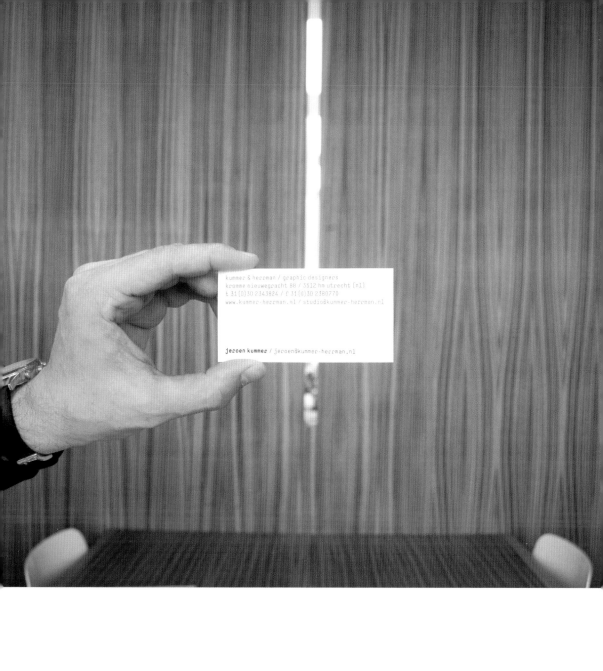

kummer & herrman / graphic designers
kromme nieuwegracht 80 / 3512 hm utrecht [nl]
t 31 [0]30 2343824 / f 31 [0]30 2380770
www.kummer-herrman.nl / studio@kummer-herrman.nl

jeroen kummer / jeroen@kummer-herrman.nl

Joe Scerri Design

Designer:
Joe Scerri Design
Client:
Joe Scerri Design

On the silver side, the nature of the business card is graphic design. On the other side, the text has been mirrored to indicate transparency. However, if you read the reflected words from a mirror, you will find different information on the card.

85 x 55 mm
n/a
PMS Metallic Silver
877 U, Warm Grey 410 U
n/a

Joe A. Scerri
Lake Lustre
info@lakelustre.com
www.lakelustre.com
+41 078 7300 884

Joe A. Scerri
Graphic Design
limepin@runbox.com
www.joescerridesign.com
+41 078 7300 884

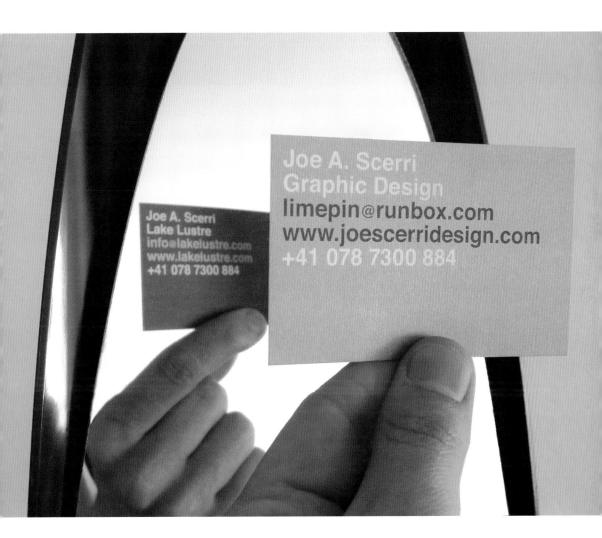

BFS

Designer:
Bleed
Client:
BFS Architects

Architects always concerned
with the dimensions of areas
or blocks of colour put up
against each other, therefore
throughout the whole iden-
tity, deisgners played with
the oversized typography
and used closed-up or angled
images of their work as an

idea. The blocks of colour also
enabled them to put their old
symbol in coherence to the
new identity.

80 x 55 mm

Basberg Kraftkartong,
Art-paper 300 gsm

White silkscreen print,
PMS 8320 C

Silkscreen print

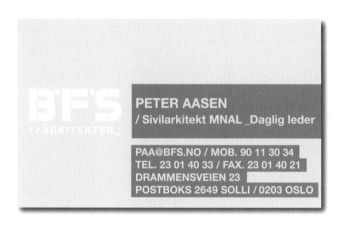

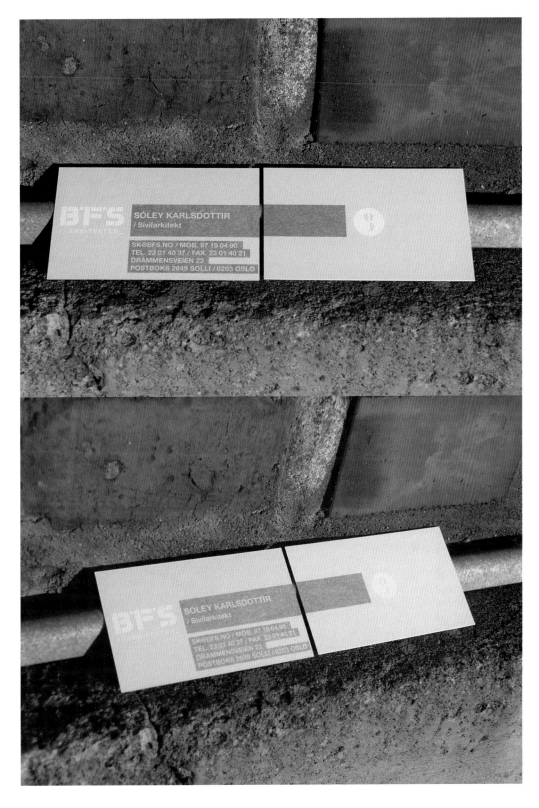

You are here

Designer:
Bleed
Client:
You are here

For this identity, the client asked for a logo that would contain a red dot, as it is seen in any street-maps that says: 'you are here'. This is incorporated to clean and simple typeface, in keeping the 1960's logotype style. The business card adds the playfulness of new/old style of 'you are here' by using varnished arrows and dividing the logo into two parts spreading to the back of the card.

80 x 50 mm
Munken Lynx 300 gsm
PMS Black 6 C, 186 C
Metallic, varnish

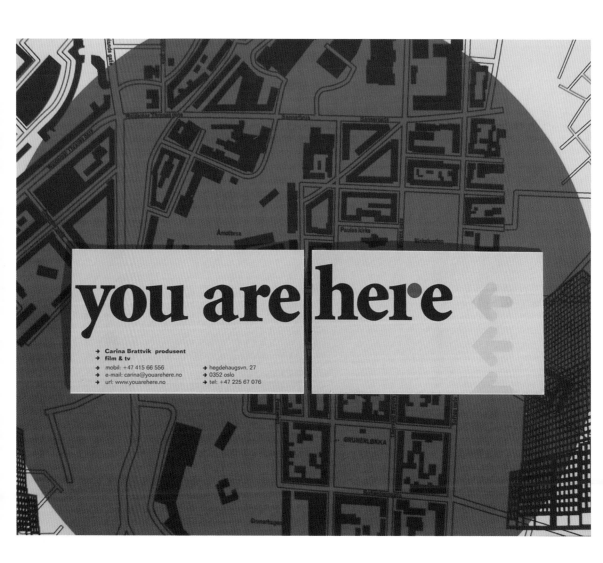

Sin ache

Designer:
Enric Aguilera
Asociados
Client:
Sin ache

In this project, the name of the advertising agency was the design target. Without harming the creativity of the name, a strong Helvetica-type letter is drawn. The logo is emphatic, simple and radical. The letter 'h' is made missing from the name 'sin ache',

which should have placed in the leaving a space. It is actually printed in black, to be visually seen, but with less intensity. It left an open concept of seeing the letter that is silent in Spanish.

80 x 50 mm
Splendorgel Extra White 300 gsm Fedrigoni
Black
n/a

Rooof

Designer:
300million
Client:
Rooof

This business card is designed for a lettings and estate agency based in Surrey, UK. They wanted an identity that could stand out from their more traditional competitors. Using a simple and bold type for their company's name, the card is designed to be folded in a way to symbolize a house's roof.

85 x 55 mm
Naturalis Uncoated
350 gsm
CMYK
Crease and fold

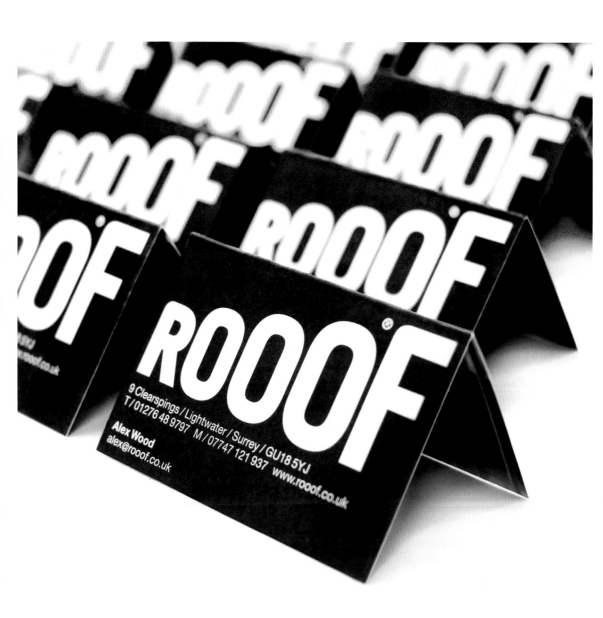

ROOÓF

9 Clearspings / Lightwater / Surrey / GU18 5YJ
T / 01276 48 9797 M / 07747 121 937 www.rooof.co.uk

Nick Lee-Clarke
nick@rooof.co.uk

Special Branch, Inc.

Designer:
Stiletto
Client:
Special Branch, Inc.

The company of this business card is a 3D effects studio, which asked for an identity that plays with the visual of institutional graphics from the 60s. To give the identity a certain twist, the designers mixed a wide spaced and rounded typeface with Times New Roman and massively used their logo on all of their collaterals. The oversized type is used to play with the idea that a letterhead can be folded into a name sign which can be placed on the table during an office meeting.

85 x 50 mm
Conquerer CX22 Bianco Brillante 320 gsm
PMS Black 4 U
n/a

SPECIAL BRANCH, INC.

Specializing in some Design and Production Specialists and blah blah blah blah.

Fran Roberts

625 Broadway, 2nd Floor
NYC, New York 10012
(t) 212.844.2233
(f) 212.844.0550
fran@specialbranch.tv
www.specialbranch.tv

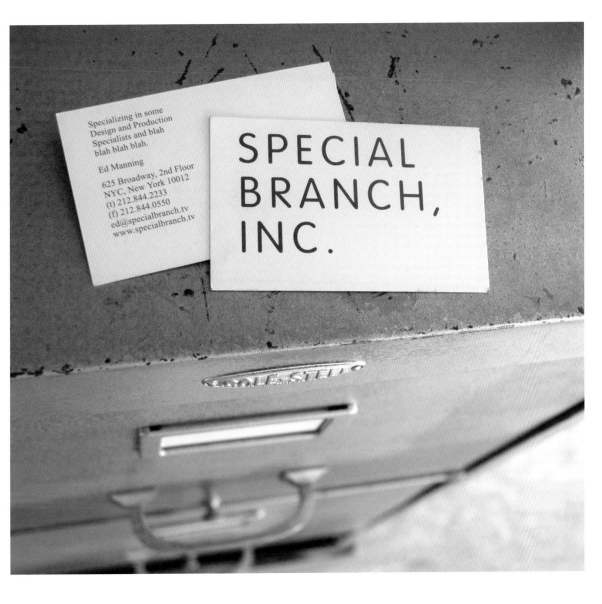

Specializing in some
Design and Production
Specialists and blah
blah blah blah.

Ed Manning

625 Broadway, 2nd Floor
NYC, New York 10012
(t) 212.844.2233
(f) 212.844.0550
ed@specialbranch.tv
www.specialbranch.tv

SPECIAL BRANCH, INC.

Solites

Designer:
Stiletto
Client:
Solites

This newly established company with a group of young scientists asked the designer to catch their spirit by representing this new high technology firm with a friendly and human design. The outcome is a custom-made logotype, plus a technical font called 'Plotter' that was designed by the designer's friend Wolfgang Breuer.

85 x 50 mm

Favini Bianco
Uncoated 350 gsm

PMS 021 C

n/a

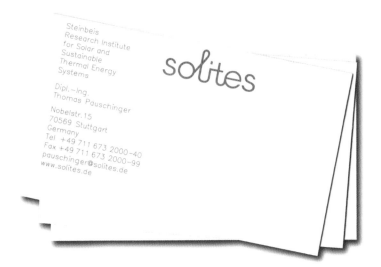

Steinbeis
Research Institute
for Solar and
Sustainable
Thermal Energy
Systems

Dipl.–Ing.
Thomas Pauschinger

Nobelstr. 15
70569 Stuttgart
Germany
Tel +49 711 673 2000–40
Fax +49 711 673 2000–99
pauschinger@solites.de
www.solites.de

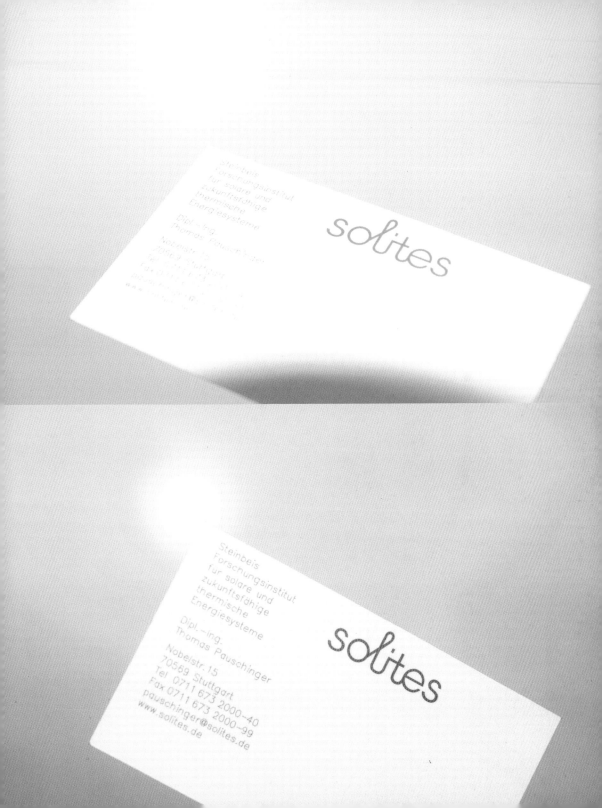

C100

Designer:
C100
Client:
C100

Reflecting a subtle use of
material and form, this one-
colour business card design
stresses on the logo of the
company, which is centered
in a black background.

n/a
300 gsm, 150 gsm
Black
n/a

CHRISTIAN HUNDERTMARK

C100
SCHWEIGERSTR. 8
81541 MÜNCHEN
GERMANY

T/F +49.89.65309520
M. +49.177.3668528
HELLO@C100STUDIO.COM
WWW.C100STUDIO.COM

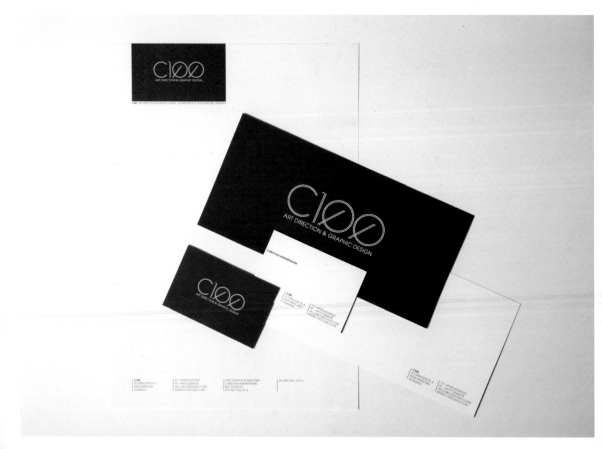

Found

Designer:
....,staat
Client:
Found

The concept of this card says, 'When the client is lost, Found is the one to look for.' Found resources the smartest and the most economical ways to produce and organize campaigns, instore merchandising and many others. The stationary represents this down-to-earth and practical way of thinking, which also tells you that Found is taking care of business.

85 x 55 mm
Conqueror CX22
250 gsm
PMS 8340 Metallic Gray,
8395 Dark Blue
Matt lamination, gloss
lamination

you
are
lost

you
are
fabulous

we
are
Found.

I am Ab de Graaff
managing partner

Found.
Noordhollandstraat 71, 1081 AS Amsterdam, NL
t.+31 (0)20 517 15 45, f.+31 (0)20 517 15 17
m.+31 (0)655 330 636, ab@youhavefound.com
www.youhavefound.com

Stiletto

Designer:
Stiletto
Client:
Stiletto.

This business card was de-
signed for the design studio
themselves. They redesigned
their logo a while back and
mixed a hand drawn font with
Baskerville italic. The thing
they liked best was to print
postcards and business cards
on a super thick cardboard.

85 x 50 mm

Double thick cardstock

Custom PMS metallic
tone

n/a

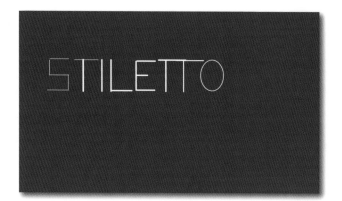

+1.646 336 0500, 86 forsyth street, nyc 10002
www.stilettonyc.com, julie@stilettonyc.com
julie hirschfeld

architecture, interiors, design & space planning

studio g&a

Studio G&A

Designer:
Stiletto
Client:
Studio G&A

This is from an identity for
an architecture firm in New
York. The designers mixed a
rounded font with Impressum
Italic, which creates a nice
mix of different textures.

85 x 50 mm

Conquerer CX22 Bianco
Brillante 300 gsm

PMS 5477 U

n/a

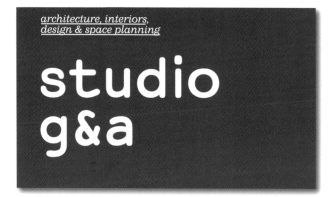

Tobin Yelland

Designer:
Stiletto
Client:
Tobin Yelland

The designer created this business card that can be flipped. In a continuous paragraph you can read "photographer" on one side and "filmmaker" on the other side - expressing the two professions of the client, Tobin Yelland, on just one card. They used Univers as the identity and mixed with colours like brown and pink.

85 x 50 mm
Conquerer CX22 Bianco Brillante 300 gsm
PMS 497 U, 4685 U
n/a

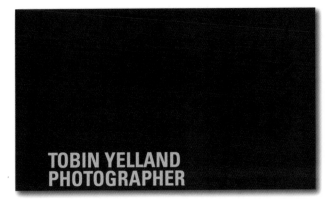

**TOBIN YELLAND
PHOTOGRAPHER**

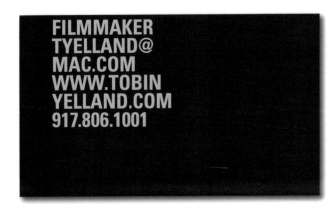

**FILMMAKER
TYELLAND@
MAC.COM
WWW.TOBIN
YELLAND.COM
917.806.1001**

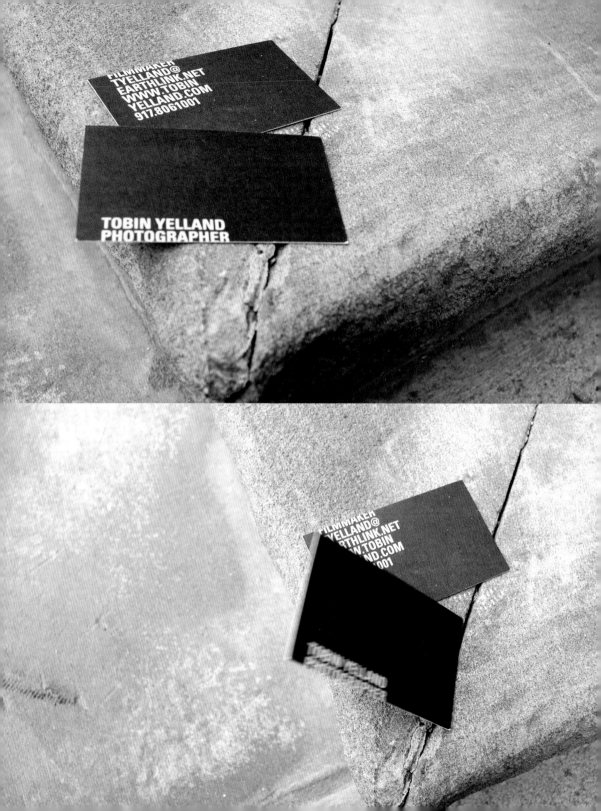

Pun

Designer:
Stiletto
Client:
Pun

Pun's wallpaper designs are
very lush & bold, and are
made for large hotel lobbies
and restaurant murals. The
designer wanted to create an
identity that feels very exclu-
sive. For which, they created
a customized logo mark and
used a classic serif font for it.

82 x 50 mm

180 lb Pegasus Midnight
Black matt cover

PMS Metallic 8002 C

Metallic silk screen

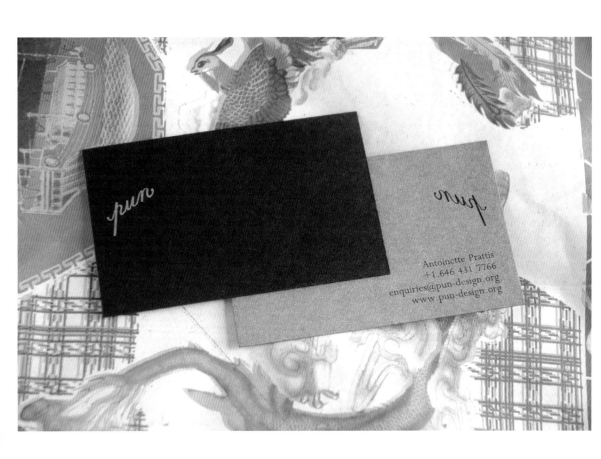

As Four

Designer:
Stiletto
Client:
As Four

The designer designed this
business card as part of the
identity of a New York fashion
label 'As Four', in which they
designed a customized logo
mark and used their house
font- Helvetica Neue.

85 x 50 mm
Cardstock
Light gray
Letterpress

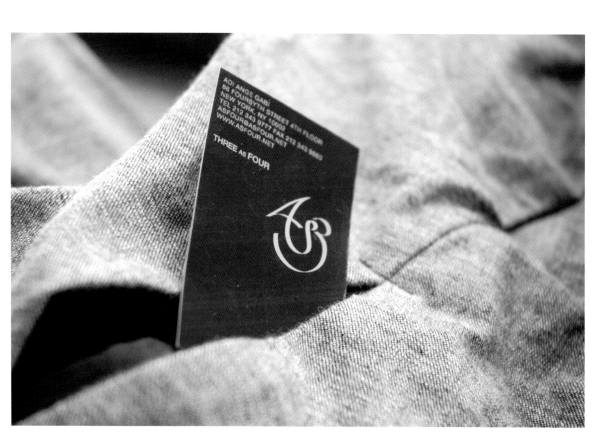

Book

Designer:
Kinetic
Client:
Alex Goh

This name card is made for a writer and is designed to look like an opened book. One page is left blank so he can customize the card with reference to the recipient, and showcase his creativity and

writing prowess in the process – sharing his views, tips, musings and more. In short, creating a personal connection with the recipient.

n/a
n/a
CMYK
n/a

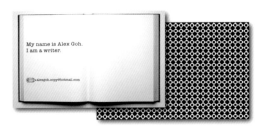

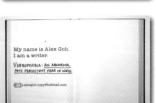

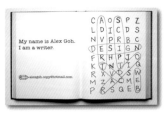

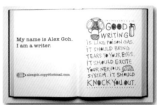

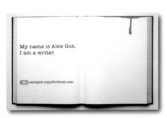

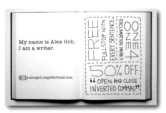

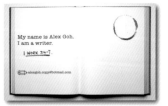

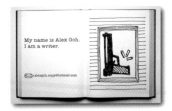

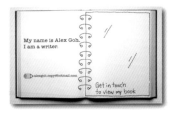

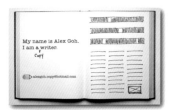

Row 1:

My name is Alex Goh.
I am a writer.
alexgoh.copy@hotmail.com
ONE IDEA IS NEVER ENOUGH

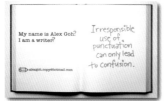
My name is Alex Goh?
I am a writer?
alexgoh.copy@hotmail.com
Irresponsible use of punctuation can only lead to confusion.

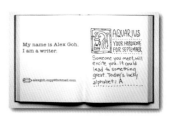
My name is Alex Goh.
I am a writer.
alexgoh.copy@hotmail.com
AQUARIUS
YOUR HOROSCOPE FOR SEPTEMBER
Someone you meet will excite you. It could lead to something great. Today's lucky alphabet: A

Row 2:

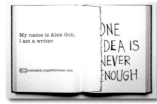
My name is Alex Goh.
I am a writer.
alexgoh.copy@hotmail.com
This Book Belongs to:

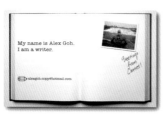
My name is Alex Goh.
I am a writer.
alexgoh.copy@hotmail.com
Greetings from Cannes!

My name is Alex Goh.
I am a writer.
alexgoh.copy@hotmail.com
Marina
is infinitely fascinating as the sea from which her name is derived. Not one to be confined, she excels in the creative arts.

Row 3:

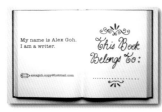
My name is Alex Goh.
I am a writer.
alexgoh.copy@hotmail.com

My name is Alex Goh.
I am a writer.
alexgoh.copy@hotmail.com
NOTES

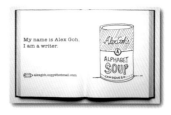
My name is Alex Goh.
I am a writer.
alexgoh.copy@hotmail.com
Alex Goh's ALPHABET SOUP

Row 4:

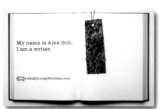
My name is Alex Goh.
I am a writer.
alexgoh.copy@hotmail.com
I love to write. I love to write. I love to write. I love to write.

My name is Alex Goh.
I am a writer.
alexgoh.copy@hotmail.com
" ★★★★★ "

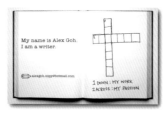
My name is Alex Goh.
I am a writer.
alexgoh.copy@hotmail.com
1 DOWN : MY WORK
2 ACROSS : MY PASSION

Row 5:

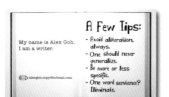
My name is Alex Goh.
I am a writer.
alexgoh.copy@hotmail.com
A Few Tips:
- Avoid alliteration, always.
- One should never generalize.
- Be more or less specific.
- One word sentence? Eliminate.

My name is Alex Goh.
I am a writer.
alexgoh.copy@hotmail.com
Tyler
[The Talented One]
Passionate, artistic, cool, creative, imaginative and inspiring.

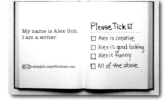
My name is Alex Goh.
I am a writer.
alexgoh.copy@hotmail.com
Please Tick ☑
☐ Alex is creative
☐ Alex is good looking
☐ Alex is funny
☐ All of the above

MEWE Design Alliance

Designer:
MEWE Design Alliance
Client:
MEWE Design Alliance

With the most simple printing technique and typography, three names have been printed on the same card with unnecessary information crossed out, which is just in plain white background with black type.

90 x 45 mm
Glass Card 80 gsm
Black
n/a

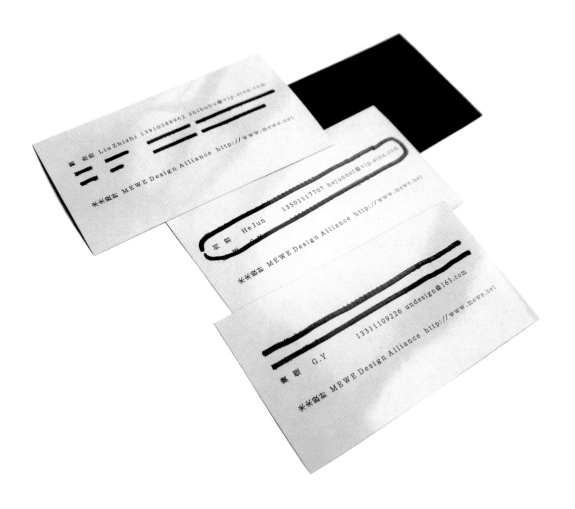

蔡 姐姐 Liu Zhizhi 13910288962 zhihuhu@vip.sina.com

米米盟云 MEWE Design Alliance http://www.mewe.net

何 骏 HeJun 13501117707 hejunnet@vip.sina.com

米米盟云 MEWE Design Alliance http://www.mewe.net

蒙 婺 G.Y 13311109226 undesign@163.com

米米盟云 MEWE Design Alliance http://www.mewe.net

Andrew Demianyk

Designer:
Andrew Demianyk
Client:
Andrew Demianyk

The designer does not want his personal collection of business cards amount to nothing more than a pile of scrap paper with biro scrabblings on them. Hence the inspiration is 'No position, no company, simply with the name, phone number, website and a vague idea of what he does'. Job title is not indicated here as people will have to meet him anyway. So a scrap of paper with just the name and number on is all what you need.

85 x 55 mm
Card
Blue, red
Gloss finish on writing to make it appear to be fresh ink

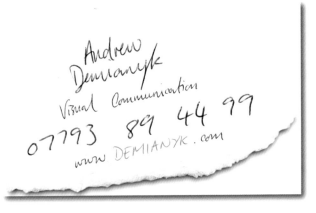

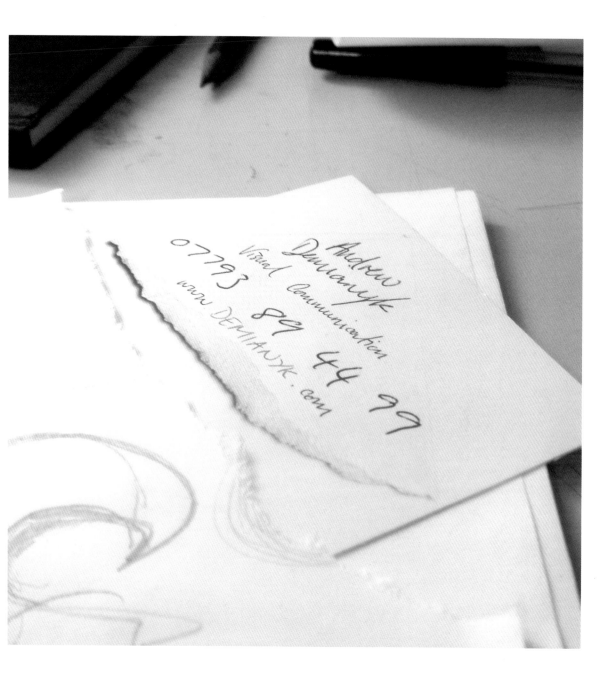

Andrew
Demianyk
Visual Communication
07793 89 44 99
www.DEMIANYK.com

Warmrain

Designer:
Warmrain
Client:
Warmrain

Each card is unique, having been die-cut out of old books with a sentence or phrase highlighted with a marker pen. The uniqueness of each card reflects the consideration that the designer takes with every design decision. A sense of personality is hence captured as the individual who uses the business cards tailors them by choosing his/her own phrases.

85 x 55 mm

Paper from old books laminated onto 300 gsm matt

n/a

n/a

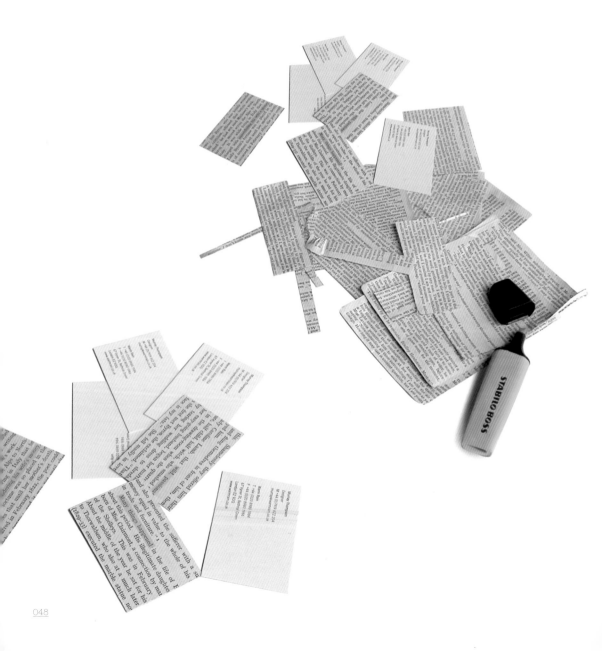

man of brilliant genius, who, like a new
wept into the space of English Literature, w
ouse their interest and quicken their enthusi

" It was not her purpose to discuss the pri
aults and follies of so brilliant a genius as By
or she considered a man's worth was a n
rue self. It was by the work he left to the v
hat he should be judged.

" More had been said, written, and sugge
bout Byron's private life than was creditabl

we; but Byron, who was keenly wounded
iis criticism, affirmed that before writing
ifred " he had not read Marlowe's work.
ʒron soon moved across the Alps to North
taly. It was while living in Italy that he
harged with squandering his wife's money
ady Byron's fortune was so placed in the
i of trustees that until her mother's death
occurred in February 1822, the poet could

and also presented the sufferer with a su
money equal in value to the whole of his
in trade and furniture." [1]

Many things happened in the life of E
about this period. His illegitimate daughter
born of Miss Clairmont, a connection by mar
of the Shelleys. This was in February
About the middle of the year he sat for his
to Thorwaldsen, who also at a much later
(1829–33) executed the marble statue no

Embassy Row

Designer:
Mattisimo
Client:
Embassy Row

A card for an English broad-
cast network debuting in Los
Angeles and New York that
specializes in reality series
television. The dotted pattern
resembles the networking
and the technology.

86 x 49 mm

Domtar colours Britewhite
Smooth 175 lb Tag

PMS Solid Uncoated
312 U, 1545U

Metallic silk screen

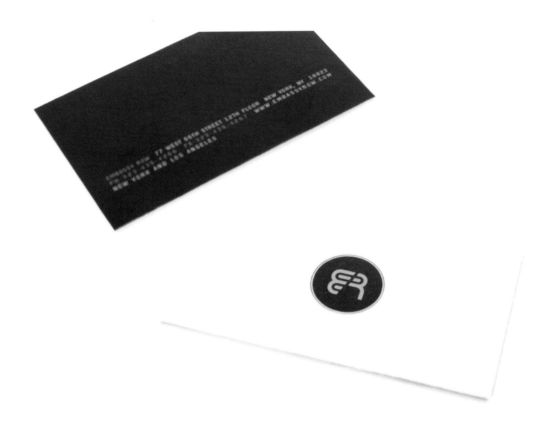

Beat Steinmann

Designer:
NuDesign
Client:
Beat Steinmann

This business card was
designed for a copywriter.
For this, designers played
with English characters to
assoicate with the nature of
the business.

1. 54 x 85mm
2. 163 x 52 mm
Cardboard 500 gsm
Black, red
Screenprint

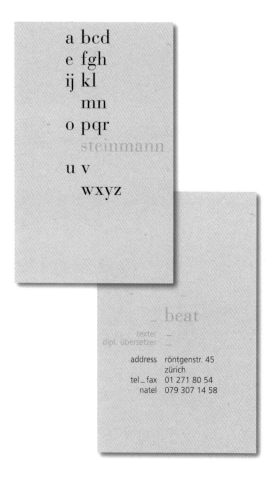

abcdef
ghijkl
mnopq
rstuvw
xyz,.+"
ç;:%&/(
)=?!äö
üéèà_

beat steinmann
texter – dipl. übersetzer

röntgenstr. 45
8005 zürich
tel. _ fax 01 271 80 54
natel 079 307 14 58

1

2

Mwmcreative

Designer:
Mwmcreative
Client:
Mwmcreative

This card was designed as having two main functions: business card and compliment slip. With basic information about the person/company, the design is extremely original and quirky due to its colour, font size and a reserved space with three blank lines for further written information. The logo in white on 805 background stands out as it plays tricks with the eyes.

75 x 55 mm
n/a
PMS 805 C
Flourescent ink

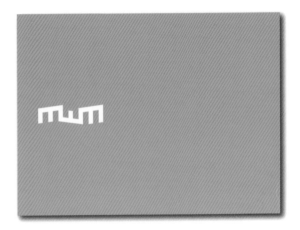

MARIA DA GANDRA
MARIA@MWMCREATIVE.CO.UK
M 077 9049 6501

- -

- -

- -

WWW.MWMCREATIVE.CO.UK

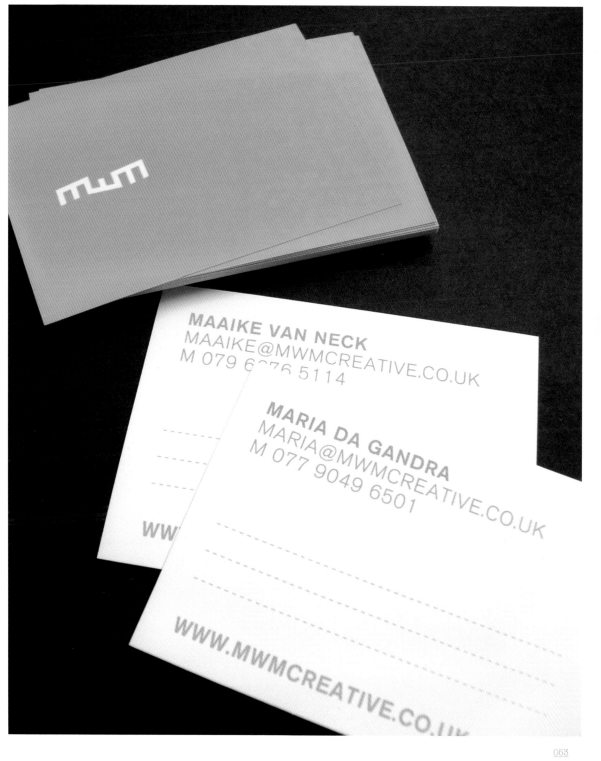

MAAIKE VAN NECK
MAAIKE@MWMCREATIVE.CO.UK
M 079 6376 5114

MARIA DA GANDRA
MARIA@MWMCREATIVE.CO.UK
M 077 9049 6501

WWW.MWMCREATIVE.CO.UK

Stylo

Designer:
Stylo
Client:
Stylo

This card was designed as part of the new identity and stationery set when the company had to move to a new office space on the piazza in Covent Garden. It uses the company's own colour mixed on press partnered with black foiling.

85 x 55 mm
Challenger 400 gsm
Black, Orange
Black foiling

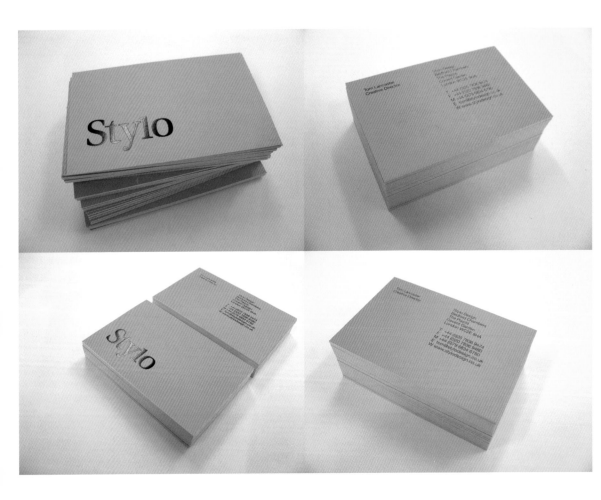

Pentas Project

Designer:
undoboy
Client:
Pentas Project

'Pentas Project' in Chinese, 'Pin Tai', indicating a flat stage. It possesses an unique characteristic, that is a flat land without walls and boundaries, a stage that could be more transparent and equal, a stage for interactions, understandings and that could strengthen the relationships between different cultures and realms.

91 x 50 mm
n/a
PMS DS 293-3C, Black
Metallic silk screen

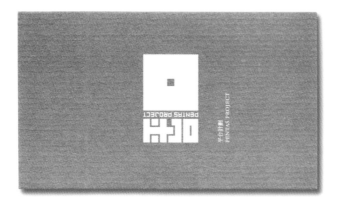

—HELLO,

PLEASE
KEEP IN TOUCH.

WE ARE NOT
FAR FROM YOU.

LOH KOK MAN 羅國文
ARTISTIC DIRECTOR

TEL: 603.9171 9423
HP: 012.607 1318
MADELOH@GMAIL.COM

10A, LORONG IKAN EMAS 1,
TAMAN IKAN EMAS, BATU 3½ CHERAS,
56100 KUALA LUMPUR, MALAYSIA.

1. Granite

Designer:
Form
Client:
Granite Colour Ltd

The name of this printing company, Granite is so powerful that the identity had to be big, with a lot of weight behind it. Designer used a foil on two layers of colour plan duplexed together to represent the layering of granite in the earth and to create a bold and powerful introduction.

88 x 55 mm

Mandarin/Dark Gray Colourplan Duplexed 270 gsm

PMS 405 U

Gunmetal block foil

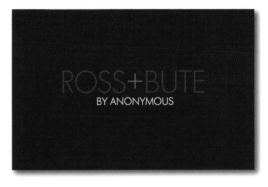

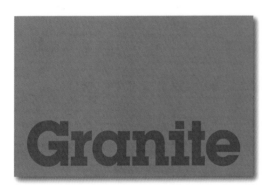

Head Office: Anonymous Limited
19 Baseline Studios, Whitchurch Road, London W11 4AT
Telephone: 020 7727 2370 Fax: 020 7168 2465
Email: info@anonymousclothing.com

Shop: Ross+Bute by Anonymous
57 Ledbury Road, Notting Hill, London W11 2AA
Telephone: 020 7727 2348 Fax: 020 7727 7400
Email: shop@anonymousclothing.com

www.anonymousclothing.com

Neil Smart

Granite Colour Ltd.
50 Progress Road
Leigh-on-Sea
Essex SS9 5PR

Tel: 01702 507 900
Fax: 01702 507 903
www.granitecolour.com

2

1

2. Ross+Bute

Designer:
Form
Client:
Ross+Bute
by Anonymous

A card designed for a clothing label Anonymous. A recognizable identity representing their feminine clothing was created. It features their 'corporate' plum colour as a full bleed background which has been matt laminated.

Such matt laminated finishing means that the silver foil blocked logo could stand out even more from the background.

88 x 55 mm

Conqueror High White 350 gsm

PMS 262 U, Rhodamine Red U

Silver block foil, matt laminatation

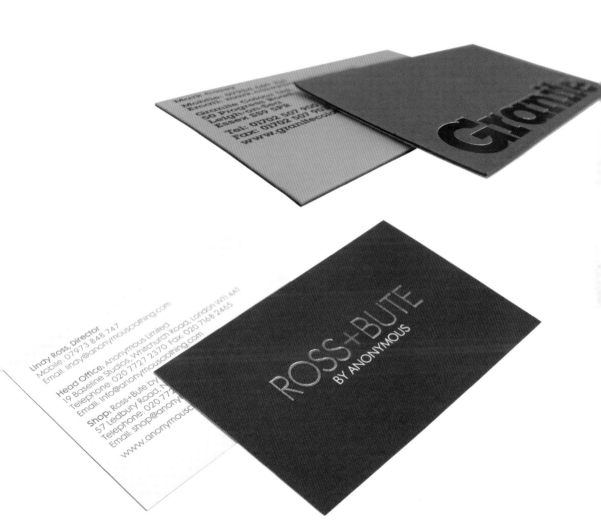

Frost Design

Designer:
Frost Design
Client:
Frost Design

This card designed for them-
selves is bold and impactful.
With the use of the dayglow
orange that has a bright eye
burning effect, it often cre-
ates the response 'gee they're
bright'. The designer for this
business card thought it is
important to be memorable.

85 x 55 mm

Mohawk Superfine Ultra
White Eggshell 270 gsm

PMS 804 double
impression

n/a

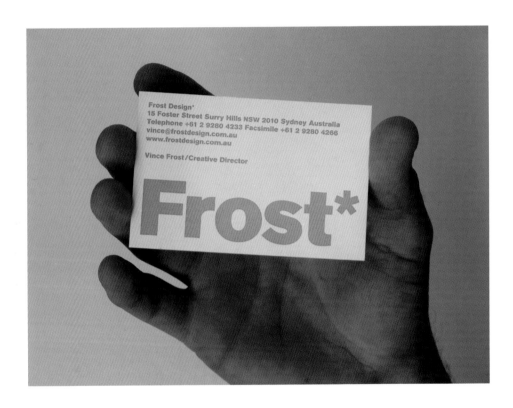

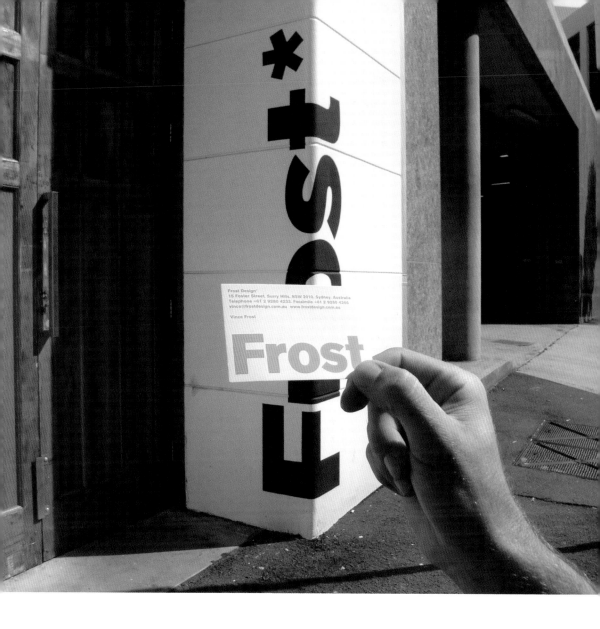

Henchem

Designer:
Viction Design Workshop
Client:
Henchem International
(HK) Ltd.

This card designed for a trad-
ing company is printed in
subtle colours and simple type
to stress on the logo of the
company, in which suggests
the link between two spots,
associating with trades. The

hot-stamping pattern created
by the repetitive use of the
logo at the back of the card
adds texture and tone to the
design.

89 x 55 mm

Arjowiggins Impressions
Village, White 280 gsm

PMS 231 U, 2955 U,
Cool Gray 3 U

Transparent
hot-stamping

henry tsang
director

room 605 6/f no.1 hung to road kwun tong
kowloon hong kong
tel: 852. 3106 0938 fax: 852. 3106 0939
mobile: 852. 9467 2510 / 86. 13686 181866 (china)
email: henrytsang@netvigator.com
usa office: 382 north lemon ave #346 walnut
ca 91789 los angeles usa
email: henrytsangusa@aol.com

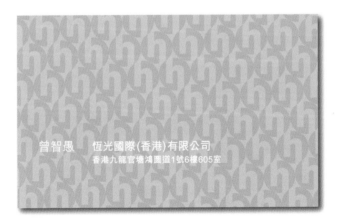

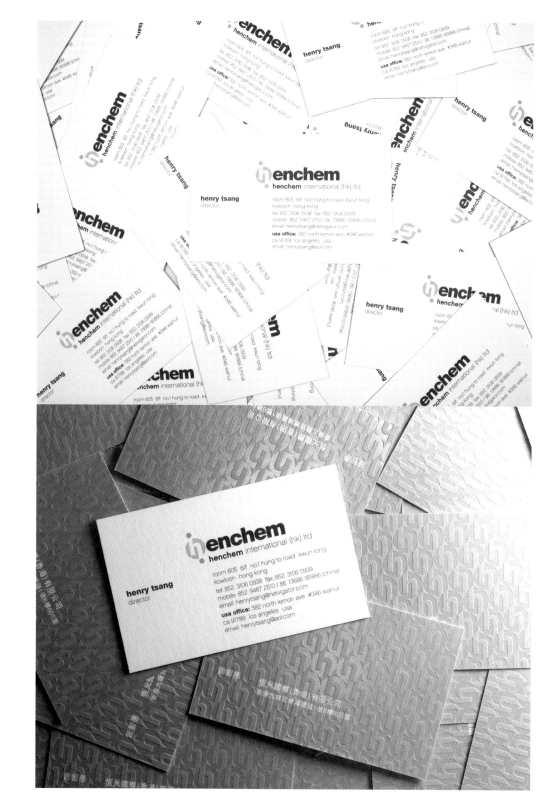

Trollbäck+Company

Designer:
Trollbäck+Company
Client:
Trollbäck+Company

This card was designed in 2005 when the company rebranded themselves. It is kept with the graphic umlaut derived from Jakob Trollbäck's last name. While before their logo was a lowercase 'a'

with the umlaut over it, they have since minimized this to merely the umlaut, a reference to Jakob's Swedish roots.

90 x 50 mm

Cardstock

PMS 1925, Cool Grey 10 C, Black

n/a

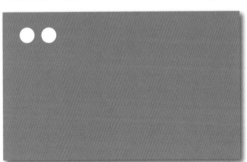

TROLLBÄCK+COMPANY
302 FIFTH AVENUE
14TH FLOOR
NEW YORK, NY 10001
TROLLBACK.COM

Jakob Trollbäck / Creative Director

Tel 212 529 1010 · Fax 212 529 9540 · jakob@trollback.com

TROLLBÄCK+COMPANY
302 FIFTH AVENUE
14TH FLOOR
NEW YORK, NY 10001
TROLLBACK.COM

Elizabeth Kiehner / Executive Producer

Tel 212 529 1010 · Fax 212 529 9540 · elizabeth@trollback.com · Cell 917 406 1933

Gilles Gascon CA

Designer:
Philippe Archontakis
Design
Client:
Gilles Gascon CA

The client wanted a classy, clean corporate image reflecting its personality and its office space, so the colours of Eggplant and Cream were chosen from its walls and furniture. The "g" in the square illustrates g2 from the client's name Gilles Gascon. It is also an analogy and meta-phor for their accounting service. This square is embossed to add emphasis and texture. The typography Akkurat, is a fully-packaged modern and corporate font.

91 x 44 mm

Mowahk Ultra White,
100 pt double cover

4 PMS

Emboss

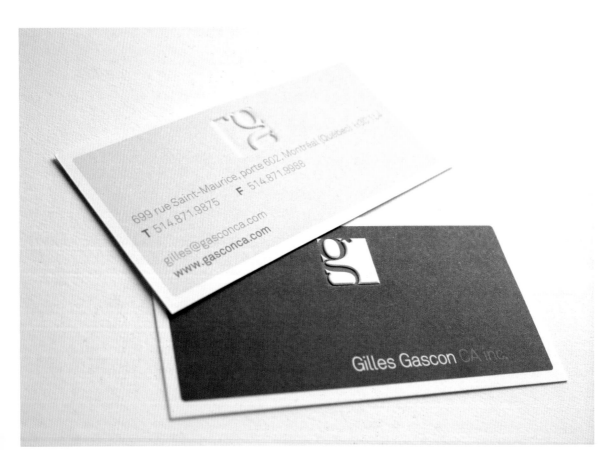

Lambert
Communications

Designer:
Philippe Archontakis
Design
Client:
Lambert
Communications

The client of this business card wanted to put emphasis on her name and address at the same time. To do that, the designers used embossing and put her logo on one side and the address centered in the debossed area on the other side. Such embossed area in the middle of the card suggests one big button to push, just like calling for her services. It also suggests the connectivity and relationships building between the company and the clients of this public relations based company.

89 x 51 mm
Mowahk Ultra White,
80 pt cover
3 PMS
Emboss

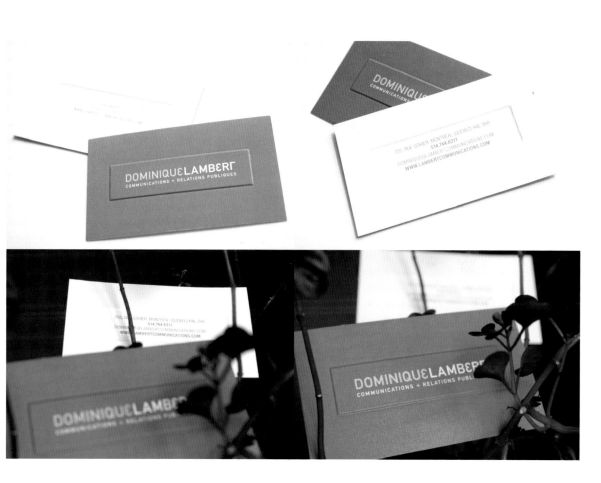

Frog Design

Designer:
FEZ Design
Client:
Frog Design

1. This card design is simple and subtly reference the legacy of 'frog' icon with a modern edge and sophistication. The concept was to use the frog logotype as a window into new ideas as well as making it prominent on the front of the card. It relates design to the four essential elements of the earth, making design an essential part of our world.

2. This second concept of the business cards for Frog Design plays off of a simple, clean, modern layout with all the information on the front of the card. It still holds the legacy 'frog' icon, and reinforces the 'frog' green.

85 x 54 mm

1. 180 LB Pegasus Midnight Black matt cover
2. Strathmore Bright White 25% Cotton

1. CMYK
2. PMS 375 U, Cool Gray 4 U, 425 U

1. Gloss UV coating
2. n/a

frog™

Prof. Dr. Hartmut Esslinger
co-chief executive officer

frog design inc.
3640 hillview avenue palo alto CA 94089

t (1) 650 391 1408 **e** h@frogdesign.com
www.frogdesign.com

1

Prof. Dr. Hartmut Esslinger
Co-Chief Executive Officer

frog design™

Hartmut.Esslinger@frogdesign.com
+1 650 856 3764
www.frogdesign.com

2

Design People Studio

Designer:
Design People Studio
Client:
Design People Studio

The form of the letters in
this business card evokes the
design of this creative studio
which is also represented by
the vector art.

84 x 55 mm

Semimate Couche
300 gsm

PMS Black, 812 C2X
(fluor pink)

UBI

DESIGN PEOPLE STUDIO/MADRID
CONCEPTION, CONSTRUCTION, SUCCESS TM
DISEÑO GRAFICO Y CREATIVIDAD ONLINE/OFFLINE

MARIA MONFERRER
MARIA@DESIGNPEOPLE.NET

DESIGN PEOPLE STUDIO

MAURICIO LEGENDRE 5, 28046 MADRID
T:91 733 73 72 M:678 63 30 69
TALK:INFO@DESIGNPEOPLE.NET
STUDIO:WWW.DESIGNPEOPLE.NET
PLAY:WWW.PEOPLELOVEMACHINES.COM
BUY:WWW.THEPEOPLESHOP.COM

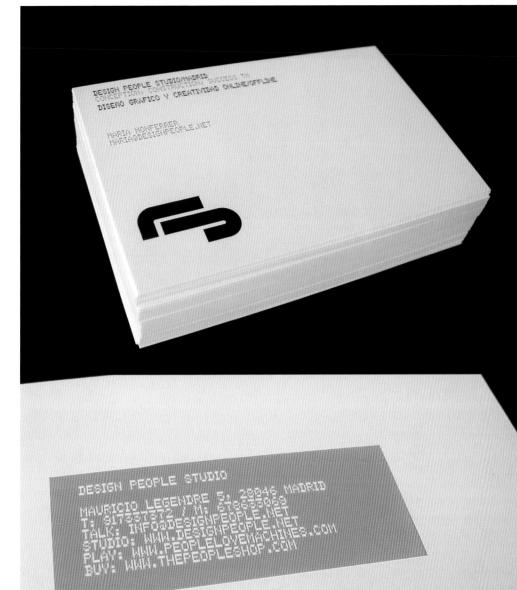

Design People Studio

Designer:
Design People Studio
Client:
Design People Studio

The form of the letters in
this business card evokes the
design of this creative studio
which is also represented by
the vector art.

76.5 x 50 mm

Semimate Couche
90 gsm

PMS 1788 C2X, 812 C2X

n/a

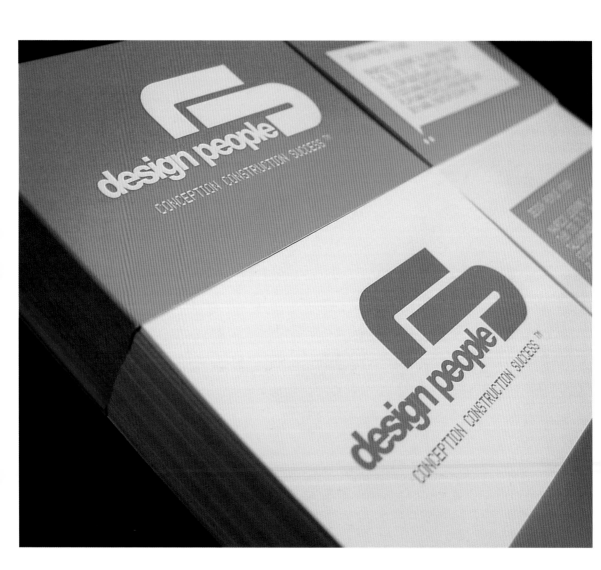

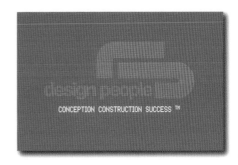

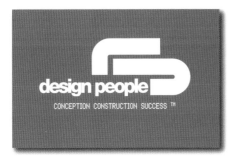

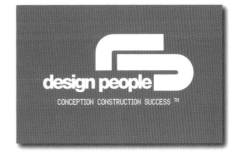

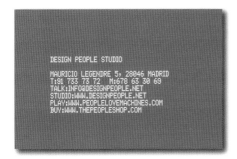

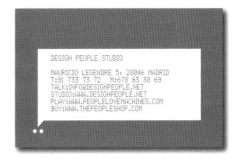

Timothy Saccenti

Designer:
Build, Michael C. Place
Client:
Timothy Saccenti

Strong typography and vivid
colour variations for client's
information made up such
heavy text which has added
the designer's aesthetic for
this card.

100 x 80 mm
n/a
n/a
n/a

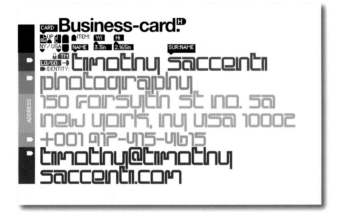

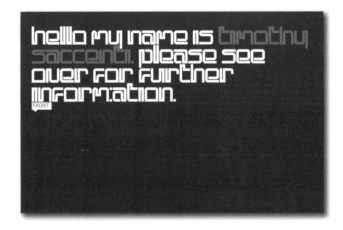

Yosho

Designer:
Segura Inc.
Client:
Yosho

This business card with
rounded corners die-cut in
square format is simple but
outstanding at the same time.
With a series of three front
colours, the logo in white,
which is associated with
numbers also correspond to
the back of the card.

n/a
n/a
n/a
n/a

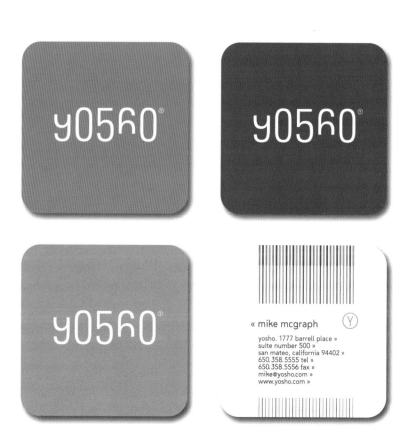

Ir. Marinus Oostenbrink

Designer:
DesignArbeid
Client:
Marinus Oostenbrink

The keywords for the work of this client, whose work is to advise the council and housing coorperations about city development and architecture, are: Advice, City development and Architecture. These words, and a series of associations for each of them, are mentioned on the back-side of the card. Given advice by the client tells you about the definition of space and how to use it, this card can be read in four directions, every direction explaining one key element of his work.

85 x 55 mm
n/a
Black, PMS 805 U
n/a

PROGRAMMA MANAGEMENT
STEDENBOUW
ARCHITECTUUR

IR.MARINUS.OOSTENBRINK

KERKSTRAAT 347.E
1017 HV AMSTERDAM
T. 020 620 46 39
M. 06 516 039 65
E. MARINUS.OOSTENBRINK@XS4ALL.NL

ARCHITECTUUR

ADVIEZEN

STEDENBOUW

Bureau Keen

Designer:
DesignArbeid
Client:
Erwin Keen

A paper of an experimental
textile designer's business
card must have a 'textile
feeling' that explains the use
of pattern. Patterns are also a
part of his work and this can
be seen as a graphical quote
of his work too.

85 x 55 mm
n/a
PMS 292 U
n/a

Bellatazza

Designer:
Buzzsaw Studios Inc.
Client:
Bellatazza

Perfection was the driving force in this project from beginning to end. All aspects of the identity's hand-lettered type treatment had to be perfect: the letterforms, the slant, the spacing. About 300 versions were executed with a kolinsky sable watercolour brush and India ink.

The business cards are clean and simple with the tile icon laser cut through the card. The cards are printed with a flood coat of PMS 279 on the back and black ink for the logo and type on the front.

89 x 51 mm
Panache 100# Cover
PMS 279, Black
Die-cut

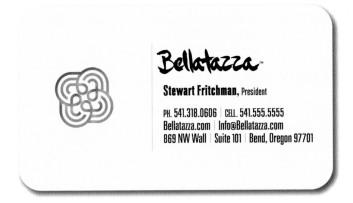

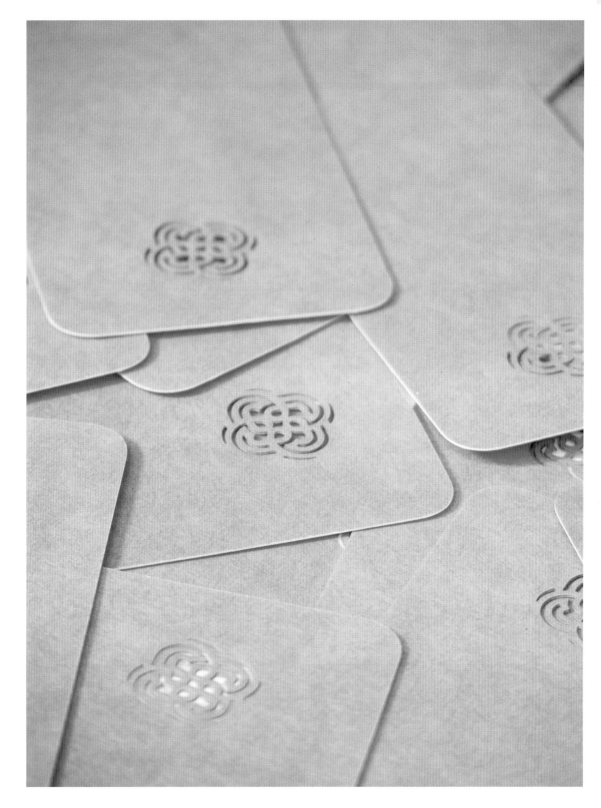

Buzzsaw Studios Inc.

Designer:
Buzzsaw Studios Inc.
Client:
Buzzsaw Studios Inc.

The Buzzsaw Studios Inc. logo, icons and business card are clean and simple. Each of the icons is a piece of the other, they all fit within each other and standalone if needed. Each of these 5 icons symbolize a different blade or buzzsaw. Depending on the client or project the designers use a different tool to achieve the best results.

The Buzzsaw lettering was hand drawn, scanned and then converted to vectors for usage across all platforms. The lettering has a feel of sharp edges and blades with a forward moving slant.

89 x 51 mm
165# Classic Crest card stock
PMS 021, Cool Gray 11
Die-cut

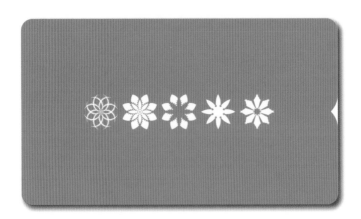

Andrea Wordhouse
Client Liaison

tparsons@buzzsawstudios.com
buzzsawstudios.com
541 382 1019 tel
541 280 1366 cell

Buzzsaw Studios Incorporated
920 NW Bond Street Suite 203
Bend Oregon 97701

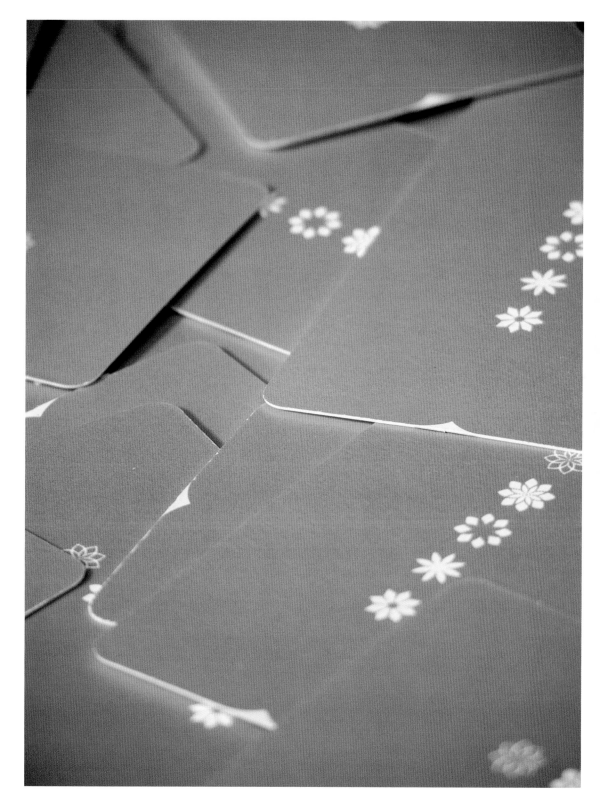

Kinetic

Designer:
Kinetic
Client:
Kinetic

This series of namecards was part of a larger project to update the firm's corporate identity. It is individual while also retaining an element of fun. Each staff-member was given a simple brief to create their own individualized name card. Words or letters on the left hand column could be highlighted and combined with short phrases on the right side to form sentences. Each card thus tells a unique story that says more about an individual than the usual name card approach. A similar style was also applied to a complete set of stationery as a part of a corporate identity update.

8.5 x 4.7 mm
n/a
CMYK
Die-cut

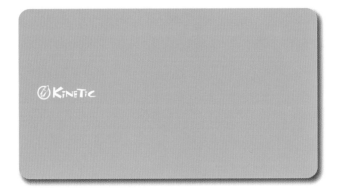

Carolyn Teo
Account Director
carolyn@kinetic.com.sg
www.kinetic.com.sg
Kinetic Design
& Advertising
Private Limited
2 Leng Kee Road
#04-03A
Thye Hong Centre
Singapore 159086
Handphone.9686.2641
Telephone.6379.5216
Facsimile.6472.5440

A Member of the Ad Planet Group

works hard for her clients, hoping to
on them to treat
as their
and to
their

budgets
her team. To her
great partnership doesn't always
around big budgets.
reality, it's about lending a
without being asked
and always going the extra

Carolyn Teo
Account Director
carolyn@kinetic.com.sg
www.kinetic.com.sg
Kinetic Interactive
Private Limited
2 Leng Kee Road
#04-03A
Thye Hong Centre
Singapore 159086
Handphone.9686.2641
Telephone.6379.5216
Facsimile.6472.5440

makes the

simple to understand.

A Member of the Ad Planet Group

Victor Low
Composer
victor@kinetic.com.sg
www.kinetic.com.sg
Kinetic Interactive
Private Limited
2 Leng Kee Road
#04-03A
Thye Hong Centre
Singapore 159086
Telephone.6379.5321
Facsimile.6472.5440

best expresses himself with music.

major
minor
augmented
diminished
flat
sharp
frequency
dB
kbps
Hz

A Member of the Ad Planet Group

Clara Teo
Web Designer
clara@kinetic.com.sg
www.kinetic.com.sg
Kinetic Interactive
Private Limited
2 Leng Kee Road
#04-03A
Thye Hong Centre
Singapore 159086
Telephone.6379.5312
Facsimile.6472.5440

isn't lost, she just enjoys searching the
for new possibilities. The
is her next of
She sleeps, eats and lives on the
Without which she is just a
soul. Some say she's on the
to perdition. To her, she's on
space voyage heading back to her control

is her pit stop and she'll soon be off
her expedition
light-years out into the universe.

A Member of the Ad Planet Group

Benjy Choo
Art Director
benjy@kinetic.com.sg
www.kinetic.com.sg
Kinetic Interactive
Private Limited
2 Leng Kee Road
#04-03A
Thye Hong Centre
Singapore 159086
Handphone.9844.7090
Telephone.6379.5310
Facsimile.6472.5440

can't spell.

But call

and he'll make you

A Member of the Ad Planet Group

Jason Chan
Junior Art Director
jason@kinetic.com.sg
www.kinetic.com.sg
Kinetic Interactive
Private Limited
2 Leng Kee Road
#04-03A
Thye Hong Centre
Singapore 159086
Telephone.6379.5323
Facsimile.6472.5440

incurable design addict
a hopeless visual romantic?
spends too much time on his
cruising the
and feeding fuel to his overactive
imagination.
(Which explains why he
thinks he is at the
of a vicious scandal involving
women and
imaginary pet monkey)
-:

A Member of the Ad Planet Group

Sean Lam
Art Director
sean@kinetic.com.sg
www.kinetic.com.sg
Kinetic Interactive
Private Limited
2 Leng Kee Road
#04-03A
Thye Hong Centre
Singapore 159086
Handphone.9684.2497
Telephone.6379.5309
Facsimile.6472.5440

can be too

times.
fact, he is also known for his

patience.

is something he can do without
him only in an emergency
...what?

A Member of the Ad Planet Group

Kenny Choo
Web Designer
ken@kinetic.com.sg
www.kinetic.com.sg
Kinetic Interactive
Private Limited
2 Leng Kee Road
#04-03A
Thye Hong Centre
Singapore 159086
Telephone.6379.5201
Facsimile.6472.5440

finds the
amazing. He believes that the
is the next big thing to iced coffee.
He loves to
with other people, yet is a very
person at the same time. He finds a
intriguing since it can be coming or going.

Still thinks that a
is a clueless smile in disguise.

A Member of the Ad Planet Group

Adrian Tan
Boss
adrian@kinetic.com.sg
www.kinetic.com.sg
Kinetic Interactive
Private Limited
2 Leng Kee Road
#04-03A
Thye Hong Centre
Singapore 159086
Handphone.9635.6618
Telephone.6475.9377
Facsimile.6472.5440

may be the undisputed

but he'll be glad to
over the mysteries of the universe with you at
or
Alternatively, drop him a fan note at
He'll be quite pleased to tell you why no
socks can be found on his feet.

A Member of the Ad Planet Group

Bra Kläder

Designer:
Lobby Design
Client:
Bra Kläder

The designer started with de-
signing the logo as a clothing
label. Then they transformed
it into hangtags. And finally,
to place the logo on business
cards, without loosing the feel
as a clothing label.

90 x 55 mm
Lessebo Linné
n/a
Punched hole

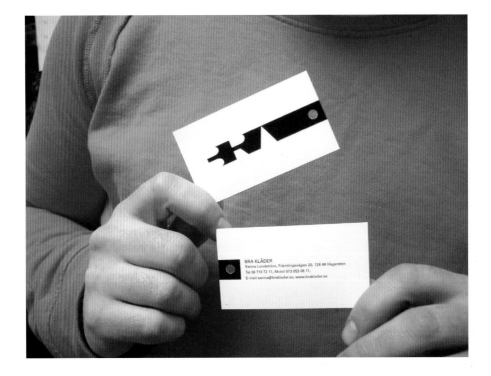

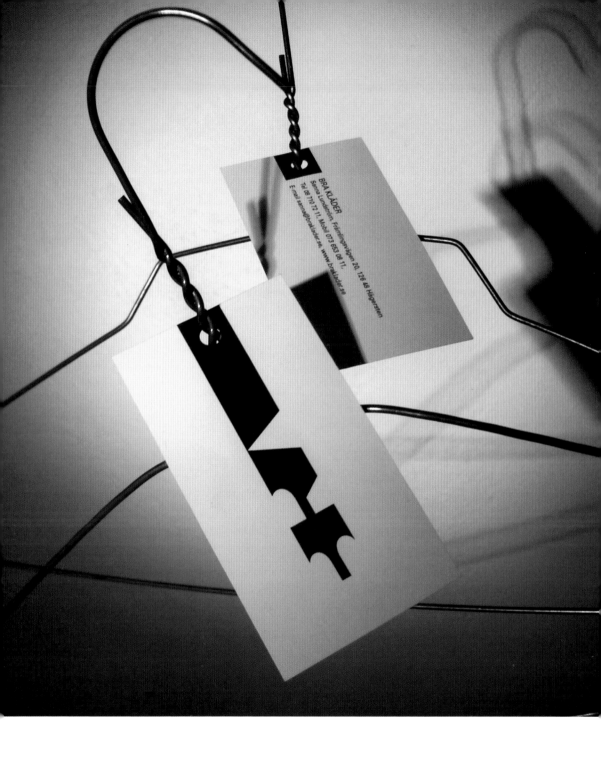

BRA KLÄDER
Sanna Lundström, Frimlingsvägen 20, 126 46 Hägersten
Tel 08 710 72 11, Mobil 073 653 08 11,
E-mail sanna@braklader.se, www.braklader.se

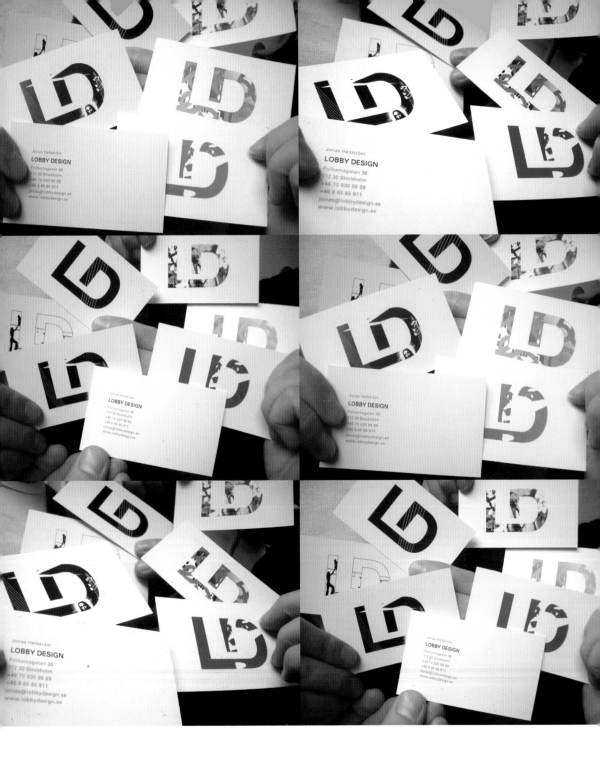

Lobby Design

Designer:
Lobby Design
Client:
Lobby Design

By having different contents
inside the logo, the design-
ers show their diversity as a
design studio, that are made
up by different styles but are
bound together by a company,
Lobby Design.

90 x 55 mm
Conqueror
n/a
n/a

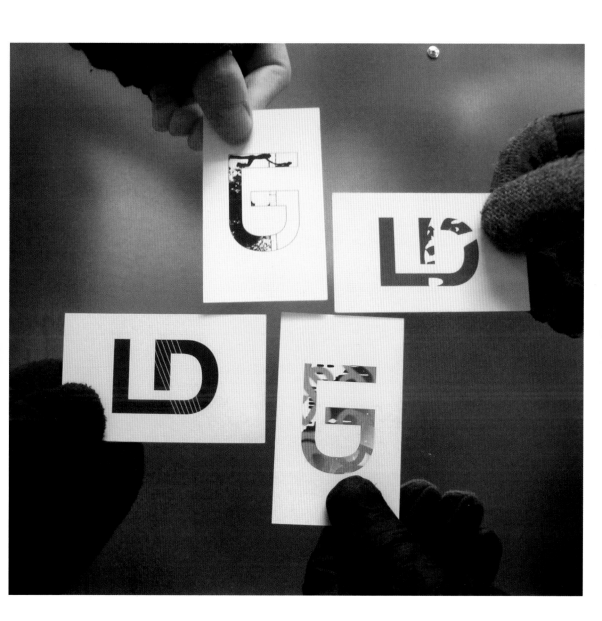

Vaja

Designer:
RDYA
Client:
Vaja

An innovating, distinguished and refined image was created for Vaja cases, which unite style and functionality. The orange colour is cheerful and solid while the silver colour relates to the concept of premium, technology and innovation. The colours and the organic forms in the card relate to the isotype which reinforce the brand's spirit.

80 x 50 mm
Rives 300 gsm
PMS 877 C, 021 C
Bas-relief, die-cut

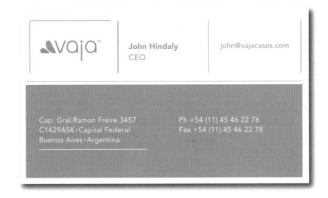

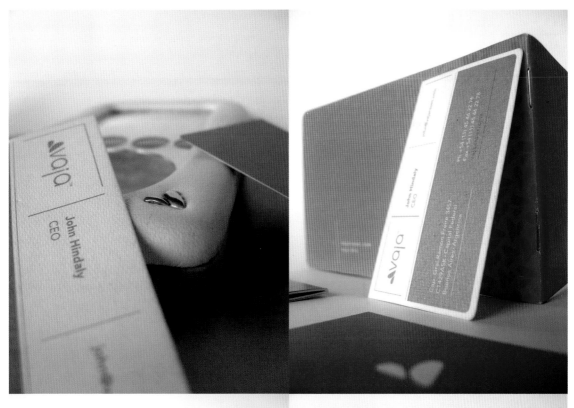
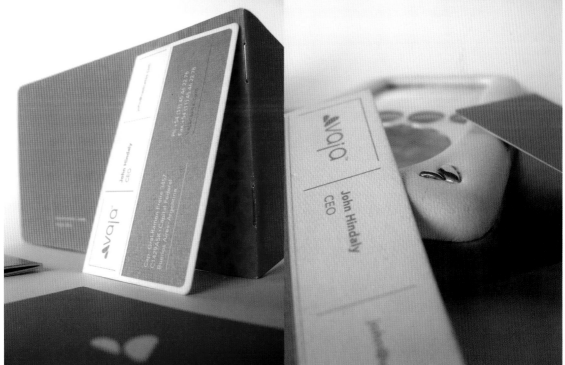

Euroamerican

Designer:
RDYA
Client:
Euroamerican

The identity of this edu-
cational group stands on
red- its institutional colour
related to warm, positive, and
Latin. In addition, the light
blue colour used in band´s
shape represents water and
ocean that connects cultures

and relates to the language
education that unites people.
Meanwhile, the card´s thick-
ness and texture transmit
the global identity.

80 x 50 mm

Rives Design Bright
White 250 gsm

PMS 485 U, 2707 U,
Black

n/a

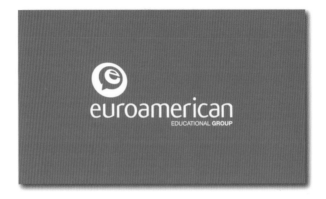

Brainfruit

Designer:
Layfield
Client:
Richard Watson

Brainfruit is a company that produces a quarterly publication focusing on the best new ideas and trends from around the world. The design of the identity had to be accessible, different and fun. When you're given a name as great as Brainfruit, you're already halfway there. The Brainfruit logo is made as a sticker, similar to the stickers on fruit that denote the country of origin. The business cards are printed satsuma orange, grapefruit yellow and lime green – and you can stick your logo wherever you like.

90 x 55 mm

Raleigh Navajo 352 gsm, JAC self adhesive

PMS 151 U, Reflex Blue, Black

n/a

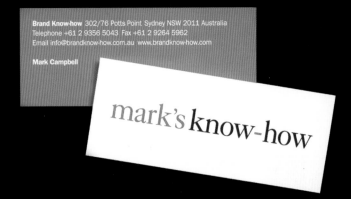

Brand Know-how 302/76 Potts Point Sydney NSW 2011 Australia
Telephone +61 2 9356 5043 Fax +61 2 9264 5962
Email info@brandknow-how.com.au www.brandknow-how.com

Mark Campbell

mark's know-how

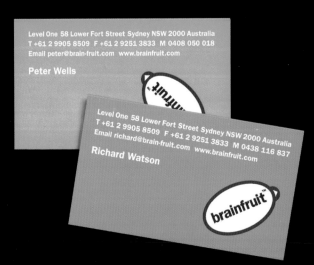

Level One 58 Lower Fort Street Sydney NSW 2000 Australia
T +61 2 9905 8509 F +61 2 9251 3833 M 0408 050 018
Email peter@brain-fruit.com www.brainfruit.com

Peter Wells

Level One 58 Lower Fort Street Sydney NSW 2000 Australia
T +61 2 9905 8509 F +61 2 9251 3833 M 0438 116 837
Email richard@brain-fruit.com www.brainfruit.com

Richard Watson

brainfruit™

Michelle Holden

Designer:
Layfield
Client:
Michelle Holden

This business card is
designed with a variety of
colours in the shape of mini
Polaroids which indicates
the uniqueness and personal
style of her work.

55 x 65 mm
Raleigh Navajo 432 gsm
PMS 354 U
n/a

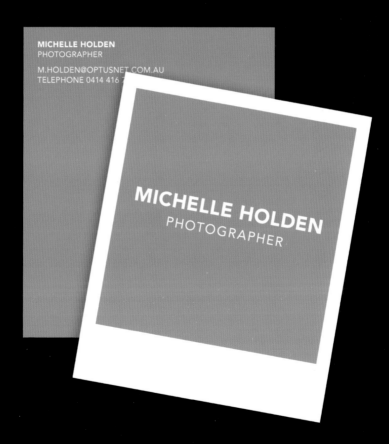

Print Solutions

Designer:
Spoken
Client:
Print Solutions

There is a lot of important
information for this business
card and so deleting some of
the text was not an option. A
simple font with a mixture
of the Helvetica family was

hence chosen by the designer
along side a few definite
colours like CMYK.

85 x 55 mm

Accent Glacier White
200 gsm

CMYK

Emboss

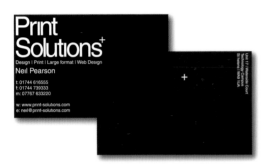

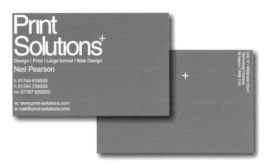

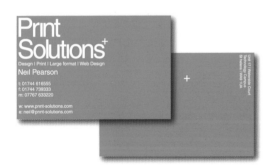

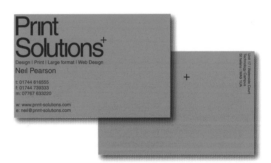

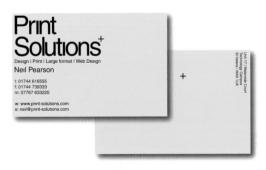

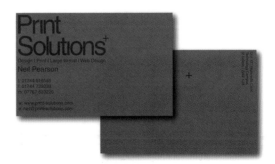

Mono Magico

Designer:
Studio Output
Client:
Mono Magico

The client wanted a happy
monkey and so here we go!
With the usage of three dif-
ferent refreshing colours for
the client's name and as the
background colour for the
backsides, it gives a joyful feel
to recipient.

85 x 55 mm
n/a
n/a
n/a

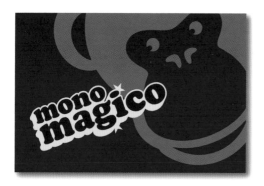

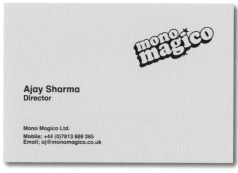

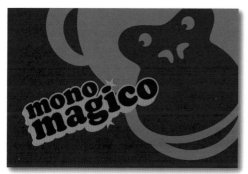

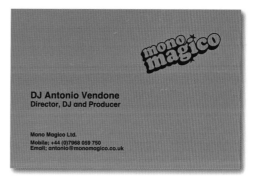

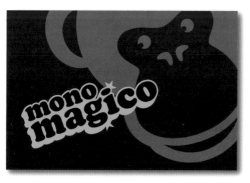

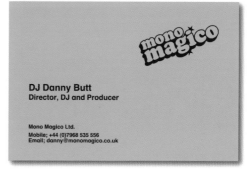

Acorn

Designer:
Studio Output
Client:
Acorn

This card design is based on
the identity of the client's
logo. In which, the logo is
developed based on the inter-
pretation of the word 'acorn'
and utilization of drawn
tree elements. The logo is
also combined with varying
textured and patterned
backdrops.

94 x 56 mm
n/a
CMYK
Die-cut

Acorn fabric sample

Aurastate

Designer:
Aurastate
Client:
Aurastate

The designer wanted to
reflect his own humor and
passion for graphics through
a simple yet informative
card and the end result is a
double-sided card printed
in a friendly summer sky
blue and crisp white. A witty
message can be found on

the front of the card next
to the high five positioned
hand while a list of services
and contact information are
featured at the back.

90 x 51 mm

n/a

Summer Sky Blue, White

n/a

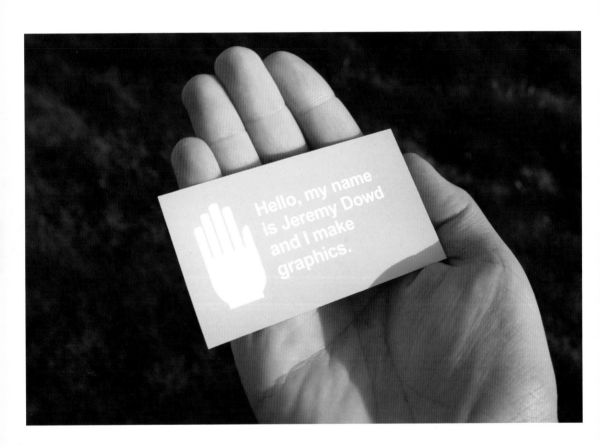

Lily of the Valley

Designer:
Underline Studio
Client:
Lily of the Valley

This business card is de-
signed for a very talented
and recognized stylist in
Toronto, Lily, originally from
Indonesia. The intent for the
identity and business card
was to give the salon a mod-
ern and contemporary look
paired with a feminine and
Indonesian feel.

76 x 51 mm
Beckett Concept 130 lb
cover
PMS 200, 23
Metallic silk screen

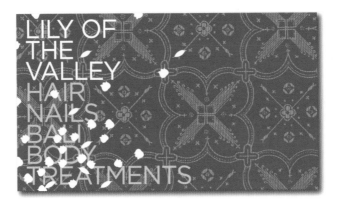

LILY OF THE VALLEY
496 COLLEGE STREET
TORONTO, ON M6G 1A4
416 913 3854
WWW.LILYOFTHEVALLEY.CA

APPOINTMENT DATE:

WITH:

Hobby Film

Designer:
Zion Graphics
Client:
Hobby Film

The client, director Oskar Bård, wanted the graphic identity of his business card to be enthusiastic, exciting and happy, just like the name of his company, Hobby Film, which shows the almost childish passion he feels for his job. Therefore it is designed to be exactly childish and happy with cartoons while a mild danger feeling is also involved. The designer took the idea of horror films and made it go through a cartoonish filter so that it is not in any way terrifying but sweet and colourful instead.

90 x 55 mm
Scandia 2000
PMS 185, 231
Spot UV

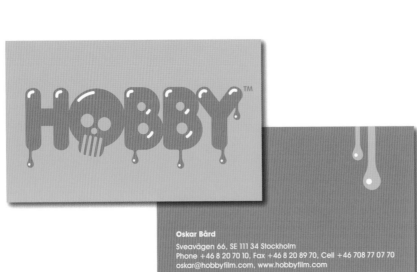

Oskar Bård
Sveavägen 66, SE 111 34 Stockholm
Phone +46 8 20 70 10, Fax +46 8 20 89 70, Cell +46 708 77 07 70
oskar@hobbyfilm.com, www.hobbyfilm.com

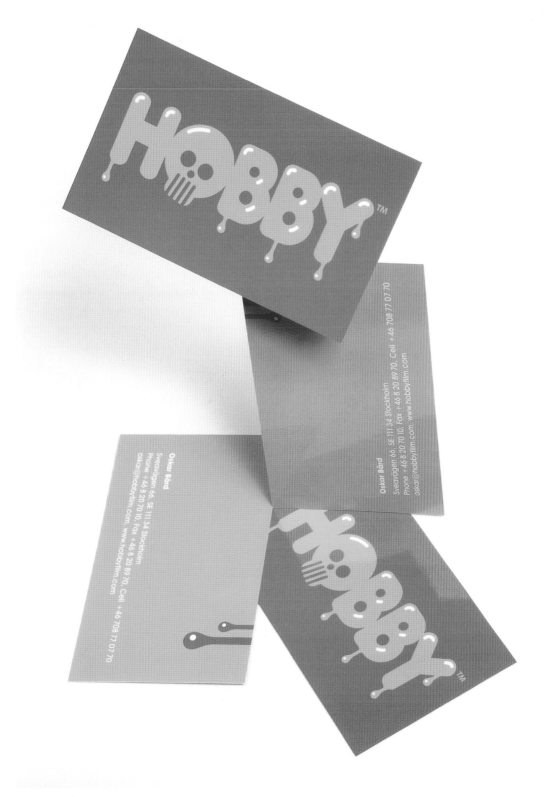

Spoon

Designer:
Zion Graphics
Client:
Spoon publishing AB

White negative text with a
warm grey background as the
front, and a yellow back side
with a silver foiled logo which
has the look and feel of a real
spoon .

90 x 50 mm
Tom&Otto Silk 250 gsm
Yellow, warm grey
Silver foil

Sanna Sjöholm
Redaktör

Tel 08-442 96 17
Mobil 070-789 22 03
sanna@spoon.se

Spoon Publishing AB
Kungstensgatan 21 B
113 57 Stockholm
Tel 08-442 96 20
Fax 08-442 96 39
www.spoon.se

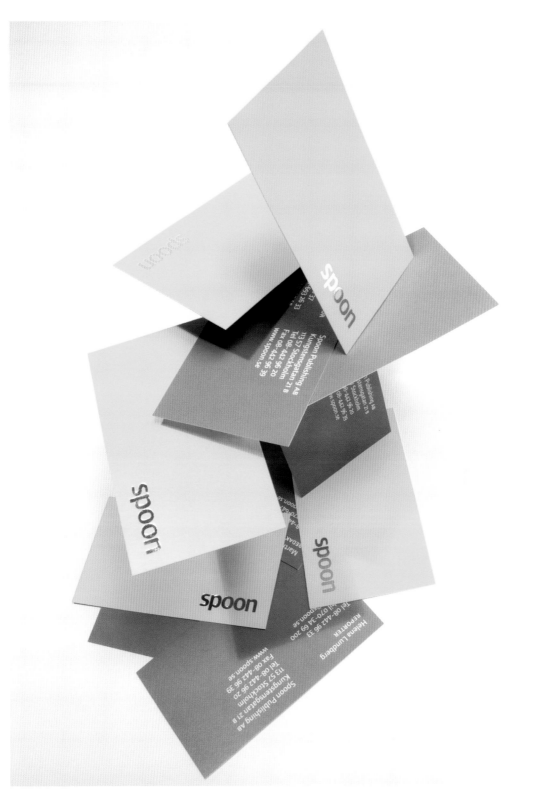

Photo Comma

Designer:
Milkxhake
Client:
Photo Comma

The identity was developed
for a studio of a Hong Kong-
based photographer. A new
punctuation symbol is utilized
in both the logotype and the
business card design.

80 x 50 mm
n/a
Black, Orange
Emboss

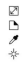

24HR

Designer:
Zion Graphics
Client:
24HR

All information plus a glossy
foiled logo are placed in a
simple black and white back-
ground as the front while the
back side is in plain orange.

85 x 48 mm
Tom&Otto silk, 250 gsm
Black, orange
Black foil

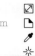

Henrik Öhman
System Developer
Phone: +46 40 661 49 85
Mobil: +46 704 444 575
Email: henrik@24hr.se

24HR Communication AB
PART OF DACKE GROUP NORDIC AB
Östergatan 21
SE- 211 25 Malmö
Sweden
Phone: +46 40 661 49 80
Fax: +46 40 661 49 81
www.24hr.se

Grandpeople

Designer:
Grandpeople
Client:
Grandpeople

This business card uses a selection of the designer's recent work, where they were redesigned and applied to an informational template. The template is overprinted in a greenish silver Pan-tone colour. It can also be overprinted in other colours and made several randomly picked backgrounds.

90 x 50 mm
MultiArt Silk
CMYK, PMS 8321
Metallic PMS overprint

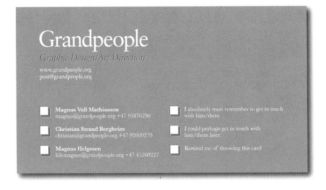

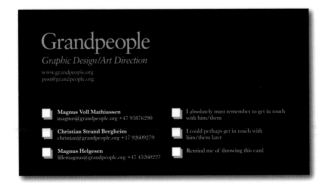

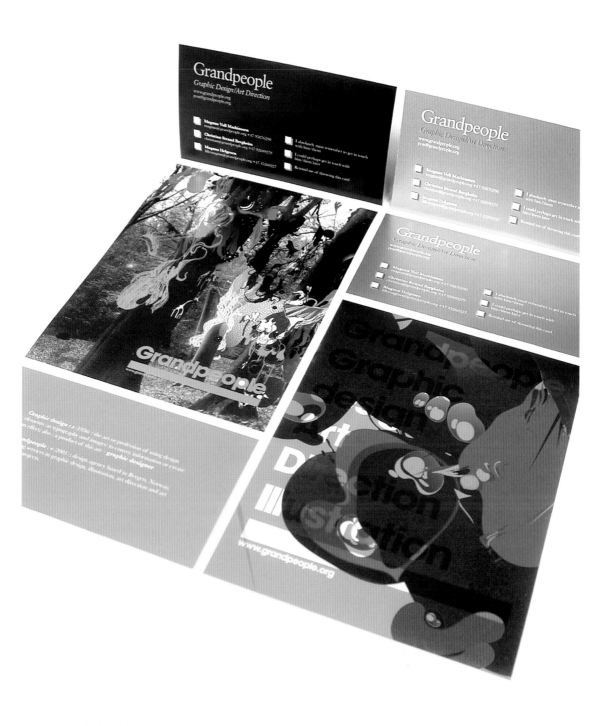

RSI Construction

Designer:
SWIGG Studio
Client:
RSI Construction

Using a photograph of
natural wood materials on
their projects with a bold
logo and colour scheme plus
illustrations of their working
process, this constructional
company's business card re-
inforces their tagline "From
conception to completion".

89 x 51 mm

14 pt cover stock with
satin finish

CMYK

Satin finish

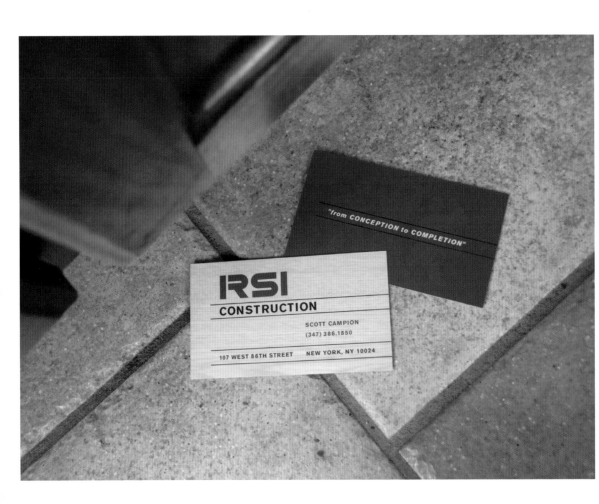

Enochian Inc.

Designer:
SWIGG Studio
Client:
Enochian Inc.

This card features a printing
process called letterpress.
Attention is drawn to each
one of these hand-printed
and laminated cards which
is meant to mimic the high
quality of hand-sewn clothing
created by Enochian Inc.

89 x 51 mm

80 lb Tropical Green
cover laminated to
French Speckletone
100 lb Brown cover

2 PMS
Letterpress

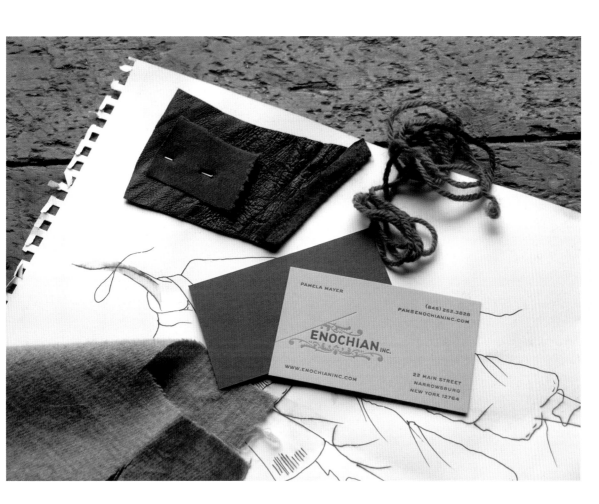

Marmalade

Designer:
300million
Client:
Marmalade Creative

This business card is designed for a media company which has a broad stretch of capabilities: from creating a worldwide award-winning animation series to writing childrens' books and coordinating television projects.

They wanted a stationery range that stood out amongst their peers and therefore the designer gave them a solution that literally 'speaks' their clients' language.

85 x 55 mm
Naturalis Matt Coated
350 gsm
Black, PMS 123 U
n/a

Do you expect me to talk?
No, no Mr Bond. I expect you to **marmalade**©

Don't worry Mr B, I have a cunning **marmalade**©

We came, we saw, we kicked its **marmalade**©

At my signal... unleash **marmalade**©

They're not gonna catch us. We're on a mission from **marmalade**©

Andy Cutbill

Mobile +44 (0)7841 576 000
Landline +44 (0)20 8846 3731
andy@marmaladecreative.co.uk
www.marmaladecreative.co.uk

Marmalade Creative
The Courtyard
42 Colwith Road
London W 0EY
United Kingdom

Matt Stuart

Designer:
300million
Client:
Matt Stuart

A business card for an award-winning photographer who has a witty visual identity, every trick in the book had been done to death. The designer therefore used words instead of images for the business card. By finding the inspiration for their tone of voice in Matt's 'street' style, they created a series of tabloid headline-style phrases across all his communications as 'Matt Stuart snaps legs' is often used to chase late payment.

85 x 55 mm
Naturalis Uncoated
350 gsm
Black, PMS Warm Gray 4
n/a

MATT STUART SHOOTS PEOPLE

Matthew Stuart Photographer
67 Speed House Barbican London EC2Y 8AU
m +44 (0)7956 178690 t +44 (0)20 7628 8793
matt@mattstuart.com www.mattstuart.com

MATT STUART SNAPS LEGS

Matthew Stuart Photographer
67 Speed House Barbican London EC2Y 8AU
m +44 (0)7956 178690 t +44 (0)20 7628 8793
matt@mattstuart.com www.mattstuart.com

MATT STUART FRAMES STRANGERS

Matthew Stuart Photographer
67 Speed House Barbican London EC2Y 8AU
m +44 (0)7956 178690 t +44 (0)20 7628 8793
matt@mattstuart.com www.mattstuart.com

MATT STUART EXPOSES EVERYTHING

Matthew Stuart Photographer
67 Speed House Barbican London EC2Y 8AU
m +44 (0)7956 178690 t +44 (0)20 7628 8793
matt@mattstuart.com www.mattstuart.com

say it in "graphics"

グラフィックで見せる名刺

Booklet

Designer:
BENG
Client:
Het is simpel
(It is simple)

A business card in booklet style with inspiring images that inspired the founder of the company, who aims to inspire his potential clients with such. Contact information were asked to put with their favorite image. While the page with client's website tells you why they picked such images, it will also tell you about why they find the image so inspiring after you read through the whole 'booklet'.

85 x 55 mm
Biostop
CMYK
n/a

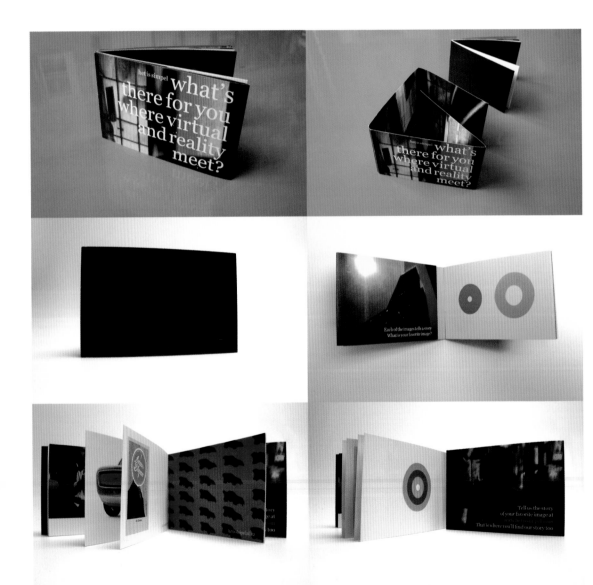

Pee&Poo

Designer:
Zion Graphics
Client:
Pee&Poo

This card uses the main
characters from the client,
'Pee' and 'Poo'. With a light
grey background and a big
logo, the design is distinctive
and easy to remember. Very
simple and straight forward.

85 x 55 mm
Revive uncoated
CMYK
Matt UV

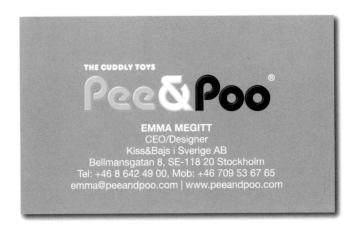

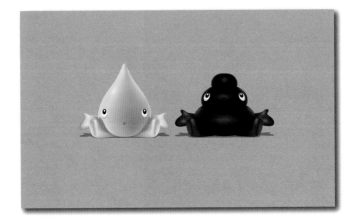

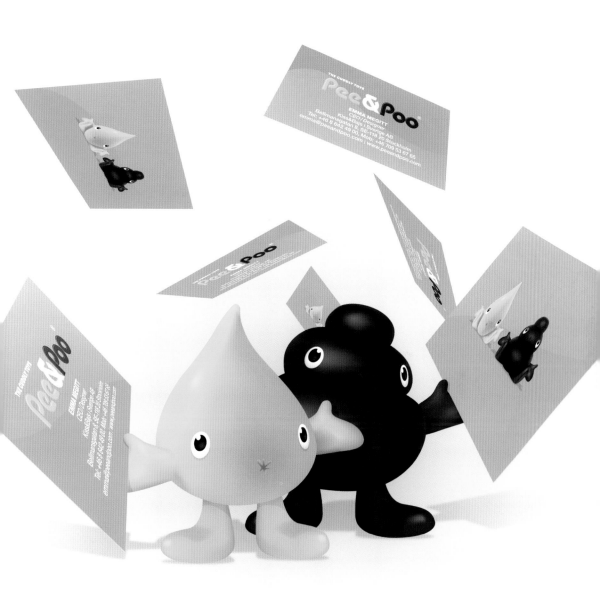

The Virgin Marie

Designer:
Rumbero Design
Client:
Antoine Gamard

This card was created for a
painter/street artist, Antoine
Gamard. The front uses one
of his latest painting while
the back uses the same paint-
ing but in a negative style.
The design gives a strong and
shocking feeling just like the
client's art.

150 x 100 mm
Matt paper 300 gsm
CMYK
n/a

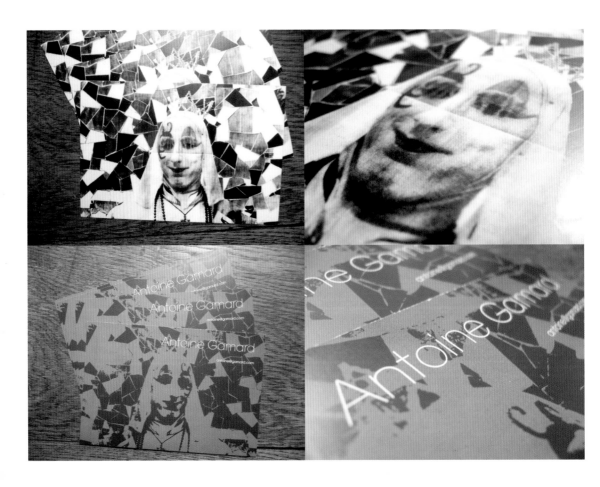

Antoine Gamard

antoine@gamard.com

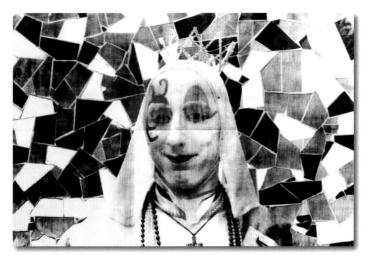

Da TeamBronx

Designer:
Da TeamBronx
Client:
Da TeamBronx

This card uses a well-known
character designed by Tim
Tsui for the front. Main colour
black gives a mystery feeling
and the ape gives a meaning
of full of energy and power.

90 x 55 mm
Matt art board 300 gsm
CMYK
Spot UV

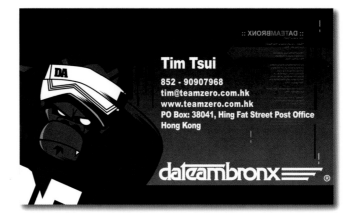

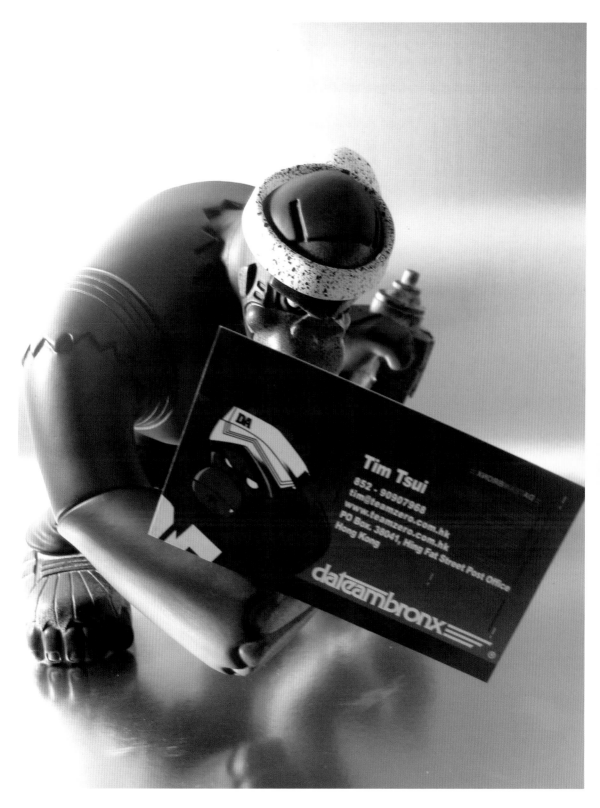

Rick's Picks

Designer:
Stiletto
Client:
Rick's Picks

There are two levels to work on for the identity of this newly launched gourmet pickle company - in a delicatessen store as well as at organic markets. The designers wanted to keep the design simple, so they used the green and white colour associating with vegetables and freshness. They also added a little fun with varieties of vegetable illustrations on the back of the card.

85 x 50 mm
Cardstock
PMS 357 U
n/a

rick's picks ™

rick field

195 chrystie street #602e
new york, ny 10002
tel/fax: 212.358.0428
www.rickspicksnyc.com
rickspicks@verizon.net

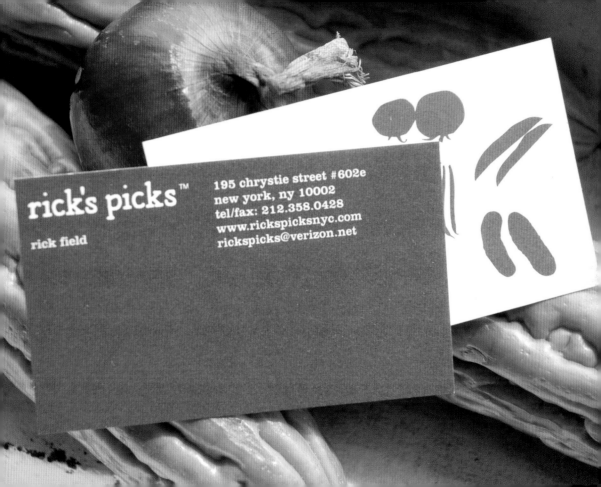

rick's picks ™

rick field

195 chrystie street #602e
new york, ny 10002
tel/fax: 212.358.0428
www.rickspicksnyc.com
rickspicks@verizon.net

bob (SALON)

HILLARY BILHEIMER
STYLIST

398 FOUNDRY STREET
ATHENS, GA 30601
706.546.0950

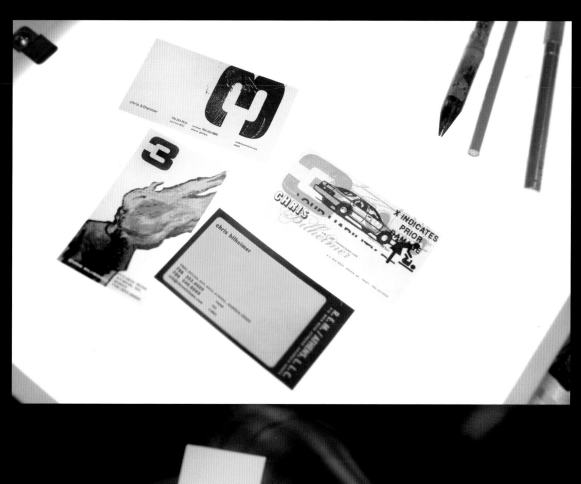

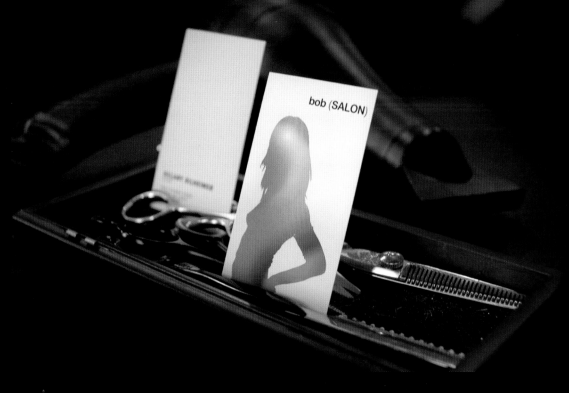

Jimmy Woo

荷蘭阿姆斯特丹窗戶大道18號
郵政區號1017 rc
電話+31 (0)20 626 31 50 / +31 (0)6 271 839 97 傳真+31 (0)20 626 34 81
電子郵件 mr.woo@jimmywoo.com 網站 www.jimmywoo.com

esigner:
assvite (Filipe Mesquita/
edro Serrão)
lient:
guas Furtadas

is located on the last floor of a traditional Portuguese house, typically named 'águas furtadas', means 'stolen water'. The card was created to transmit the meaning particularity and it was done within a small budget.

White
Positive relief

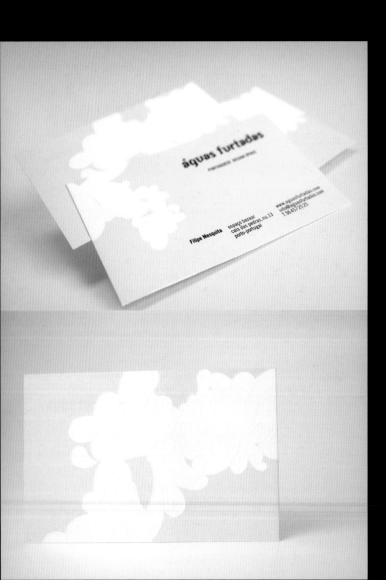

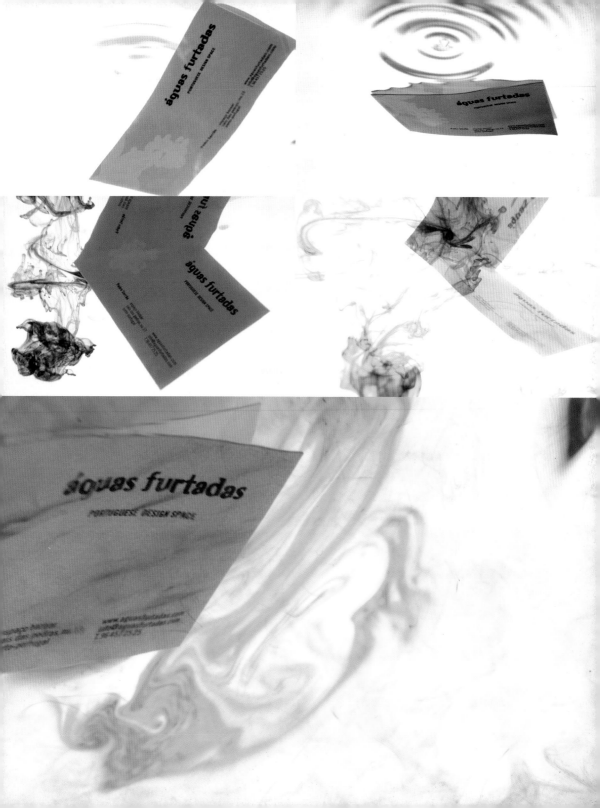

Koichi Kamoshida

Designer:
so+ba
Client:
Koichi Kamoshida

A slogan, 'See the world with different eyes' is placed on the card front with client's information. For the back, the set of cards is designed in black, red and white with mechanical images of cameras which explains the service that the client, a cinematographer can offer you.

91 x 55 mm

Matt paper, tracing paper wrapper

CMYK

n/a

CINEMATOGRAPHER
KOICHI KAMOSHIDA
カモシダ コウイチ

LH 1 #502, 2-13-1 Shibasaki
Chofu-city, Tokyo182-0014
東京都調布市柴崎 2-13-1 LH 1-502
+81 (0) 424 41 62 71 Phone
+81 (0) 90 32 21 99 34 Mobile
+81 (0) 424 41 62 71 Facsimile
kic65721@ja2.so-net.ne.jp

カモシダ コウイチ

LH 1 #502, 2-13-1 Shibasaki
Chofu-city, Tokyo182-0014
東京都調布市柴崎 2-13-1 LH 1-502
+81 (0) 424 41 62 71 Phone
+81 (0) 90 32 21 99 34 Mobile
+81 (0) 424 41 62 71 Facsimile
kic65721@ja2.so-net.ne.jp

SEE THE WORLD WITH DIFFERENT EYES

CINEMATOGRAPHER
KOICHI KAMOSHIDA
カモシダ コウイチ

LH 1 #502, 2-13-1 Shibasaki
Chofu-city, Tokyo182-0014
東京都調布市柴崎 2-13-1 LH 1-502
+81 (0) 424 41 62 71 Phone
+81 (0) 90 32 21 99 34 Mobile
+81 (0) 424 41 62 71 Facsimile
kic65721@ja2.so-net.ne.jp

CINEMATOGRAPHER

KOICHI KAMOSHIDA
カモシダ コウイチ

LH 1 #502, 2-13-1 Shibasaki
Chofu-city, Tokyo182-0014
東京都調布市柴崎 2-13-1 LH 1-502
+81 (0) 424 41 62 71 Phone
+81 (0) 90 32 21 99 34 Mobile
+81 (0) 424 41 62 71 Facsimile
kic65721@ja2.so-net.ne.jp

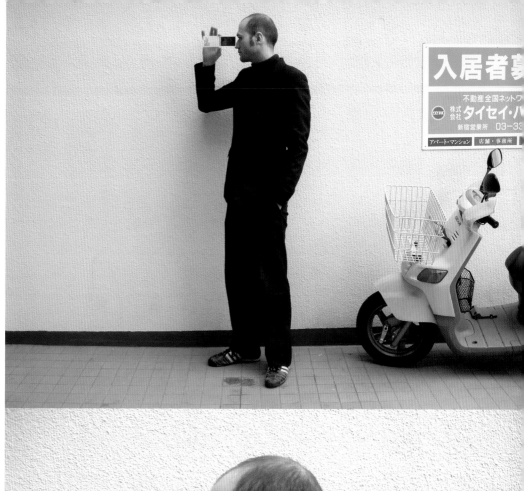

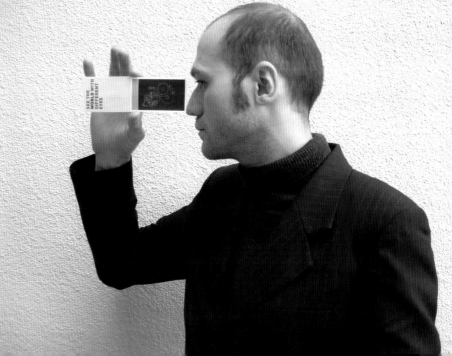

Les Courts Metrages

Designer:
so+ba
Client:
Les Courts Metrages

Further elaborated from the logo, this green business card suggests a clean and direct approach implied by a short film distribution company, Les Courts Metrages.

91 x 55 mm
Matt paper
CMYK
n/a

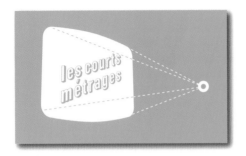

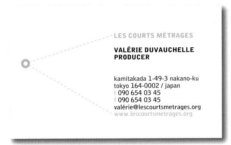

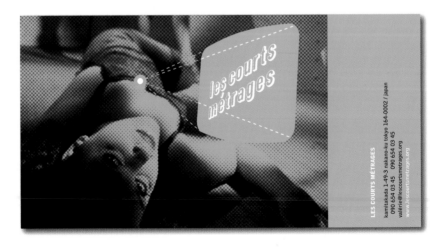

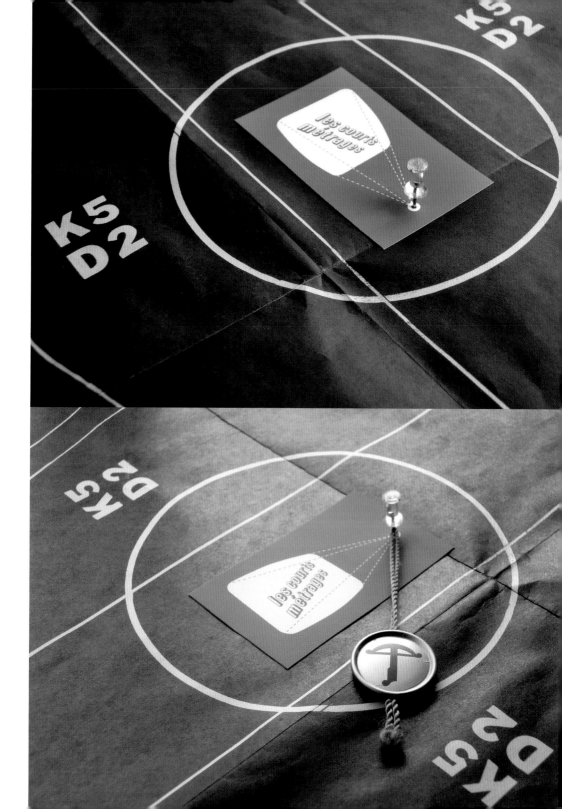

Porto Digital

Designer:
Nuno Martins
Client:
Porto Digital

The business card is a deriva-
tion of the logo. To break
the wrong idea of a cold and
distant relationship between
men and machine, it is made
of two circles. For the orange
one, it represents edge,
dynamism and youth. The 'P'
inside stands for Porto and
associates the city with the
concept of innovation and
modernism. While for the
magenta one, it represents
affection, caring and love; the
smile face inside is very com-
monly used in nowadays' web
language and text messages.

85 x 55 mm
Revive uncoated
Silver, 3 PMS uncoated
Varnish

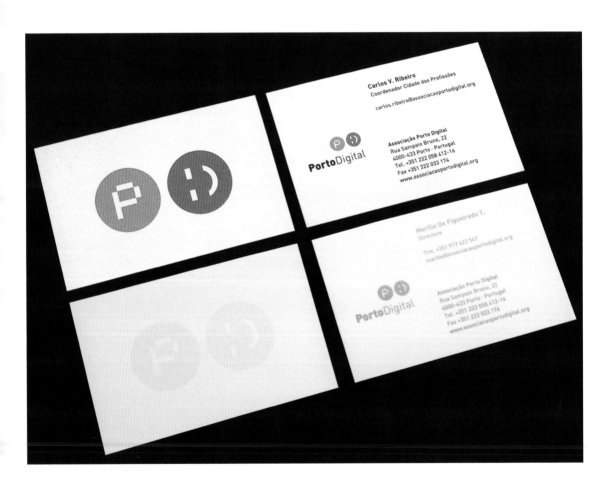

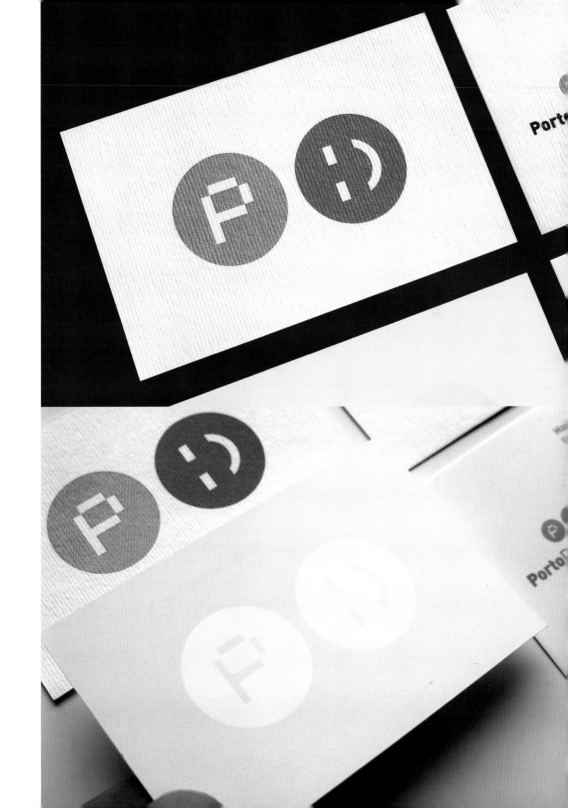

Spoken

Designer:
Spoken
Client:
Spoken

This design is based on the
idea of simplicity as the de-
signer believes that an over-
done design would destroy the
minimal structure of a card.
The use of colour gives this
design a modern but warn
feeling to each recipient.

85 x 55 mm

Double side coated
Phoenix motion 250 gsm

PMS DS: 5-1 C, 45-6 C,
1-2 C

n/a

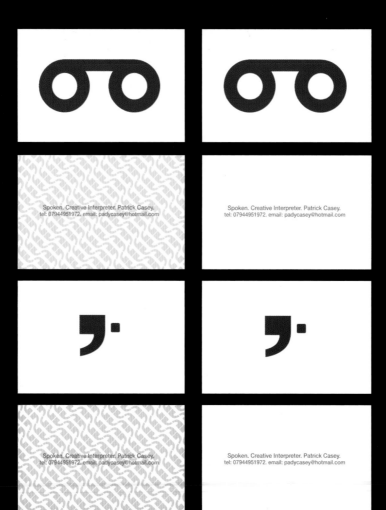

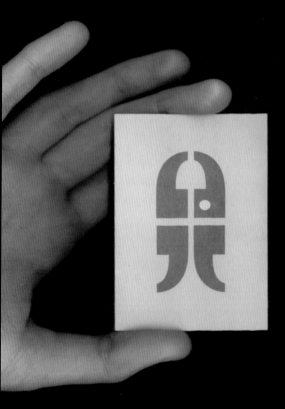
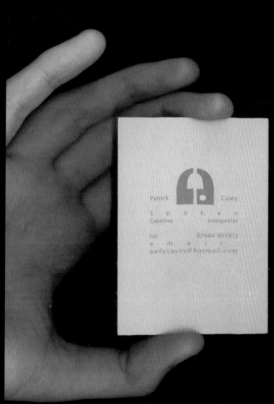

Patrick Casey
S p o k e n
Creative Interpreter
tel: 07944 951972
e m a i l
padycasey@hotmail.com

Hair Shoppe

Designer:
NuDesign
Client:
Hair Shoppe

This business card for a hair-stylist has a tricky printing concept behind and the hair images on the card appears to be transparent. This method of screenprinting on plastic also suggests the lightness associating with hair. This printing method took the designer a lot of nerves to find a printer who could handle it.

85 x 54 mm
Plastic
Brown, orange
Screenprint

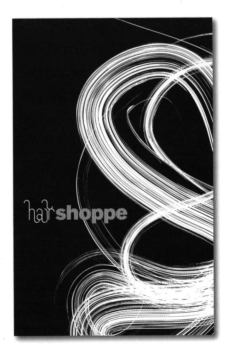

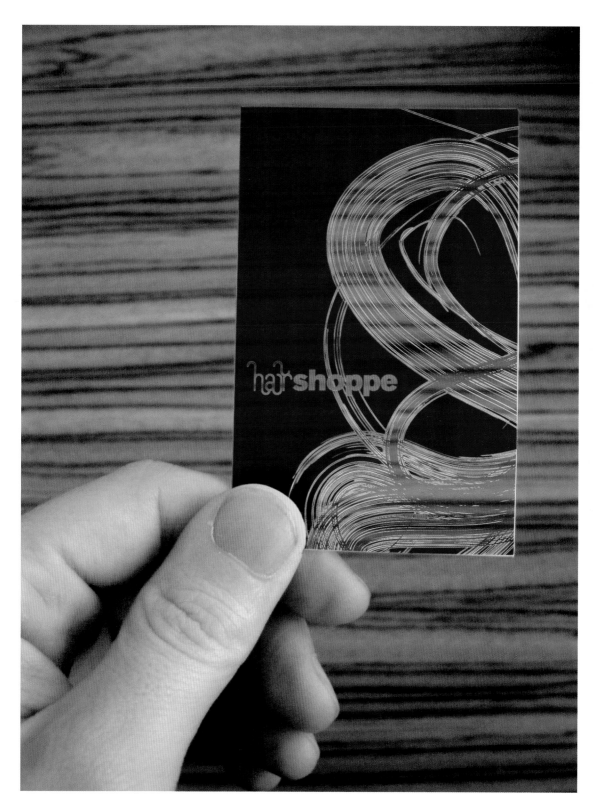

Kauz

Designer:
Viagrafik
Client:
Kauz

This business card is designed for Kauz, a streetwear label designed by viagrafik. The use of colour of brown, fluor green and copper symbolizes the linkage between nature and urban/technical aspects, which is an essential inspiration for the designs of the brand. Since Kauz is the German word for a sort of owls but also a synoym for a person who is kind of an outsider, therefore the imperfection and errors also get counted in the design concept.

85 x 50 mm
Semi coated paper
200 gsm
PSM 175, 876, 802
n/a

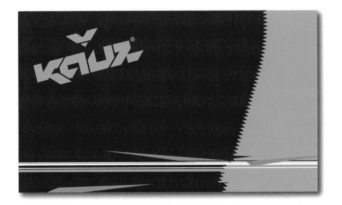

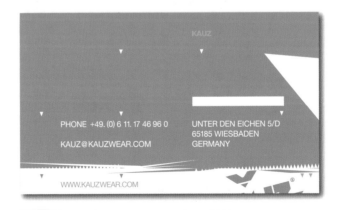

Root Idea

Designer:
Root Idea
Client:
Root Idea

Simultaneous contrast effects was chosen for this business card. When green on the front associats with plants and origins and also represents the originality of Root Idea, red is the contrast colour chosen for the back, which has been found more stimulating to brain and nerve system than green and creates the feeling of arousal. The "soft touch" paper on the front side and a glossy varnishing with shiny effect on the back side is another contrast. The logo and the font is the 3rd contrast here, between contemporary and traditional. Also, the front side with right image and text while the back side is reversed like a negative film which tells you the need of different views during design process.

90 x 50 mm

Antalis, Curious
Touch Soft 300 gsm

PMS 368 C, 1788 C

Emboss, gloss varnish,
die-cut

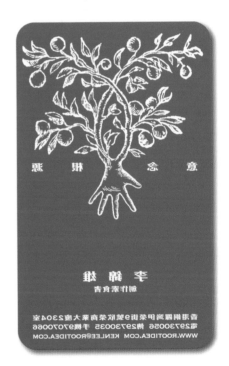

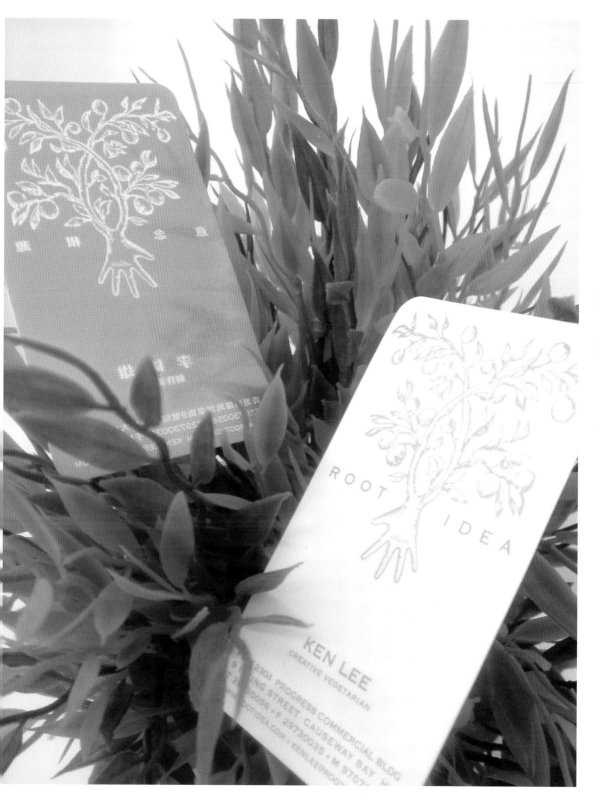

Fantefilm

Designer:
Bleed
Client:
Fantefilm

A bold visual profile design has made the company stands out as innovating and unafraid of trying new visual forms. Next to the logo, there are various movie-genres which they can animate in the beginning of a movie, such as a thriller or a comedy, to add emphasis. The use of hand-drawn illustration is also chosen to give strong impression to recipient too. A few parts of the logo have been drawn out and used on the different business cards, these are the favorite parts of the employees of Fantefilm.

80 x 50 mm

Munken Pure 300 gsm

Black, PMS Metallic 8243 C

Metallic

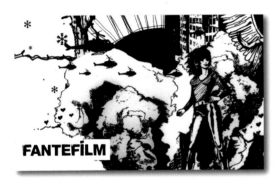

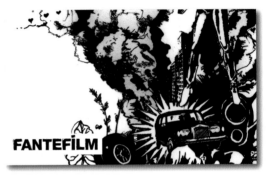

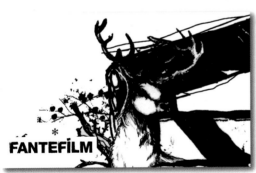

MARTIN SUNDLAND
PRODUSENT

MARTIN@FANTEFILM.NO
MOB. +47 982 13 922
WWW.FANTEFILM.NO

FANTEFILM AS

DRAMMENSVEIEN 40 PB 2879 SOLLI TEL. +47 232 75 100
0255 OSLO 0230 OSLO FAX. +47 232 75 101

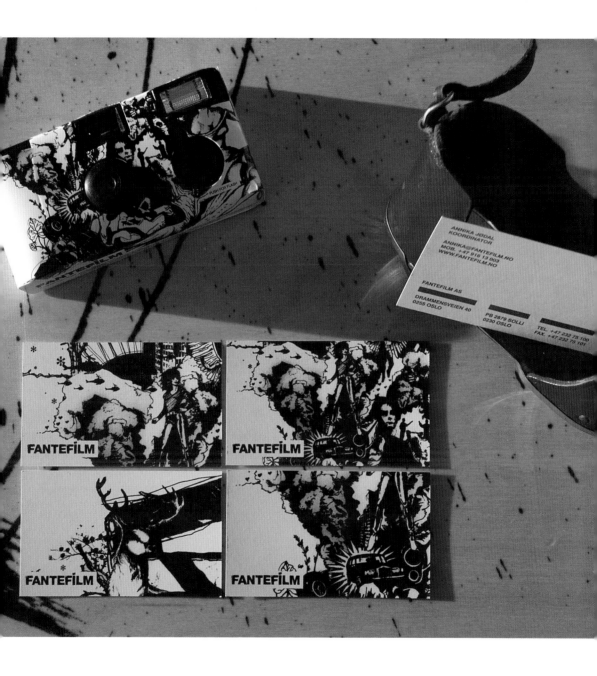

Fashion Futures

Designer:
Bleed
Client:
Fashion Futures

This business card contains two key elements: sewed elements and fashion illustrations. To demonstrate uniqueness, each card has a different layout and illustration.

80 x 50 mm
Munken Elk 150 gsm
CMYK
n/a

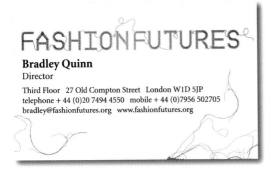

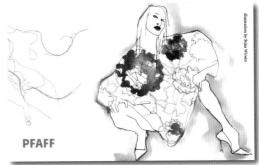

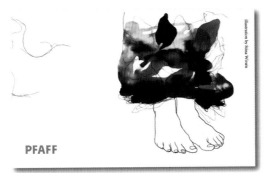

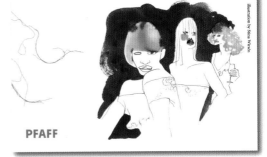

Dimaquina

Designer:
Dimaquina
Client:
Dimaquina

This business card was designed to represent the identity of each member in the studio. On one side, there is the same information for every card and on the the other side, there is a small preview of each person's work. It serves as a mini-portfolio for each member and gives them a sense of individuality.

90 x 50 mm
n/a
n/a
n/a

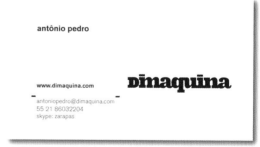

antônio pedro

www.dimaquina.com
antoniopedro@dimaquina.com
55 21 86032204
skype: zarapas

dimaquina

By02

Designer:
Passvite (Filipe Mesquita/
Pedro Serrão)
Client:
By02 Design

Due to small budget, one colour printing is used and designer explored the full characteristics inherent to the type of paper Gmund Reaction instead, which has a soft texture and nice variations of colour. It also adapts very well to office laser printing and hand-made cutter. All this production process was not hidden, but was explored to be part of the cards' exhibition. The final idea was to respond the briefing demands of a young and adaptive company, where the identity could work as a stamp and to be applied in various materials easily and cost-effectively.

100 x 40 mm
Gmund - Reaction
n/a
n/a

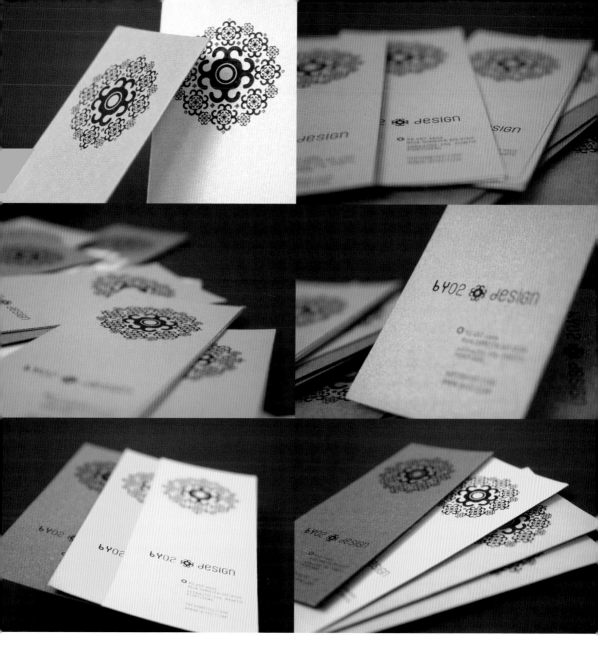

SWIGG

Designer:
SWIGG Studio
Client:
SWIGG Studio /
SWIGG Products

This card represents one
company with two distinct
divisions: design and prod-
ucts. The studio side features
the branding elements
specified to the design firm's
identity and the products side
features a detail of a pillow
representing the products
that the company creates.

89 x 51 mm

14 pt cover stock with
satin finish

CMYK

Satin finish

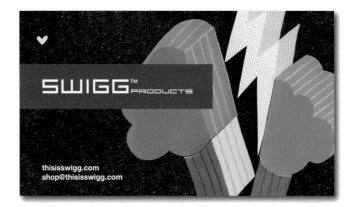

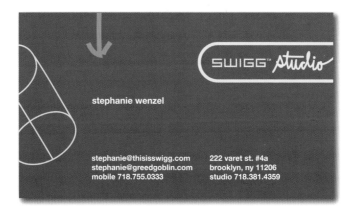

You Are Beautiful

Designer:
Beautiful
Client:
Beautiful

This business card for the designer herself used abstract images with a decorative pattern to demonstrate her photography, illustration and graphic skills.

85 x 55 mm
n/a
CMYK
Die-cut

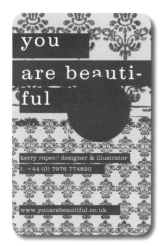

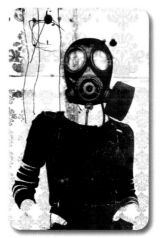

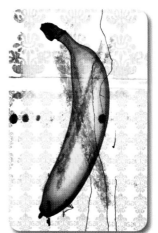

I.Do Graphic

Designer:
I.Do Graphic
Client:
I.Do Graphic

The company uses dog as their symbolic character to show that they are their client's best friend. They can be humble but dangerous sometimes. And in fact, to make it radical, different slogans were created to represent dif-ferent positions. For example, for creative designer: Beware; for project manager/traffic controller: Watch out; for client servicing: I don't bite.

85 x 45 mm
Matt Art paper 180 gsm
CMYK
n/a

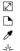

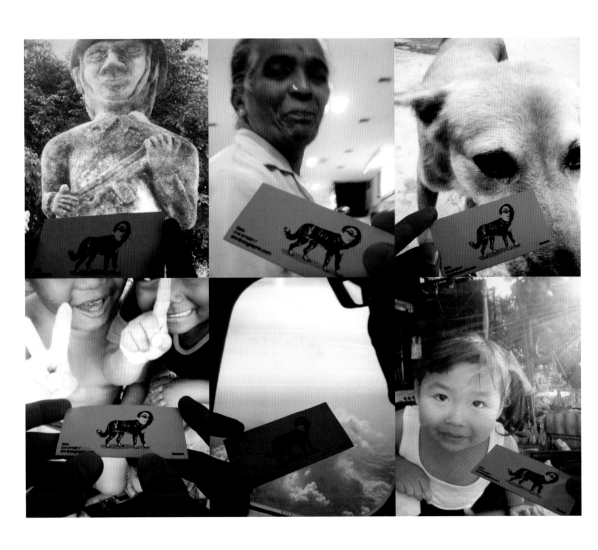

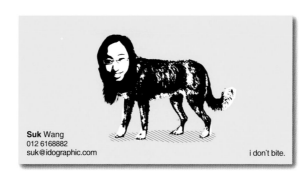

Suk Wang
012 6168882
suk@idographic.com

i don't bite.

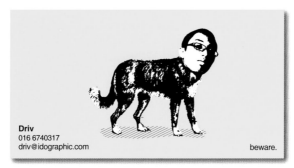

Driv
016 6740317
driv@idographic.com

beware.

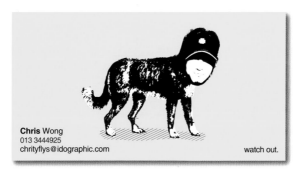

Chris Wong
013 3444925
chrityflys@idographic.com

watch out.

www.idographic.com

Park Studio

Designer:
Park Studio
Client:
Park Studio

This business card captures the company's spontaneous approach to meetings. They believe that handing out business cards is such a formal process and it is lack of genuine interaction. As these cards have a blank space for them to write or draw on, they can scribble a personal greeting or message specially designed for the particular person receiving it.

85 x 55 mm
n/a
Red
n/a

LL & NN
Park Studio
Studio 364
27 Clerkenwell Close
London EC1R OAT

T +44 (0)20 7490 7275
F +44 (0)20 7490 5856
linda@park-studio.com
nina@park-studio.com
www.park-studio.com

Catherine Lock

Designer:
Park Studio
Client:
Park Studio

A business card which communicates tradition but is also designed with a contemporary edge. The designer used an old-fashioned mortised cuts with animals holding up a blank sign. The

mortised have a light hearted quirky feel on the format of a business card. It can be customized to suit each recipient.

85 x 55 mm

n/a

n/a

n/a

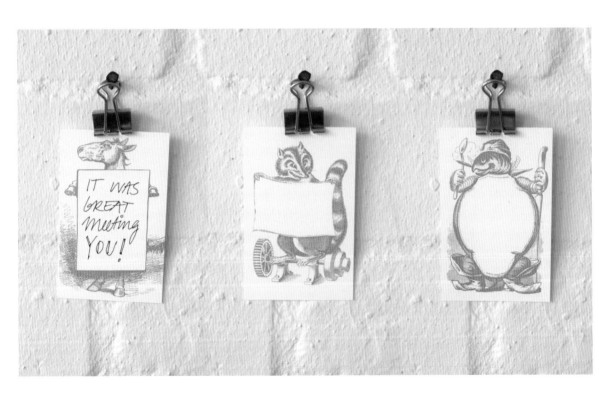

CATHERINE LOCK

9 Topham House
Prior Street
London SE10 8ST

Telephone
020 8469 0334

Mobile
07763 783 100

Email
catherine@catherinelock.com

Alicia

Designer:
Enric Aguilera
Asociados
Client:
Alicia

This business card is designed for Alicia, an advertising agency established by Fernando Macia and Fidel del Castillo. They named it Alicia because the book 'Alice in Wonderland' has always been their bed-side book and their source of inspiration. In honour of its neverending imagination, they have used illustrations reminiscent of Lewis Carroll's originals for their business cards.

85 x 50 mm
Supralbor 300 gsm
Sarriópapel
Black
n/a

Lucinda Rodgers

Designer:
Julian Morey Studio
Client:
Lucinda Rodgers

This business card, for an
illustrator who works and
lives in London, uses images
from a series of her draw-
ings of New York. Rendered
in vibrant orange, this card
forms an important aspect of
her portfolio.

85 x 55 mm

Antinoe Rough Soft
White 300 gsm

PMS Orange

n/a

Lucinda Rogers
75 Columbia Road, London E2 7RG
Telephone/Fax +44 (0)20 7729 9517
e.mail lucindadot@hotmail.com

The Red Guitar
Company

Designer:
Julian Morey Studio
Client:
The Red Guitar
Company

This business card is made
for The Red Guitar, a partner-
ship between musicians
producing music for televi-
sion commercials. The card is
designed with the image of a
collage producing and using
sound graphing software.

85 x 55 mm
Taffeta Ivory 325 gsm
PMS Cool Grey 6, 485
n/a

Keith Bayley
The Red Guitar Company Unit 17, Utopia Village, 7 Chalcot Road, London NW1 8LH
Telephone 0171 813 7962, Fax 0171 813 7964, Mobile 0860 408350

Fur Hair

Designer:
Deanne Cheuk
Client:
Fur Hair

The designer used for the first time one of her Mushroom Girls illustrations to represent a company image - Fur Hair, a Melbourne hair salon.

88 x 50 mm

14 pt uncoated cover stock

CMYK

Matt lamination

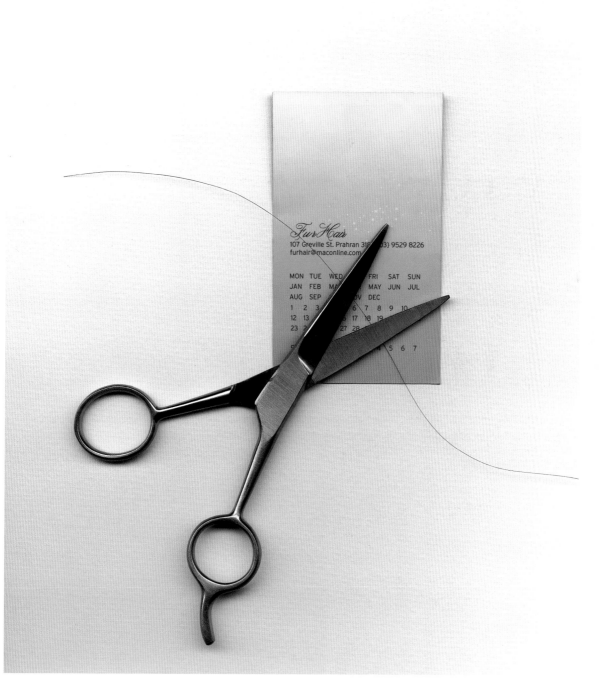

Deanne Cheuk

Designer:
Deanne Cheuk
Client:
Deanne Cheuk

This is a self promotion business
card with illustrations of water-
colour, hands and crystals. This
card serves as a quick reminder
to clients about the designer's
style.

88 x 50 mm

14 pt uncoated cover
stock

CMYK

Matt lamination,
spot UV

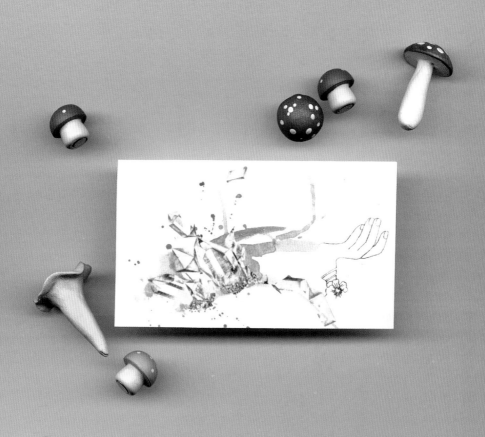

Kirsten Chadwick
Osteopathy

Designer:
Designland
Client:
Kirsten Chadwick
Osteopathy

This business card uses
vibrant colour and human
body to create a dynamic,
distinctive but relevant
identity for this osteopathy
practice.

90 x 45 mm
n/a
CMYK
n/a

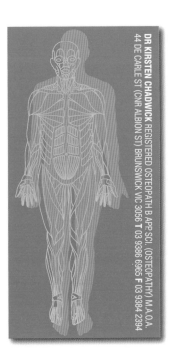

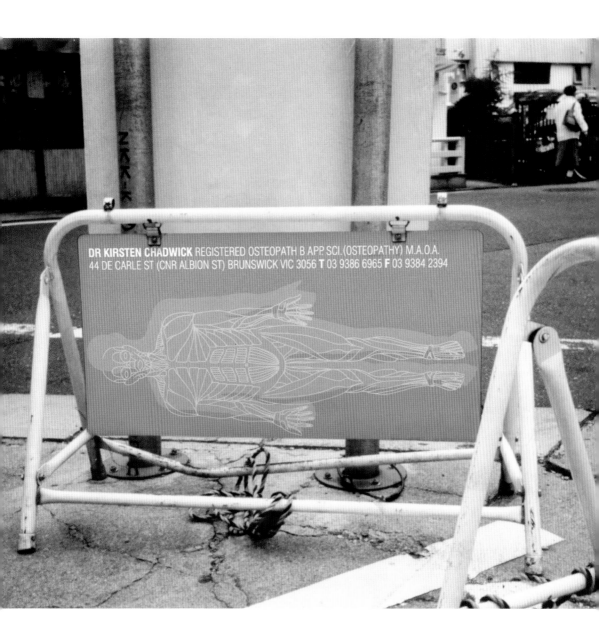

Rotterdam Agency

Designer:
Jules David Design
Client:
Rotterdam Agency

The designer has incorporated Patrick and Marian in the name card as the visual identity because they literally stand for what Rotterdam Agency is all about. The logo consists of their silhouettes and sure it can be found on their business and complementary cards.

85 x 55 mm
Target Plus 300 gsm
CMYK
n/a

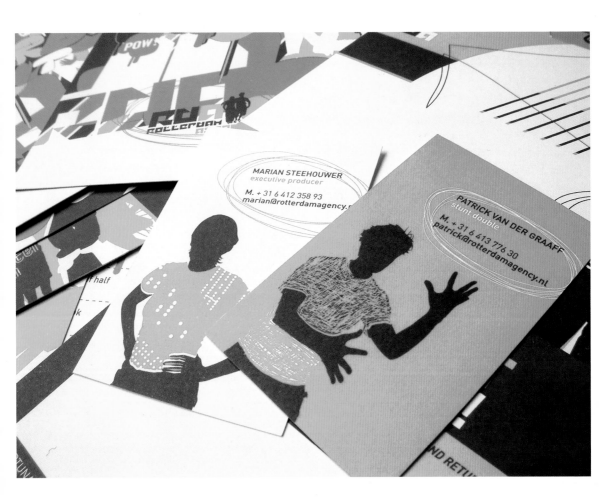

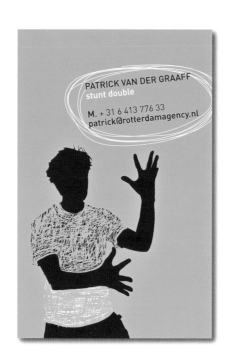

PATRICK VAN DER GRAAFF
stunt double

M. + 31 6 413 776 33
patrick@rotterdamagency.nl

Fortunaweg 26
3113 AN Schiedam
The Netherlands

P. + 31 10 225 05 33
F. + 31 10 225 11 93

rotterdamagency.nl

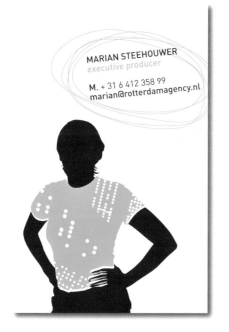

MARIAN STEEHOUWER
executive producer

M. + 31 6 412 358 99
marian@rotterdamagency.nl

Fortunaweg 26
3113 AN Schiedam
The Netherlands

P. + 31 10 225 05 33
F. + 31 10 225 11 93

rotterdamagency.nl

Mr. Bite

Designer:
RDYA
Client:
Mr. Bite

Mr. Bite is a revolutionary idea about online food delivery. The designer developed a clear, direct and agile type of communication and created the global image for this company, which is built in a combination of cheerful colours and a logo that directly represents its service. The circles used on the back relate to dishes and culinary articles, along with digital concepts.

80 x 55 mm

Rives Design Bright White 250 gsm

CMYK

n/a

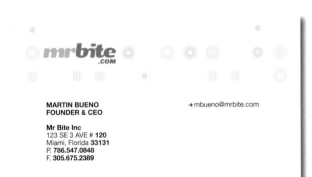

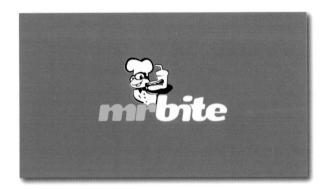

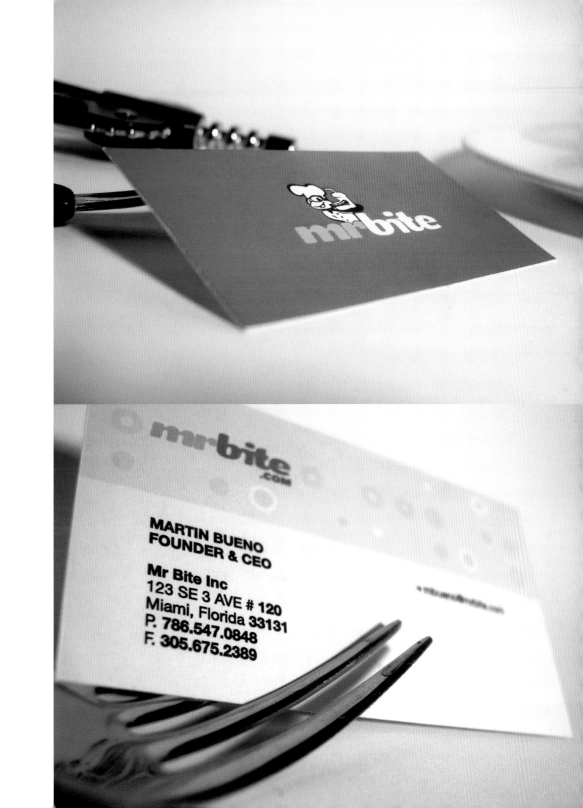

CheekySweetGraphics

Designer:
CheekySweetGraphics
Client:
CheekySweetGraphics

This business card is
developed to promote
Thibault Choquel's work and
CheekySweetGraphics' pro-
ductions. Sober and stylish as
it is in CheekySweetGraphics'
website.

90 x 50 mm

Checkmate paper
300 gsm

CMYK

n/a

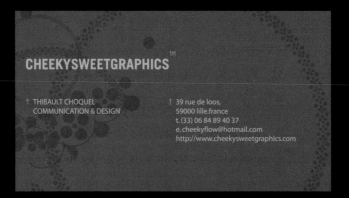

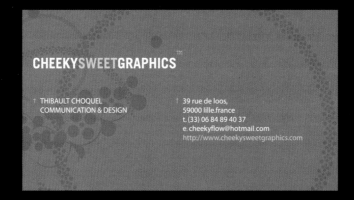

Studio Poana

Designer:
CheekySweetGraphics
(Thibault Choquel,
Nicolas Dhennin)
Client:
Studio Poana

This business card is devel-
oped for Studio Poana. The
layout of the card is same for
all the firm people but not the
icon and profile settings.

90 x 50 mm
Checkmate paper
300 gsm
CMYK
n/a

STUDIO POANA
meda and cheeky

CHEEKY / Thibault Choquel
39 rue de Loos
59000 Lille

telephone
06 84 89 40 37
e-mail
cheekyfow@hotmail.com

website
www.cheekysweetgraphics.com

STUDIO POANA
meda and cheeky

MEDA / Nicolas Dhennin
30 rue Brdas Maison
59000 Lille

telephone
06 75 40 60 91
e-mail
medaone@hotmail.com

website
www.meda1.com

Phatburger

Designer:
Mattisimo
Client:
Phatburger

A card for an upscale burger shop in New York City first opened in Harlem. The project started while the company was in litigation with 'Fat Burger' in Los Angeles over the use of the brand name. With pending legal issues and costs of changing the brand-ing dramatically, the designer created a mark that could be used with any naming while a name is not needed and the logo was literal enough to carry it.

89 x 51 mm

Domtar Titanium
Smooth White 120 lb
(meat)

CMYK

Emboss

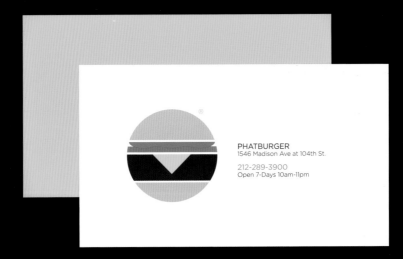

PHATBURGER
1546 Madison Ave at 104th St.

212-289-3900
Open 7-Days 10am-11pm

WowWau

Designer:
Mattisimo
Client:
WowWau

The name WowWau comes
from a German slang that
kids use when referring to
a dog 'Wau' plus an English
phrase which sounds identi-
cal to 'Wow'. Dog illustra-
tion is therefore contained
in the main visual and the
company's name.

89 x 51 mm
Domtar Titanium
Britewhite Smooth
175 lb Tag
PMS Solid Uncoated
877 U
Foil blocking, chroming

LIFE. STYLE. DOG.

Sedanstrabe 35
30161 Hannover

Ph +49-511-24457886
Fx +49-511-24457866

info@wowwau.de
www.wowwau.de

Mo.- Fr. 10 - 20 Uhr
Sa. 10 - 16 Uhr

1. Bazooka Interactive
2. Collab

Designer:
Uniform Sweden
Client:
1. Bazooka Interactive
2. Collab

1. Using bold colours and vivid gradations for this card design helps pushing the underlying motivation of Bazooka to produce designs which is more appealing to youth and urban cultural memes.

2. Incorporating the simple and timeless style of the branding helps to carry across the notion that Collab, a consortium of media and music professionals, acts solely as a network.

90 x 55 mm
Standard matt stock
CMYK
n/a

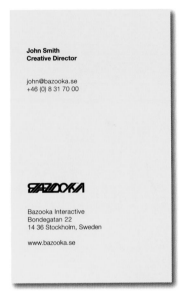

1

2

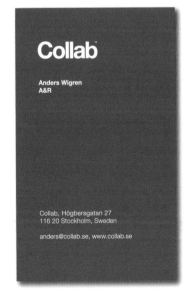

1. Uniform Sweden
2. Up2Date

Designer:
Uniform Sweden
Client:
Uniform Sweden

1. The minimal and clean design of this card serves to carry across the Uniform self-promotional branding aesthetic- simple beauty, in which they only display the content that carries across the brand.

2. Capitalising on the idea of U2D's approach of "letting ideas take flight" by incorporating the wing logo in a field of other winged logos helps to demonstrate how U2D is taking steps to stand out from the crowd of other design portal sites.

90 x 55 mm
Standard matt stock
CMYK
n/a

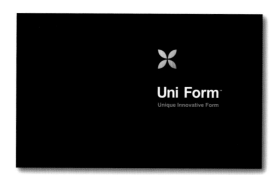

1

2

Cuban Council

Designer:
Cuban Council
Client:
Cuban Council

This business card has a playful and exclusive-with-a-twist flavor that is also the foundation of the company's brand. By mixing the roughness of the thick stock with the slickness of the glossy foil stamp that covers the cigar style banderole, the designer ended up with a very exclusive feeling card. The wood used in the print is in fact the underside of a side table they found when ransacking the Cuban Council president's home in search of high quality walnut. The font used, "Fidel", was custom-made for Cuban Council by Joe Kral.

90 x 44 mm
Starwhite 130 gsm
CMYK
Clear foil stamp banderoles, die-cut

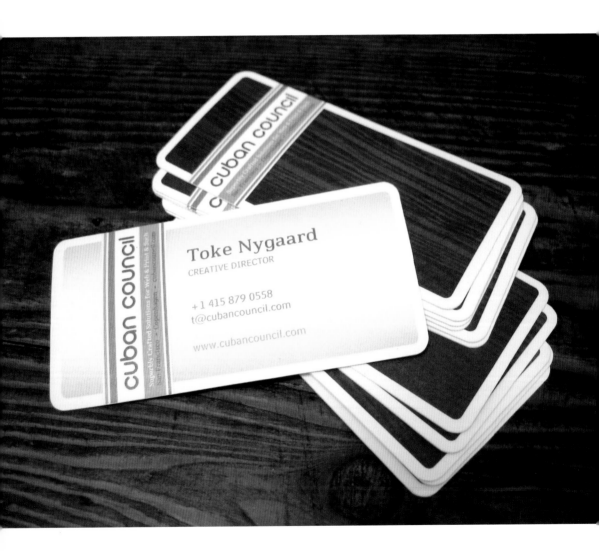

cuban council

Superbly Crafted Solutions for Web & Print & Such
San Francisco ~ Copenhagen ~ cubancouncil.com

cuban council

Superbly Crafted Solutions for Web & Print & Such
San Francisco ~ Copenhagen ~ cubancouncil.com

Michael Schmidt
CREATECH DIRECTOR

+1 415 518 8290
m@cubancouncil.com

www.cubancouncil.com

cuban council

Superbly Crafted Solutions for Web & Print & Such
San Francisco ~ Copenhagen ~ cubancouncil.com

Toke Nygaard
CREATIVE DIRECTOR

+1 415 879 0558
t@cubancouncil.com

www.cubancouncil.com

Streetcasting.ch

Designer:
Joe Scerri Design
Client:
Streetcasting.ch

The pixel shapes of this business card represent flowers that take reference from stitching. The pattern is derived from the previous flowers the client used, which was a wallpaper print. These pixel flowers now feature as a secondary element in all the stationary, printing and website.

85 x 55 mm

n/a

PMS Metallic Silver
877 U, Warm Grey 410 U

n/a

STREETCASTING.CH

STREETCASTING.CH

FROBENSTRASSE 60A CH-4053 BASEL TEL/FAX +41 61 273 16 17

INFO@STREETCASTING.CH WWW.STREETCASTING.CH

Chadwicks

Designer:
Underline Studio
Client:
Chadwicks

A business card that was part of a rebranding program for an upscale woman's fashion store, Chadwicks. Design was built based on the store's history of quality fashions, which was demonstrated through the use of quality paper and embossing, and an updated contemporary and modern brand image. The card feels like an elegant suit, beautifully detailed and crafted on one side with the surprise of feminine lace on the other.

83 x 70 mm
Beckett Concept 130 lb cover
PMS 447, 664
Emboss

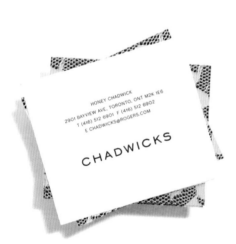

HONEY CHADWICK
2901 BAYVIEW AVE, TORONTO, ONT M2K 1E6
T (416) 512 6901 F (416) 512 6902
E CHADWICKS@ROGERS.COM

CHADWICKS

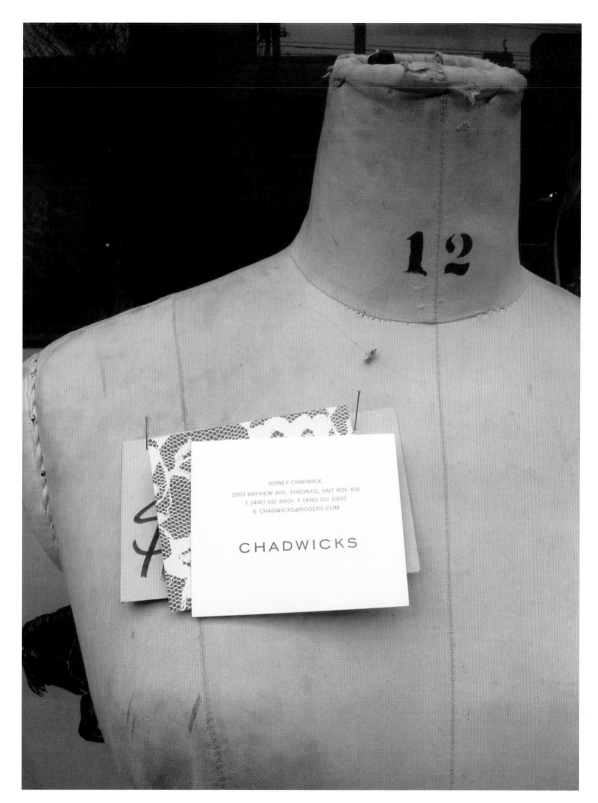

Studio Egret West

Designer:
Mark Boyce
Client:
Studio Egret West

There are three main elements for this business card design: 1) Meeting, talking and having a cup of tea. 2) Painting, drawing and exploring. And 3) Planning, building and delivering. The initial proposal suggested that the studio's identity take the form of a solid circle which was equal to the third part of their working process. The client also like the painted circle or 'Splodge' as they have come to

know it by which represents the second and most important part of their working process, painting, drawing and exploring. A monograph was also produced which consists of the company's initials and for consistency across media, the system font Helvetica is used as the supporting typeface.

85 x 55 mm
Conqueror Diamond White Micro Laid 300 gsm
Black, PMS 485
n/a

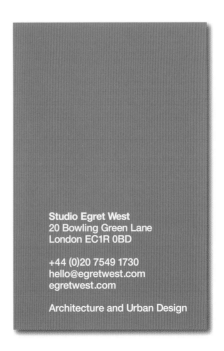

Studio Egret West
20 Bowling Green Lane
London EC1R 0BD

+44 (0)20 7549 1730
hello@egretwest.com
egretwest.com

Architecture and Urban Design

Emiliano Rodríguez
Ruiz de Gauna

Designer:
Emiliano Rodríguez
Ruiz de Gauna
Client:
Emiliano Rodríguez
Ruiz de Gauna

The idea of this business card was to include pieces of the designer's work and make a glance of his online portfolio to his personal card. His website is his most important marketing tool, from which, 90% of his clients comes to him directly just by going through the site. So the end-purpose of this business card is to bring the recipient to his site.

85 x 55 mm

Opaque Illustration Paper 300 gsm

CMYK

Polypropylene opaque finished

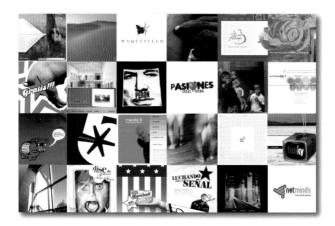

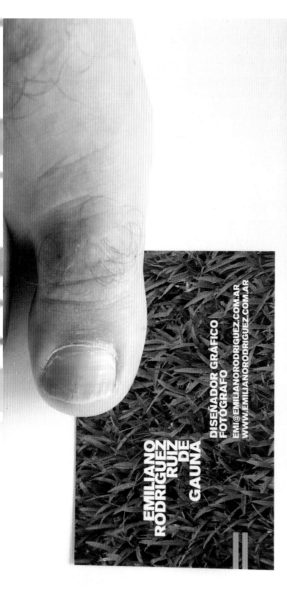

EMILIANO RODRIGUEZ RUIZ DE GAUNA

DISEÑADOR GRÁFICO
FOTÓGRAFO
EMI@EMILIANORODRIGUEZ.COM.AR
WWW.EMILIANORODRIGUEZ.COM.AR

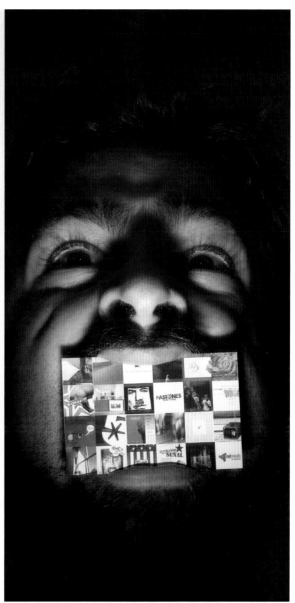

Kern02

Designer:
Kern02
Client:
Kern02

Looking at things in a different way and from a different perspective is an important value of Kern02. Therefore they designed their business cards with the logo as a transparent window. The images and structures of the cards are related to the designers. It tells the receiver what kind of person the designer is- what is the context of his design, how does he live, what is his passion- and yes, the designer Christophe is passionate with soccer, which is symbolized by grass.

85 x 55 mm
Taffeta Ivory 325 gsm
PMS Cool Grey 6, 485
n/a

Christophe Heylen

Kern02 grafische vormgeving
Oostmalsesteenweg 167 - 2310 Rijkevorsel
T 03 312 10 54 - M 0497 44 13 25
info@kern02.com - www.kern02.com

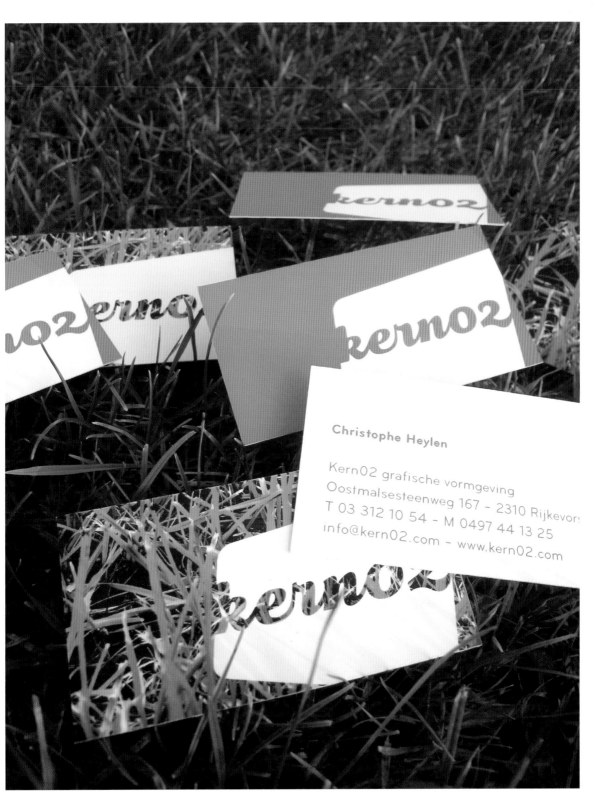

Charlie Kassel

Designer:
Mark Boyce
Client:
Charlie Kassel

These business cards created for photographer Charlie Kassel used a simple but effective formula. Beautifully set, foil-blocked contact details on one side and a selection of the photographer's work on the other. These mini billboards were also created in postcard size.

85 x 55 mm
Chromolux White
1 sided 400 gsm
CMYK
Foil blocking

Onetta Inc.

Designer:
envision+
Client:
Onetta Inc.

This start-up optical network-
ing manufacturer in Califor-
nia had a clear brief for their
identity: project a unique cor-
porate attitude. The logo and
clean crisp typography was
developed to express their
technical efficiency. It built a
striking contrast to a series of
abstract light images, which

were taken by photography
Esther Mildenberger and
Brian Switzer and has been
used in all applications.

89 x 51 mm
Zanders Ikono Silk
CMYK
n/a

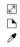

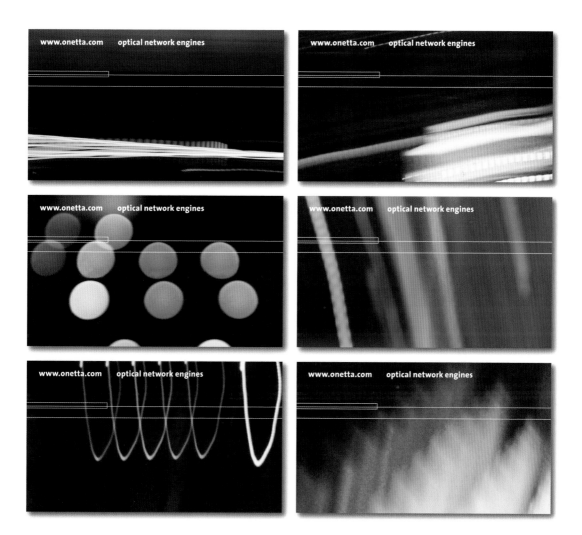

Whiplash

Designer:
Enric Aguilera
Asociados
Client:
Whiplash

Corporate identity developed
for an Internet company in
which the client wanted to
convey speed, plurality and
variety within the media.

80 x 50 mm

Splendorgel Extra White
300 gsm Fedrigoni

CMYK

n/a

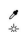

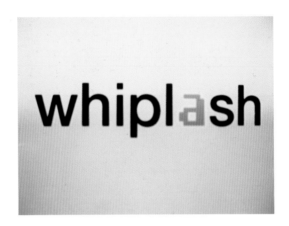

Francisco Campos 13 Local dcha 28002 Madrid Tel 917 450 539
Mov 669 364 813 e-mail diego.escriva@whiplash.es

Francisco Campos 13 Local dcha 28002 Madrid Tel 917 450 539
Mov 669 364 814 e-mail luis.gomez@whiplash.es

Francisco Campos 13 Local dcha 28002 Madrid Tel 917 450 539
e-mail whiplash@whiplash.es

Diego Escrivá de Romaní Director de contenidos

Luis Gómez Beade Director técnico

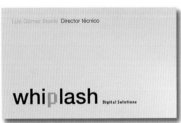

San Gervasio 354 bjs
08022 Barcelona
T +34 935 625 245
F +34 935 625 245
e-mail whiplash@rescas
www.whiplash.com

Sra. Rushmore

Designer:
Enric Aguilera
Asociados
Client:
Sra. Rushmore

Sra. Rushmore is the name of a person in a TV commercial created by Miguel García Vizcaino and María Rico. The entire corporate identity is developed based on the image of this dear lady. From her face to the outlandish wallpaper that we imagined she could have in her house.

80 x 60 mm
Glossy coated paper 300 gsm
CMYK
Glossy coated plastic

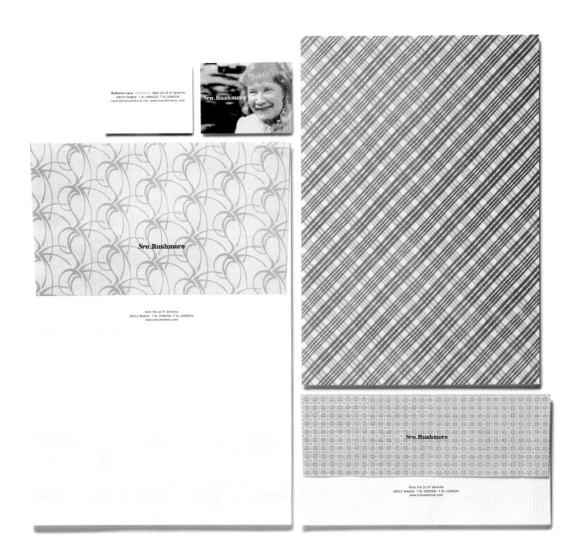

G Inc.

Designer:
Enric Aguilera
Asociados
Client:
Gipsy

This project designed for the
Gipsy production company
is a representation of images
associated with the world
of gypsies. The idea was to
change the image periodically
but always keeping the logo
with the letter 'G' as an icon
for all of their stationery.

85 x 55 mm

Splendorgel Extra White
300 gsm

CMYK

n/a

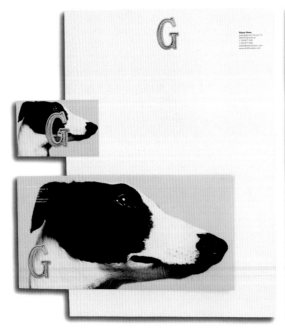

Mirjam van der Most

Designer:
DesignArbeid
Client:
Mirjam van der Most

This card designed for a free-lance photographer/traveller is a collection of all kinds of 'every day icons' as she calls them an important part of her daily routine. It is actually a mini-portfolio, in which every single card is a series of

photos in certain catergories. Shown here are portraits, cityscapes and still lives. Photography as well as the art of collecting are combined and presented in a plastic sleeve.

210 x 75 mm
n/a
CMYK
n/a

Gunn For Hire

Designer:
Designland
Client:
Elizabeth Gunn

This business card takes the advantage of a bold, humourous and dynamic interpretation of the client's name and uses it on a set of black and white images, which also reflects the idea.

90 x 40 mm
n/a
CMYK, PMS Warm Red C
n/a

ELIZABETH GUNN / EDUCATION & TRAINING CONSULTANT
Mobile 0403 827 284 Email lizgunn@netspace.net.au

RUKKIT KUANHAWATE
DESIGNER

ADRESS

228/64 PHAIROJ VILLA.BANGNA-TRAD RD 4 KM.
BANGNA, BANGKOK, 10260 THAILAND

rukkit@klearcorner.com
www.klearcorner.com

MOBILE

+66 (0)9 676 6881

Honey for the Bear

Designer:
Ben Loiz
Client:
Honey for the Bear

This business card is de-
signed for an online shop that
sells products for babies and
toddlers. The logo is centred
on one side of the card while
some cute characters are
placed beside the contact
information on the other side
to give the card a playful but
secure feel.

n/a
n/a
CMYK
n/a

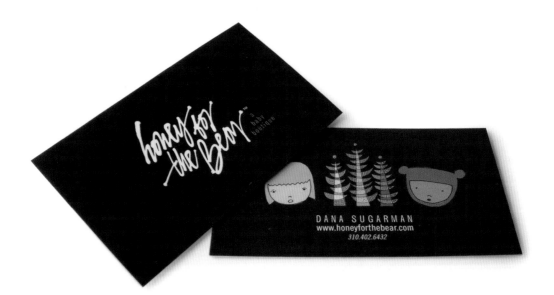

BeTV

Designer:
Base
Client:
BeTV

At the end of 2003 Vivendi-Universal sold off many of its affiliates of television network Canal+. Base was commissioned to create the overall identity, including print and screen, for the former Belgian affiliate. On top of assuming a new identity, the subscription-based network also expanded, going from three individual channels in its Canal+ incarnation to six as BeTV. To reflect the network's structure and its broad range of programming of this television network, Base designed BeTV's visual identity around a colour spectrum, with each channel represented by one sixth of the colour gradient. Each channel of BeTV thus has its own palette and sub-identity.

85 x 48 mm
n/a
CMYK
n/a

Jean-Claude Duss
Directeur général

656 chaussée de Louvain
1030 Bruxelles

Email nom@betv.be
Téléphone +32 2 000 00 00
Fax +32 2 000 00 00

www.betv.be

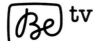

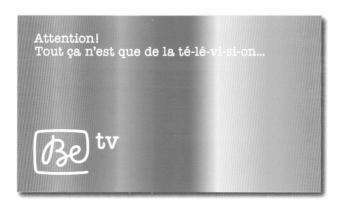

Benoy

Designer:
Benoy Ltd.
(Daniel Elsea,
Charlotte Chan)
Client:
Benoy

The obverse side of this business card is a powerful graphic image that is a manipulated image of a photograph of a design project recently completed by this firm, a renowned British architect. Here, in these new cards for their Hong Kong studio, the vibrant nature of the firm's work, which is focused in large-scale retail architecture and urban regeneration, is conveyed through a bold and punchy aesthetic. The reverse side contains all textual information with the firm's linear logo bled over as a watermark. As a playful twist, each employee receives a mixed batch of all six, which each adhere to a consistent template.

84 x 55 mm
Premium White Smooth paper 280 gsm
3 PMS
n/a

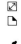
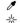

Furi Furi Company

Designer:
Furi Furi Company
Client:
Furi Furi Company

Using the logo as the back-
ground design, this die-cut
rounded shape business card
is instantly recognizable.
Each member of the company
can choose his/her favourite
colours for their own.

76 x 57 mm
Powdery Snow 210 kg
CMYK
Die-cut

代表取締役社長
平井 カズ
株式会社フリフリカンパニー
〒1510051 東京都渋谷区千駄ヶ谷
2-1-10 赤坂ビルディング202号室
phone:03-5414-5443
fax:03-5414-5448
mobile phone:090-8947-2735
kazu@furifuri.com
http://www.furifuri.com

President
Kazu Hirai
Furi Furi Company
2-1-10 #202 Akasaka Building
Sendagaya Shibuya-ku Tokyo
1510051 Japan
phone:+81-3-5414-5443
fax:+81-3-5414-5448
mobile phone:+81-90-8947-2735
kazu@furifuri.com
http://www.furifuri.com

Erin Skrypek

Designer:
Roanne Adams
Client:
Erin Skrypek

The client wanted a card that would live up to her stylish standards. So the designer decided to use a bird on the name card, which should be a great animal to represent the client. The bird was drawn by hand and a beautiful and delicate mono-line script typeface (Fig, script) has been chosen to accompany with.

89 x 51 mm
n/a
Black
n/a

Erin Skrypak
Writer

New York: 617 717 8277
Paris: +33675211387
email: eskrypek@aol.com

Fashion Wire Daily
erin@fashionwiredaily.com

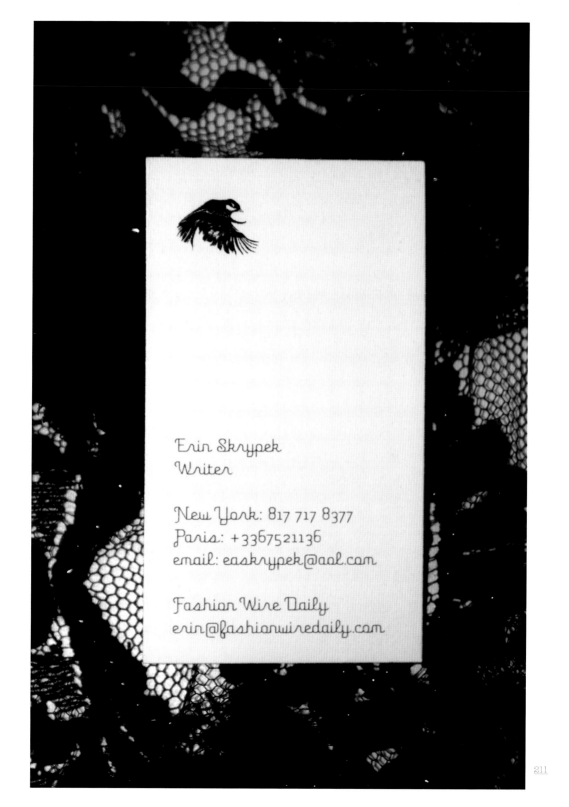

Erin Skrypek
Writer

New York: 817 717 8377
Paris: +3367521136
email: easkrypek@aol.com

Fashion Wire Daily
erin@fashionwiredaily.com

Readymade
Group Co. Ltd.

Designer:
Shellmoonsite
Client:
Readymade
Group Co. Ltd.

"Readymade" is the term used by the French artist Marcel Duchamp to describe works of art he made from manufactured objects. In 1917 in New York, Duchamp made his most notorious ready-made, "Fountain." The TATE Museum Glossary further elaborates three important points of Readymade art, "First, that the choice of object is itself a creative act. Secondly, that by dissolving the 'useful' function of an object it becomes art. Thirdly, that the presentation and addition of a title to the object have given it 'a new thought', a new meaning." This is how the team goes through the creative process of their identity.

90 x 53 mm

Woodfree Card 300 gsm

Black, PMS 185 U, 871 U, 3248 U

Emboss

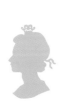

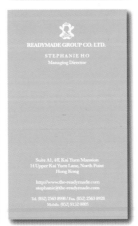

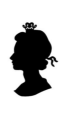

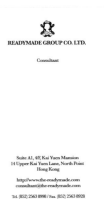

Rina Miele

Designer:
Rina Miele
Client:
Rina Miele

The designer needed an 'explosive' identity for the first piece of the HONEY stationery that got revamped in 2005. Her first business card left something to be desired, while she was still trying to find out who she was and what she wanted to tell others about herself. She needed a visual that could be remembered, something not normally seen on a business card. Then she decided to have her honeycomb pattern burst through the paper, with the 'explosive' idea taken literally.

89 x 51 mm
100 lb coated cover
CMYK
n/a

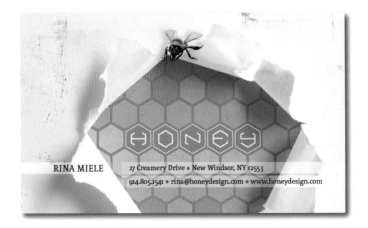

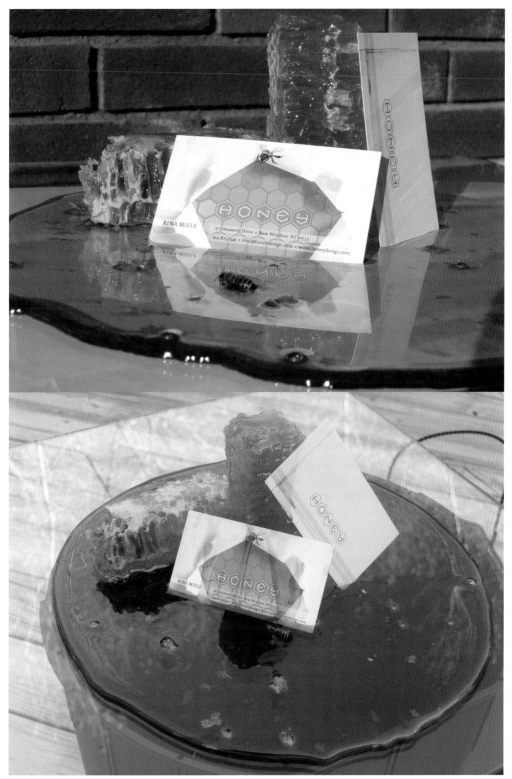

Satellite Design

Designer:
Satellite Design
Client:
Satellite Design

This set of business card is de-
signed to lead with a clean and
professional message on the
card front. But because read-
ers often flip a card quickly
to see if there's anything on
the back, they use the back to
balance the businesslike front
with a bit of fun.

89 x 51 mm

Navajo Brilliant White
130 lb cover

CMYK, PMS Black, 550

n/a

satellite design •

> Amy Gustincic

STREET 539 bryant street
SUITE no. 305
CITY / STATE san francisco, ca
ZIP CODE 94107

PHONE 415.371.1610
FAX 415.371.0458
EMAIL amy@satellite-design.com

McKinivan Moos

Designer:
one-two.org
Client:
McKinivan Moos

The business cards show por-
traits of the co-workers from
McKinivan Moos. And their
favourite things combined
with the background pattern.

85 x 54 mm
Munken Pur
PMS 485 U
n/a

Brunner Fotografie

Designer:
one-two.org
Client:
Brunner Fotografie

The idea of this business
card was to use illustration to
show the photographer at his
work - taking pictures. And
then taking pictures again
and again.

85 x 54 mm
Munken Pur
PMS 301 U
n/a

Brunner
Fotografie

Stollbergstrasse 11
6003 Luzern

078 830 89 98
www.brunner-fotografie.ch

Brunner
Fotografie

Stollbergstrasse 11
6003 Luzern

078 830 89 98
www.brunner-fotografie.ch

Dopepope

Designer:
Dopepope
Client:
Dopepope.

On going series of mini il-
lustrations are used for the
designer's own business
cards. They serve as an evolv-
ing portfoilo for Dopepope.

89 x 51 mm
Plastic
n/a
n/a

Dopepope:
Experimental Aesthetics
www.dopepope.com
joel@dopepope.com
212.206.7139

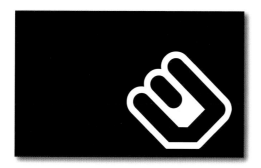

Dopepope:
Experimental Aesthetics
www.dopepope.com
joel@dopepope.com
212.206.7139

DOPEPOPE:
EXPERIMENTAL AESTHETICS
CONTACT:212.206.7139
WWW.DOPEPOPE.COM
JOEL@DOPEPOPE.COM

DOPEPOPE:
EXPERIMENTAL AESTHETICS
CONTACT:212.206.7139
WWW.DOPEPOPE.COM
JOEL@DOPEPOPE.COM

Eric Chan

Designer:
Eric Chan Design Co Ltd
Client:
Eric Chan

This personal name card for
Eric Chan uses the portrait
of himself as an identity. It is
illustrated by a Hong Kong
designer Michael Lau.

100 x 50 mm
Recycled card 721 gsm
n/a
Black stamping, deboss

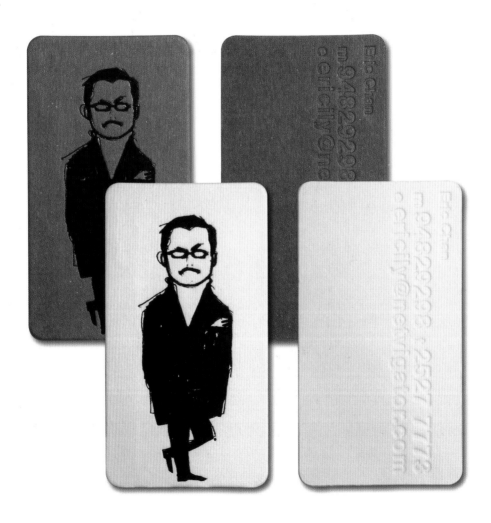

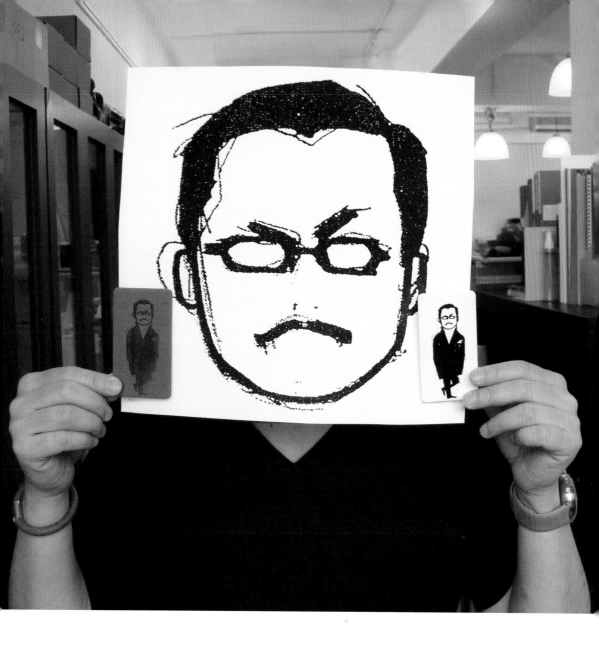

Fiona Wan

Designer:
Eric Chan Design Co Ltd
Client:
Fiona Wan

In old time, Chinese charac-
ters were only 'written' on
rocks and woods and this is
the main idea of the name
card. The client's Chinese
name was hence debossed on
the image of rocks and woods.
As the rock's grey and wood's
brown is a bit too dull, a few

fresh colours were used for
this set of name card to give
a more modern look and feel.
This is also referred to the
style of the client's writing,
which is ususally vibrant to
audience.

90 x 55 mm
Fancy Paper 220 gsm
CMYK, PMS
Deboss

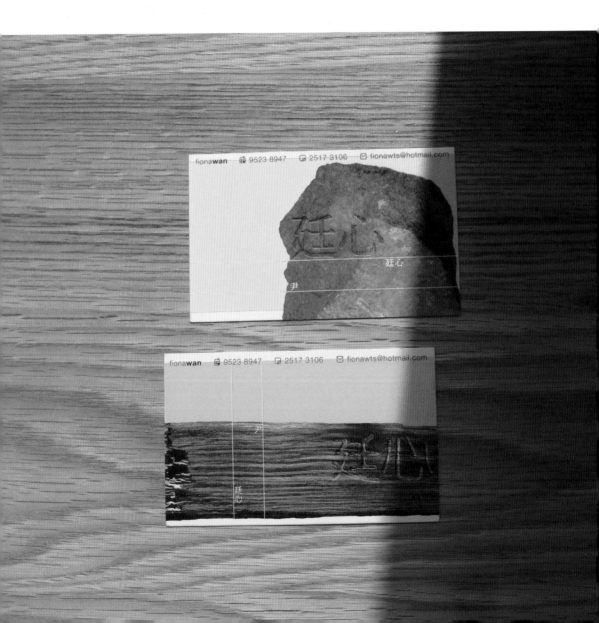

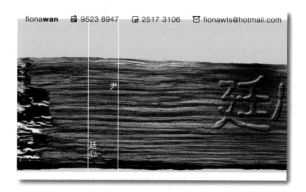

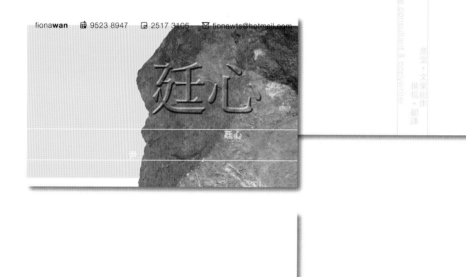

Xanidu Design

Designer:
MEWE Design Alliance
Client:
Xanidu Design

The logo of XANIDU Design is formed by tilted parallel lines, which looks exactly like the character of its Chinese name. The designer used the logo as a pattern for the front of the business card. It is printed on filmy paper and then bound with glue as a booklet.

90 x 45 mm
Munken 80g
Red, blue
n/a

捭当设计 XANIDU DESIGN

— 梁 少波 Liang shaobo
— 总经理 General Manager
A-13G,Hanhuayuan,No.56 Songyu South Street
Chaoyang District,Beijing
北京 朝阳区 松榆南路56号 汉华苑A座 13G
Z : 100020 M : 13301206829
T : +8610-8731-0964 E : lsb0210@sina.com
F : +8610-8731-4946 H : www.xanidu.com

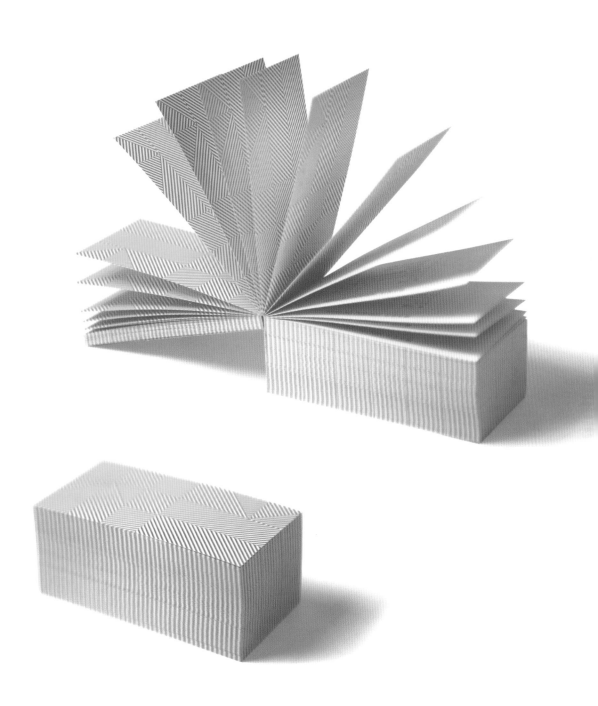

China International
Gallery Exposition 2006

Designer:
MEWE Design Alliance
Client:
China International
Gallery Exposition 2006

The core image of this name
card is grid. Those grids
composed letters and each
business card is an instance
of these variations.

90 x 55 mm
Conqueror Smooth
300 gsm
PSM 805, silver
n/a

2006 中国国际画廊博览会
China International Gallery Exposition 2006
China World Trade Center. Beijing
2006.4.12ʷᵉᵈ-16ˢᵘⁿ

岳若峰 Silky Yue

招展主管 / 总经理助理
Sales Manager / Assistant to General Manager

北京中艺博文化传播有限公司
中国北京东城区东中街 58 号美惠大厦 D 座 502 / 邮编 100027
BEIJING CHINESE ART EXPOSITION'S MEDIA CO., LTD
D-502, Mei Hui Bldg, No.58 Dongzhong Street.
Dongcheng District, Beijing, China, 100027
Tel: 86-10-65546950 / 65546951 Fax: 86-10-65546830
Mobile: 86-13718924514
E-mail: bj_cige@yahoo.com.cn
Website: www.cige-bj.com

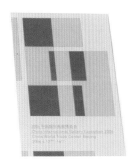

Shanghai Zero
Art Center

Designer:
MEWE Design Alliance
Client:
Shanghai Zero
Art Center

The logo of this gallery is an '0' composed with many dots. The designer duplicated this logo many times and made it like a pattern for the card back.When many of these cards i.e. the pattern got printed on a same sheet of paper and cut with a specific method, not any one of them will be the same. So even if one person received several cards from the same person, s/he could still find them different.

90 x 50 mm
Conqueror Smooth 300 gsm
Green, black
n/a

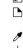

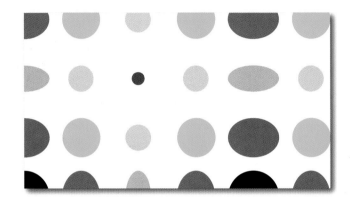

龚 彦
Gong yan

总监
Director

a 上海市松江区文翔路2200号
复旦大学上海视觉艺术学院零时艺术中心201620
No. 2200, Wen Xiang Road, Song Jiang Area,
0 ART CENTER Shanghai Institute of
Visual Art, Shanghai 201620 P.R.China

t 0086 21 67822527
f 0086 21 67823200
w www.siva.edu.cn
e yangong933@hotmail.com

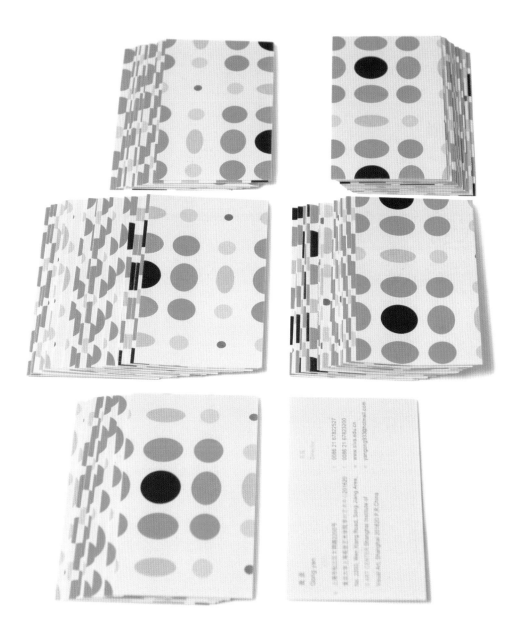

say it in "details"

特殊印刷・加工で見せる名刺

Manta

Designer:
Frost Design, Sydney
Client:
Manta

To create business cards for the staff at this prestigious Sydney restaurant, Frost Design took the elements of the identity, which included a variety of beautiful Manta shapes and the new logo design and screen printed onto boxboard. The white against the brown card looks fresh and clean and the variety of shapes on the reverse provides a diverse range of cards.

85 x 55 mm

Unlined box board
300 gsm

n/a

Screen printing

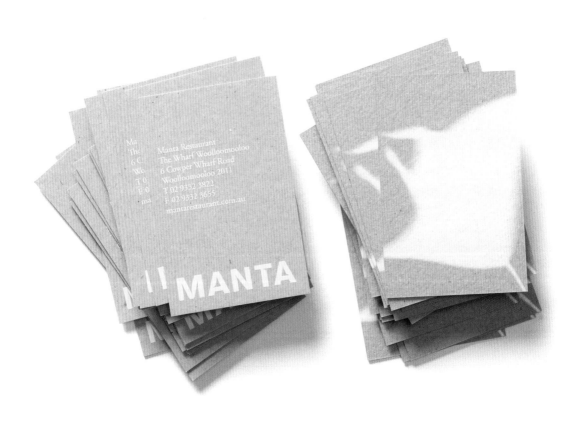

Plug

Designer:
Base
Client:
Plug

For these New York-based event planners and 'hype generators', Base designed an identity for them starting with the client's name. The word 'plug' means promotion or connection, or as a verb, to publicize. Referencing a literal electrical plug, Base designed Plug's business cards with two die-cuts in that shape. The die-cuts is extended to be used on Plug's stationery and printed materials.

89 x 51 mm
n/a
n/a
Die-cut

plug | |

lyman carter ı founder
t. 212 966 6986 f. 212 274 0876
c. 917 334 8840 e. lyman@pluglimited.com
www.pluglimited.com
158 lafayette street, 5th floor
new york, ny 10013

plug

lyman carter ı founder, principal alchemist and creative director
t. 212 966 6989 f. 212 625 0232
m. 917 334 8840 e. lyman@pluglimited.com
www.pluglimited.com
158 lafayette street, 5th floor
new york, ny 10013

500mg

Designer:
Damián Di Patrizio
Client:
500mg

This card is basically designed based on the logo of 500mg. It plays with the logo's basic colours to make it recognizable, and the rounded stamp that borders the '0' gives the card an un-usual distinction form, that, like the logo and the colours, represent the concepts of modern, creativity and differ-ence that the studio wants to communicate.

85 x 45 mm
Illustration (Matt Opaque) 350 gsm
2 PMS
Die-cut, varnish

Fashion Futures

Designer:
Bleed
Client:
T-room

The concept of this card is to use handmade logotype with a scratch effect that reflects the washed t-shirt motives appearing on vintage t-shirt. Metallic gold and brown are the colour scheme of this card to set the time of origin, the 70's.

80 x 50 mm
Munken Elk 150 gsm
CMYK
Spot print, metallic gold

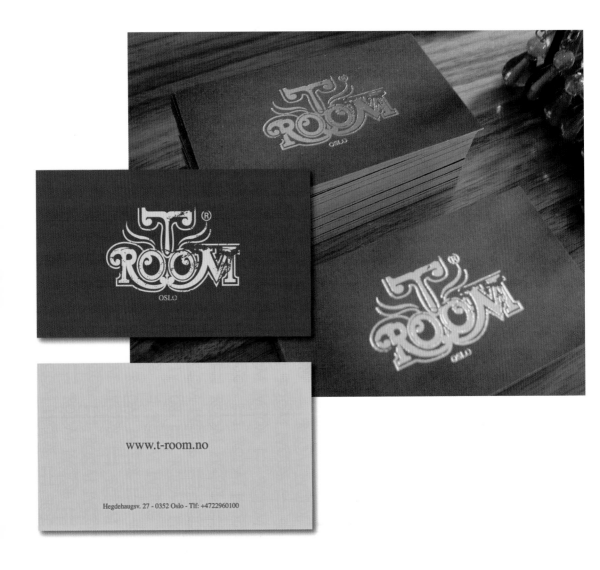

Shnel&melnychuck

Designer:
Bleed
Client:
Shnel&melnychuck

The style of this card,
with the decorative logo
of Shnel&melnychuck, an
advertising agency and the
subtle colour the designer
used, is high-class and exclu-
sive with a tactile feel.

80 x 50 mm

GF Smith Colourplan
300 gsm Morocco,
Curious Milk Soft Touch
300 gsm

Black

Emboss

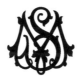

ANDRÉ KOOT

Wilsesgate 1, N - 0178 OSLO, Tlf: +47 22 98 05 50, Mob: +47 92 05 21 48,
www.melnychuck.com, andre@melnychuck.com

SHNEL&MELNYCHUCK

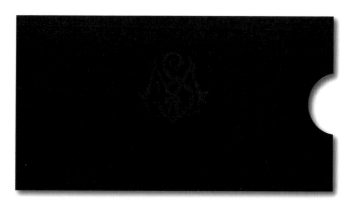

Yucca

Designer:
Yucca Studio
Client:
Yucca Studio

Using the technique of deboss/emboss, this card gives you a touch as well as feel when you read, symbolized the visual and interactive media design that the company does. The strong typography also suggests a bright, sharp and informative approach for the card.

85 x 45 mm
Curious Touch Soft Milk
300 gsm
Grey
Deboss

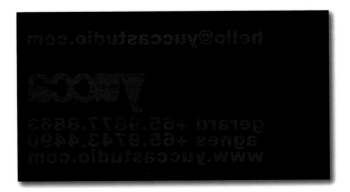

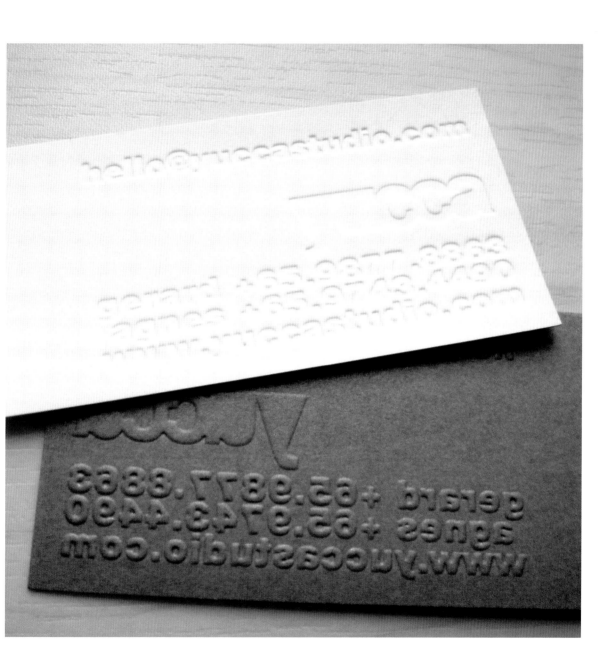

Eggthree

Designer:
Yucca Studio
Client:
Eggthree

The embossing and the spot UV varnish used on the business card gives a clean, sleek and subtle feel that ties in with the look and feel of the shop. The bold typography and the repetitious use of the company's logo on the art card also give the company name a textural and tonal variation.

60 x 60, 90 x 45 mm

Art Card 350 gsm

Black

Matt lamination, spot UV, emboss

Mike Tan
9 733 0633
mike@eggthree.com

33 Erskine road #01-08 Singapore 069333
T +65 6 536 6977 F +65 6 536 9677 W www.eggthree.com

33 Erskine road #01-08 Singapore 069333
T +65 6 536 6977 F +65 6 536 9677
www.eggthree.com

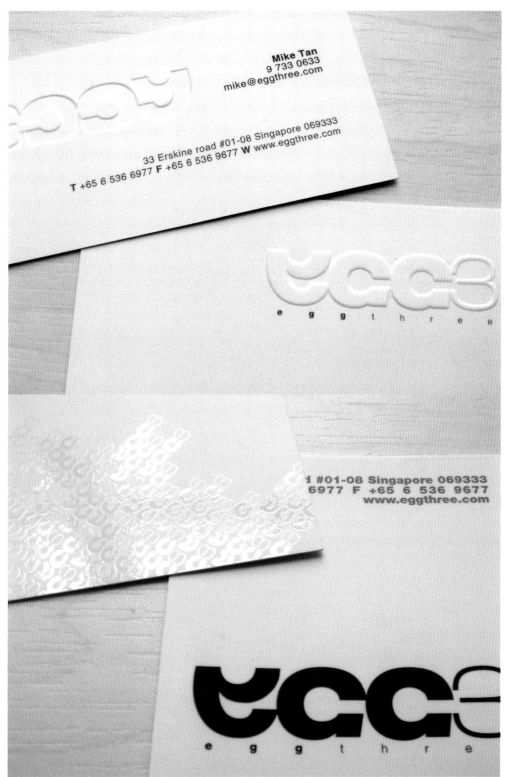

Mike Tan
9 733 0633
mike@eggthree.com

33 Erskine road #01-08 Singapore 069333
T +65 6 536 6977 F +65 6 536 9677 W www.eggthree.com

ɛɑɑ3
e g g t h r e e

d #01-08 Singapore 069333
6977 F +65 6 536 9677
www.eggthree.com

ɛɑɑ3
e g g t h r e

Owen Evans /
Furnace Design

Designer:
Parent
Client:
Owen Evans /
Furnace Design

The heavy weighted stock gives
this card a solid luxurious
feel. The use of two different
coloured cards laminated
together instead of printing a
colour gives this card added
depth and interest, reflecting
the design of the product of
this company. It is finished with
a simple silver foil block.

85 x 60 mm

Duplexed Colour plan 540
gsm, Pristine White Colour
plan 270 gsm, Pale Grey
Colour plan 270 gsm

n/a

Silver foil block

Owen Evans
Director

Unit 33
Level 6 North
New England House
New England Street
Brighton BN1 4GH

Telephone / Facsimile.
01273 683777

Mobile.
07780 677430

Online.
www.furnacedesign.co.uk
owen@furnacedesign.co.uk

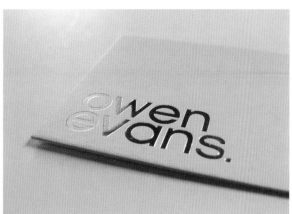

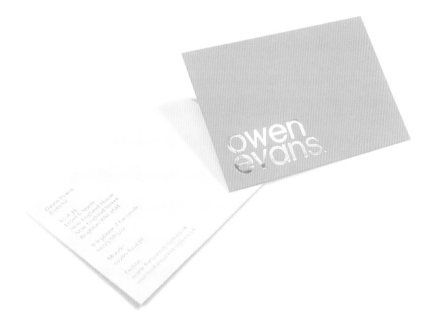

CTS

Designer:
Parent
Client:
CTS

The Plike stock has a beauti-
ful matt finish, almost
rubbery, this works perfectly
with the spot UV varnish to
give a subtle, luxurious look
to a company whose clients
include many luxury brands.

85 x 55 mm
Black Plike 350 gsm
n/a
Spot UV

Peter Sage

The Old Fire Station
140 Tabernacle Street
London. EC2A 4SD

T. +44 (0)20 7300 7226
M.+44 (0)7776 156 669

peter@creatingit.com
www.creatingit.com

CTS

Peter Sage

The Old Fire Station
140 Tabernacle Street
London. EC2A 4SD

T. +44 (0)20 7300 7226
M. +44 (0)7776 156 669

peter@creatingit.com
www.creatingit.com

Parent

Designer:
Parent
Client:
Parent

The heavy weighted stock gives this card a solid luxurious feeling. The simple white foil on white board give a minimal, subtle yet luxurious quality to the card.

85 x 60 mm

White Colour plan 540 gsm

n/a

White foil block

Shana London

Designer:
Parent
Client:
Shana London

The heavy weighted stock
gives this card a solid feeling.
The rose gold foil adds a twist
of femininity and luxurious
style.

85 x 60 mm

White Colour plan 540
gsm

n/a

Rose gold foil block

®bePOS|+|VE design

Designer:
Tnop™ & ®bePOS|+|VE
design
Client:
®bePOS|+|VE design

This plastic business card has one colour black silk-screen on front and black sticker strip on back for the information of a person. The concept of this piece was to create the 'Lab-like entry card' for the designer's team. That is why they went with the clean black and white colours. On the back of the card they created the black strip, which represents the magnetic strip of an actual lab card. But for this version, the information is actually printed on it instead of store in the magnetic strip. They also wanted the card to look as close as the actual ones, so they choose a milky plastic material with matt finishing.

89 x 45 mm
Matt finish plastic card
Black
Silk-screen black,
black sticker

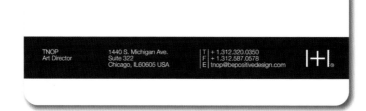

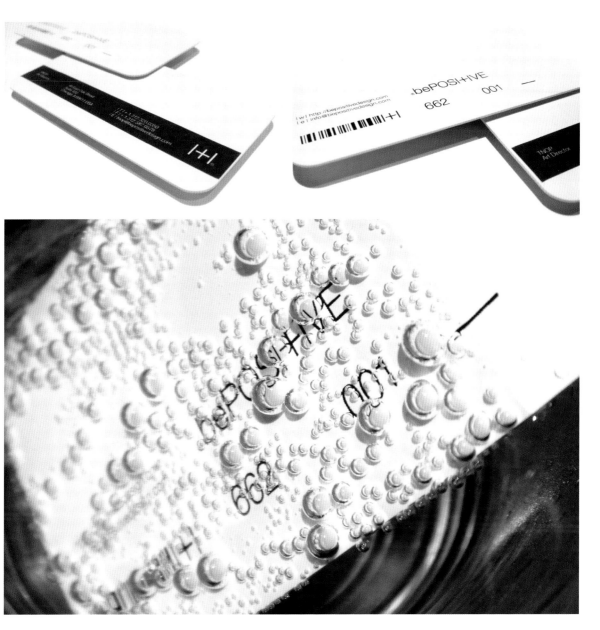

GAD

Designer:
Made
Client:
GAD

This card is made for GAD Gallery, which is a very special gallery located in the container harbour in Oslo. The material used for the building is containers. So the card follows this concept. With thick UV on both sides, there is a feeling of the rough container on the outside, and the smooth surface of a gallery on the inside.

84 x 54 mm
Matt paper 330 gsm with low bulk
Black, silver
Spot UV

GAD⁻

Knut Blomstrøm

Postboks 1873 +47 93 21 72 67 www.gadart.no
Vika 0124 Oslo kb@gadart.no

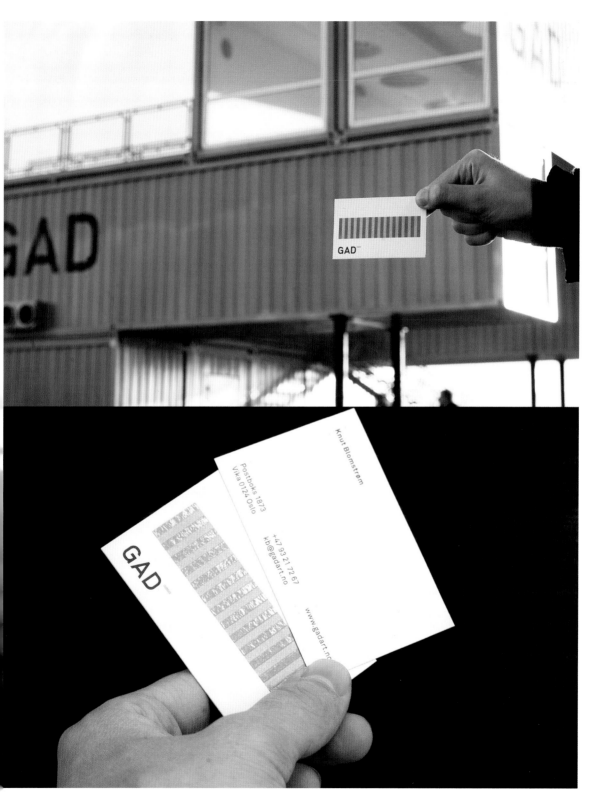

...,staat creative
statements

Designer:
...,staat
Client:
...,staat creative
statements

This card is made in plain
white, black and silver. No
nonsense and premium just
like the designer, ...,staat, is.
The concept is clear and plays
with the emotional value of
plastic credit card vs. busi-

ness card. The credit card
concept is used all over the
...,staat stationery, include a
stamping in the letterhead
and with compliments card.

85 x 54 mm
0.76 mm white PVC
Black
Emboss with silver
tipping, gloss lamination

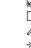

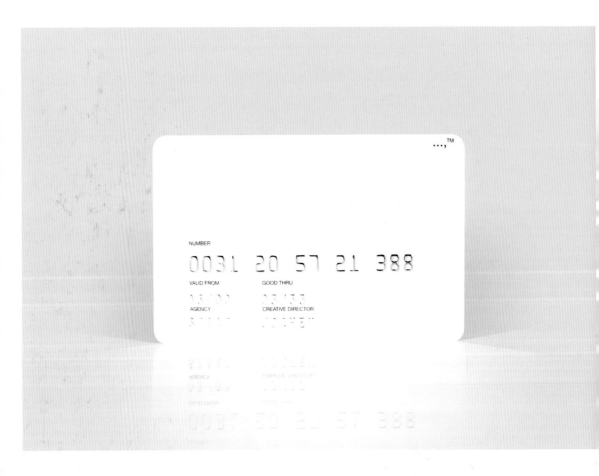

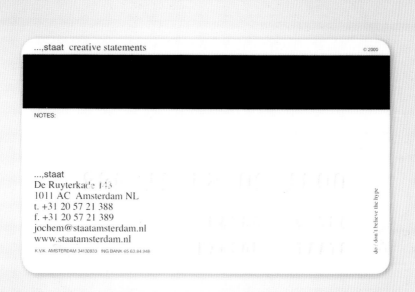

...,staat creative statements
© 2000

NOTES:

...,staat
De Ruyterkade 143
1011 AC Amsterdam NL
t. +31 20 57 21 388
f. +31 20 57 21 389
jochem@staatamsterdam.nl
www.staatamsterdam.nl

K.V.K. AMSTERDAM 34130833 ING BANK 65.63.84.948

do / don't believe the hype

Concrete Architectural
Association

Designer:
...,staat
Client:
Concrete Architectural
Association

The paper used for this business card has a rough and matt front but a smooth and shiny back, which gives a rough vs. glossy feel in just one piece of paper. The idea is to use the roughness to stand for 'concrete' and the glossiness to stand for their work. Black and orange represent the overall identity of Concrete. The logo is not a logo in the classic point of view: the paper is approached as a piece of three-dimensional material in which the logo is cut out – as Concrete creates dimensions in material.

85 x 54 mm
Chromolux 700 350 gsm
Black
Laser-cut, gloss lamination, orange lacquer

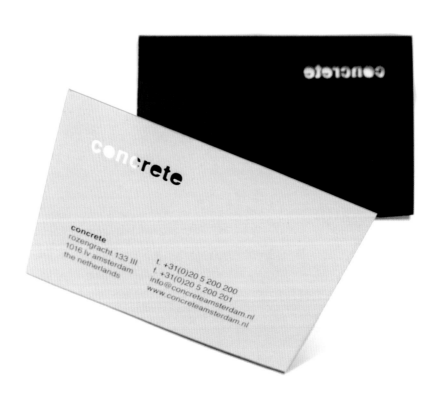

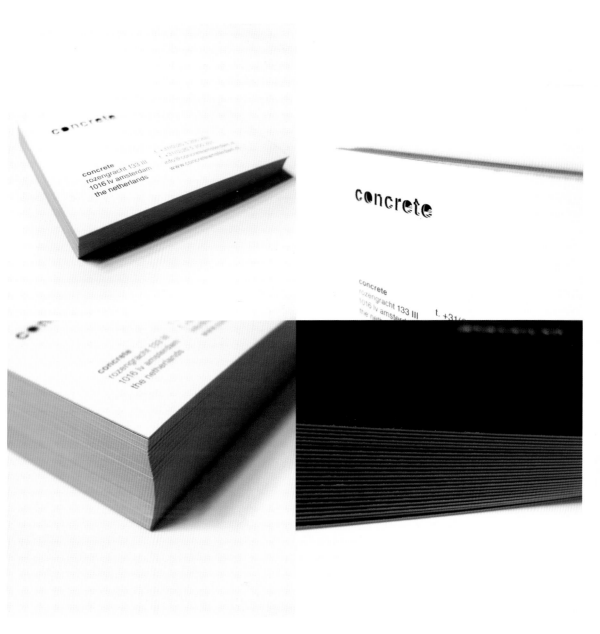

Tnop™

Designer:
Tnop™ & ®bePOS|+|VE
design
Client:
Tnop™ & ®bePOS|+|VE
design

This business card was
done in limited quantities of
100 cards. The idea was to
experiment with the goggo
screen print kit and handheld
embosser to create something
fast and easy to produce by
one person within limited
budget.

57 x 51 mm

Black colour paper

Silver, gold, copper

Gocco screen print,
handheld embosser

TNOP W.
DESIGNER
+1.312.
235.0170
1440 S. MICHIGAN
AVE. #322 CHICAGO
IL 60605 USA
TNOP@
TNOP.COM
HTTP://WWW.TNOP.COM

TNOP W.
DESIGNER
+1.312.
235.0170
1440 S. MICHIGAN
AVE. #322 CHICAGO
IL 60605 USA
TNOP@
TNOP.COM
HTTP://WWW.TNOP.COM

TNOP W.
DESIGNER
+1.312.
235.0170
1440 S. MICHIGAN
AVE. #322 CHICAGO
IL 60605 USA
TNOP@
TNOP.COM
HTTP://WWW.TNOP.COM

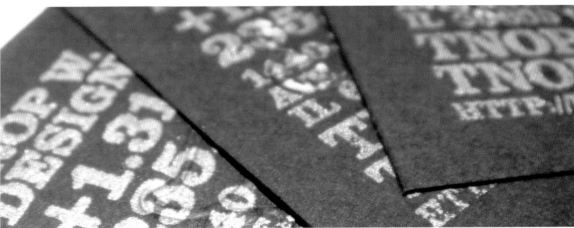

Mamouche

Designer:
...,staat
Client:
Mamouche

This card is designed for a French-Moroccan restaurant, Mamouche, which is known for its pure and honest cuisine. 'Mamouche' means 'darling' in Dutch, a word that became the main ingredient for the visual identity: creating unique darlings by putting together with 274 photographs of memories, napkins and wrapping paper.

85 x 50 mm

High Speed Opaque 50 gsm

PMS Red, Blue, Beige, Warm Black

Split colour print

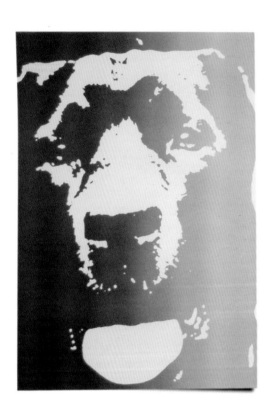

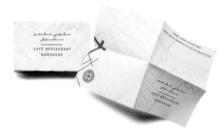

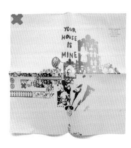

مقهى مطعم
ماموش

CAFÉ RESTAURANT
MAMOUCHE

Made

Designer:
Made
Client:
Made

The Made Studio's business cards are designed based on the expression of Made Men. Back in the old time, a Made Man was a person connected with mafia. The designer thought this was a funny way to portrait themselves since they are directly the opposite, and not really into an organized crime. They found the images when traveling in Eastern Europe. Under these travels, they bought old family photo albums from second hand stores. These albums were full of inspiring pictures and they were used for the design. All the photos are originally hand coloured and were taken between 1910-1920. They use different photo for each employee, so none of the cards are the same.

84 x 54 mm
Matt laminated paper 200 gsm
Black, silver
Spot UV

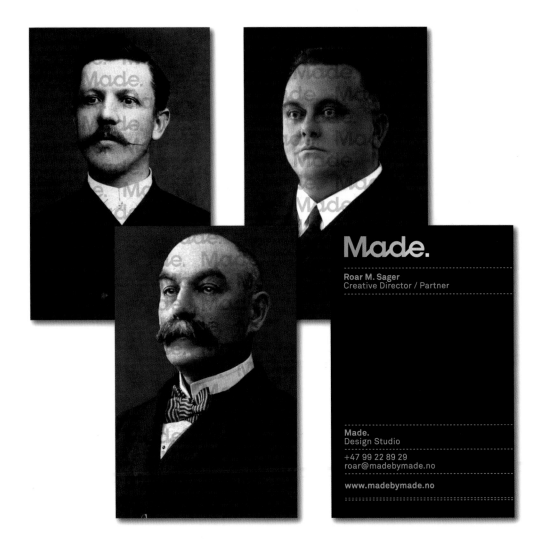

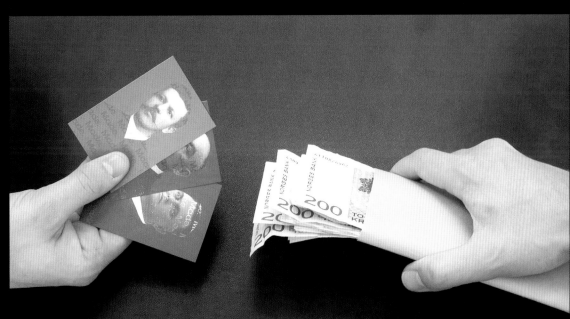

tomoby

Designer:
tomoby
Client:
tomoby

A bespoke, yet subtle busi-
ness card that has rounded
corners and black foil block-
ing on a thick black uncoated
stock. The type is friendly font
type and information appears
and disappears depending on
the surrounding light.

80 x 50 mm

GF Smith Colour plan
Ebony 540 gsm plain
finish

Gloss black foil

Foil block, die-cut

UBB

·Designer:
WE RECOMMEND
Client:
Ulrik Boel Bentzen

The business card is de-
signed in black to reflect the
client's very elegant and sub-
tle work. The text is printed
in UV varnish and therefore
only visible when light is
reflected in the letters.

85 x 55 mm

Papyrus, Magno Satin,
350 gsm

Black

Spot UV

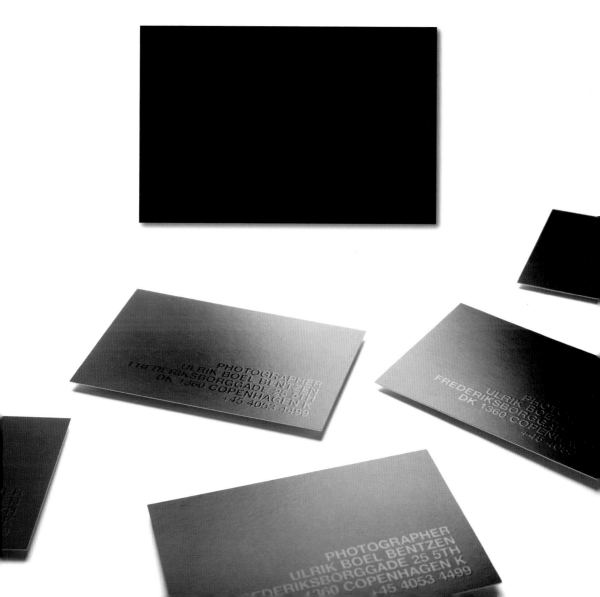

VM Christopher

Designer:
Milkxhake
Client:
Christopher Lee

A business card for a visual
merchandising consultant
with a minimal approach. It
bares an humor touch with
the copyright icon which
symbolizes the consultant's
initial.

90 x 50 mm
Paper
1 colour
Die-cut

Sony Valo

Designer:
RDYA
Client:
Sony Valo

A brand refreshment was
made for this business card,
in which colours and shapes
play an important part in
contributing to innovation
and modernity, following the
product's concept. Also, the
colours' degrade transmits
speed and technology sensa-
tions.

80 x 50 mm
Starmax 280 gsm
CMYK
Polypropylene

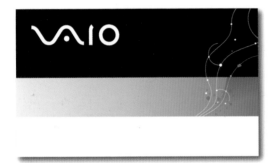

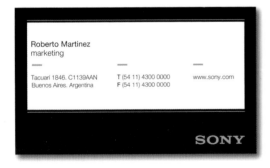

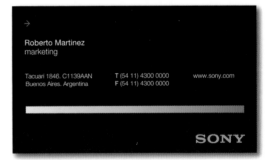

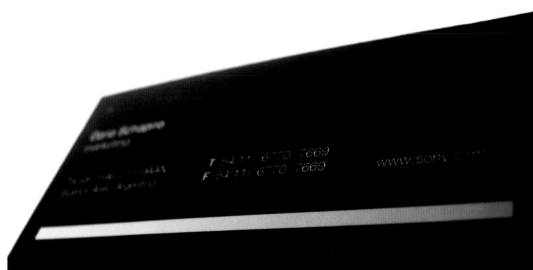
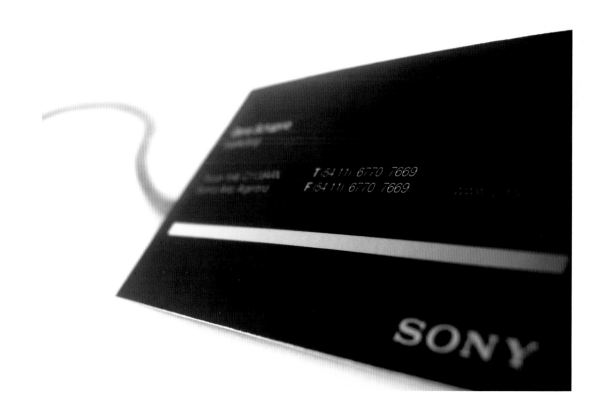

The Consult

Designer:
The Consult
Client:
The Consult

The concept of this business card is based on a comment about how designers communicate with people by showing their 'tongue in cheek' internal guide to 'making people like us'. The spread shown goes into details about when

they would use their business card and how it could be effectively communicate with the people they meet. The design is also intended to make people smile!

85 x 55 mm
n/a
PMS 319 U
Emboss

Nice to
meet you

Rebecca Keast
Managing Director

The Consult
Regent House
8 Regent Street
Leeds LS7 4PE
Telephone
+44 (0) 113 269 6899

Online
rebecca@theconsult.com
www.theconsult.com

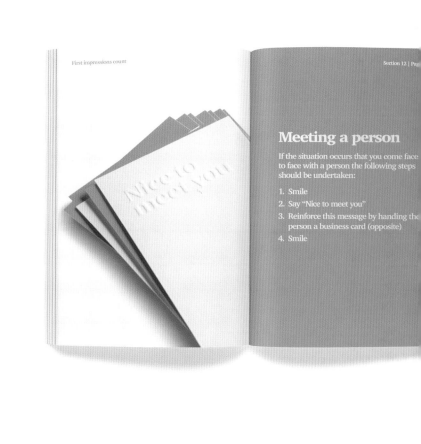

Meeting a person

If the situation occurs that you come face to face with a person the following steps should be undertaken:

1. Smile
2. Say "Nice to meet you"
3. Reinforce this message by handing the person a business card (opposite)
4. Smile

Nice to meet you

First impressions count
A guide to making people like us

TheConsult
Design & Art Direction

A guide to making people l

Jimmy Woo
Membercard

Designer:
...,staat
Client:
Jimmy Woo /
TAO group

The design is in plain black,
silver and gold, looks like
a premium credit card. The
concept is clear and plays
with the emotional value of
plastic.

85 x 54 mm

0.76 mm thick white pvc

Black

Emboss with silver or
gold tipping, gloss
lamination

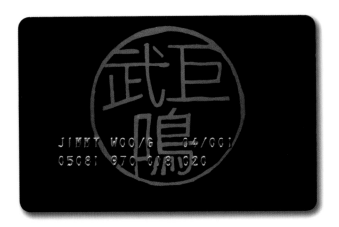

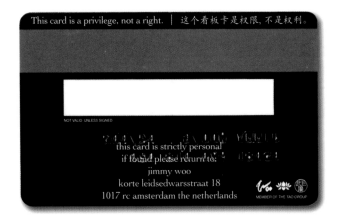

Designklinik

Designer:
Designklinik
Client:
Designklinik

With this special plastic card, you feel the invaluable touch of a real paycard and a special quality and self-documenting form. The design is reduced for the maximum input of client's information.

90 x 60 mm
Plastic
1 colour
Offset printing

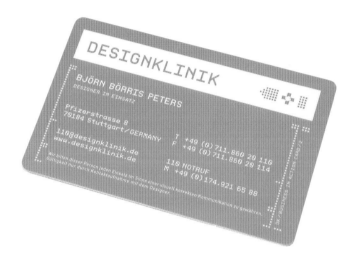

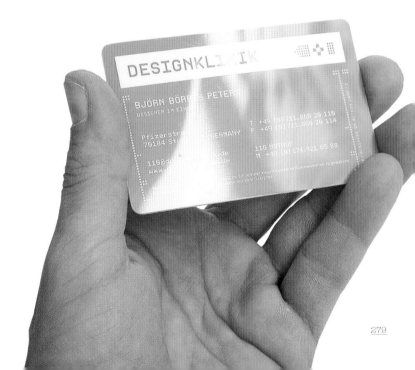

Colorola

Designer:
Colorola
Client:
Colorola

This card is called 'calling card' because the client and designer move around a lot and the studio's address is about to change. Therefore a 'calling card' is a reasonable idea, which usually provides basic infomation of a name and related email address. The card is created slightly bigger than a typical business card in order to ensure the intricate die-cut perfectly. It is also multifunctional that the stencil can be used to customize envelopes, cd's and the sidewalks in the neighbourhood.

100 x 70 mm
Tiara Hi-tech. 65 lb cover
PMS 179 C
Die-cut

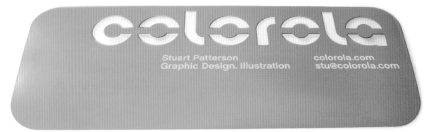

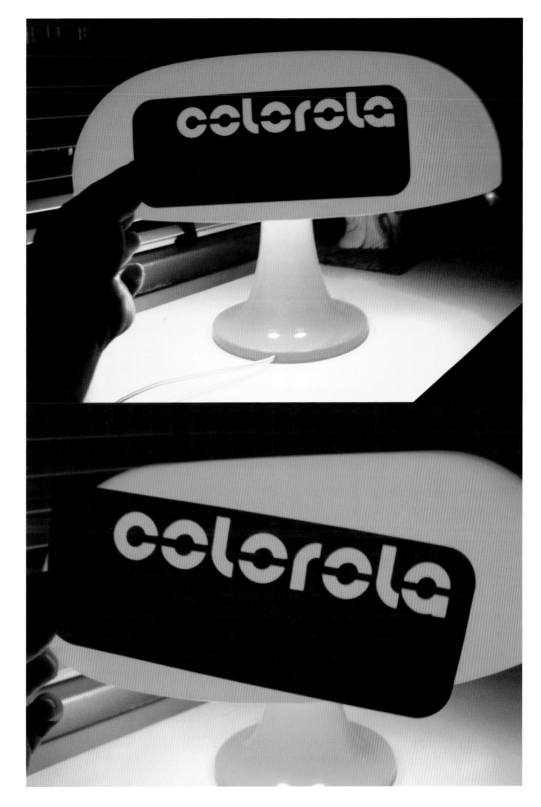

Naked Music

Designer:
Colorola
Client:
Naked Music
Recordings

With the Naked Music Business System, the designer wanted to downplay the nudiness with something more minimal and resolute but still sexy. The 'Naked Chick' logo is relegated to the bottom corner on the reverse side of the card, while the 'Muni' monogram traverses the front center embossed. Four solid colours- orange, red, blue and pink, were each used separately to give the holder an option to go with his or her mood for the day.

85 x 748 mm
Tiara Hi-tech. 65 lb cover
Florescent orange, warm red, black uncoated
Die-cut, emboss

Becky Wisdom

Naked Music Recordings
148 west 24th st. #4R
New York, NY 10011

212 206 7588 phone
212 206 7597 fax

becky@naked-music.com
www.naked-music.com

NakedMusic

Dave Boonshaft, CEO

Naked Music Recordings
148 west 24th st. #4R
New York, NY 10011

212 206 7588 phone
212 206 7597 fax

dave@naked-music.com
www.naked-music.com

Becky Wisdom

Naked Music Recordings
148 west 24th st. #4R
New York, NY 10011

212 206 7588 phone
212 206 7597 fax

becky@naked-music.com
www.naked-music.com

Bruno Ybarra Label Director

Naked Music Recordings

74 Caselli Ave
San Francisco, CA 94114

415 565 0345 fax
415 307 4700 mobile

bruno@naked-music.com
www.naked-music.com

Solution

Designer:
Studio Output
Client:
Solution

This card, bares a classic
type and motif solution, is
designed for a national foot-
wear retailer. The floral motif
serves as a secondary device
used as a spot UV on print,
bringing the image of Soku-
tion: fashionable, feminine
and fresh.

85 x 55 mm
n/a
1 PMS
Spot UV

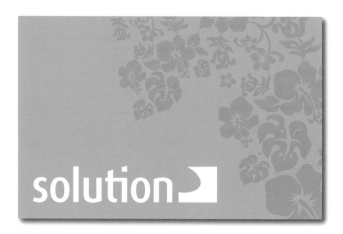

solution

Michael Singh
Managing Director

Rinzen

Designer:
Rinzen
Client:
Rinzen

Combining the favourite colour
of friendly sunny yellow with
a distinctive roof-top form,
this business card design has
served them long and well due
to its simplicity. It also feels
good - the stock is heavy and
the celloglase, smooth!

90 x 55 mm
350gsm coated
PMS 109, 1405
Matt Celloglase, die-cut

RILLA ALEXANDER . RILLA@RINZEN.COM

RINZEN . THEY@RINZEN.COM . WWW.RINZEN.COM
PO BOX 1729 . NEW FARM . QUEENSLAND 4005 . AUSTRALIA

Gardens&Co.

Designer:
Milkxhake
Client:
Gardens&Co.

This card is designed for
Gardens&Co., a visual mer-
chandising consultancy. A
dedicated dialogue next to
the logotype added a personal
touch on every single piece of
application.

90 x 50 mm
Paper
1 PMS
Emboss, die-cut

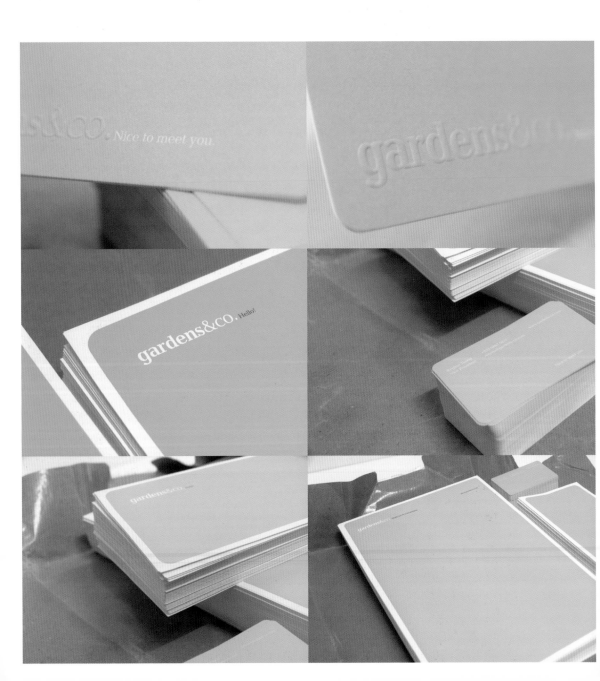

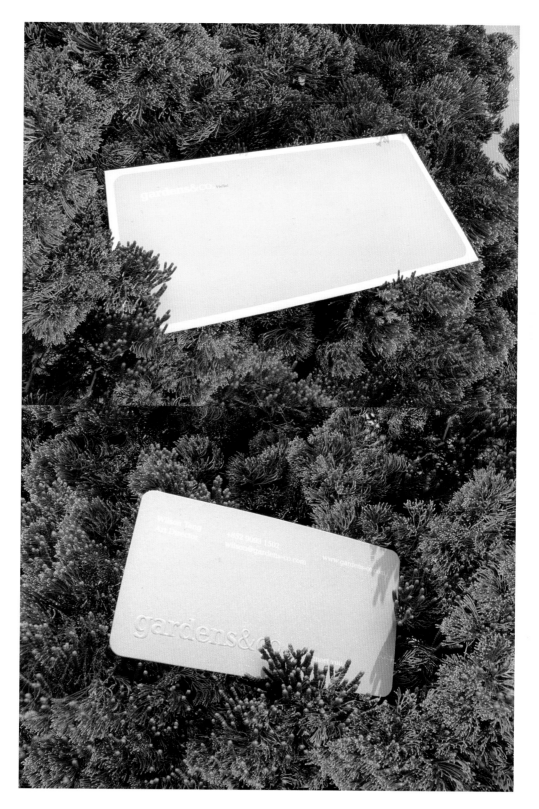

Milkxhake

Designer:
Milkxhake
Client:
Milkxhake

This card is designed by Milkxhake for themselves, who is a young Hong Kong based graphic design unit. The 'X' in Milkxhake alludes to the continuous idea of mixing and multiplying. In order to keep a neat and clean design for the business card, the logo 'X' is simply cut out by laser and printed on their favourite milkxhake flavors - Chocolate and Vanilla.

90 x 50 mm
Paper
2 PMS
Laser-cut

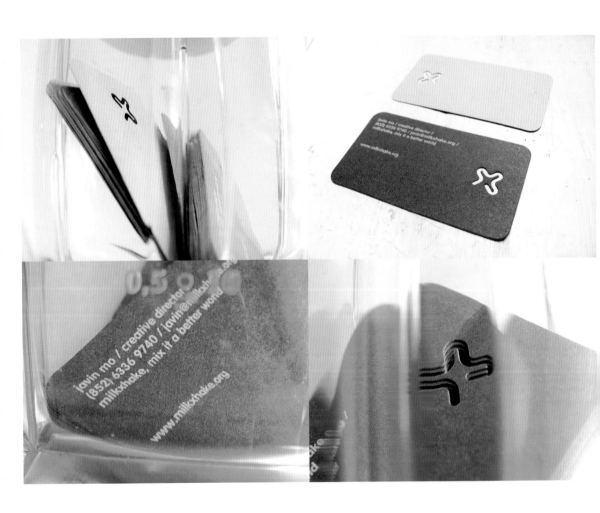

dotplus

Designer:
NuDesign
Client:
dotplus

This business card/ badge
is sent to designers and
contributors for shows and
expos. Since most of them are
from outside of the country,
they may practically put the
badge on their baggage while
they are travelling and they
will not get lost.

90 x 60 mm

Papercard, baggage-
badge made of plastic

Red, black

Baggage-badge

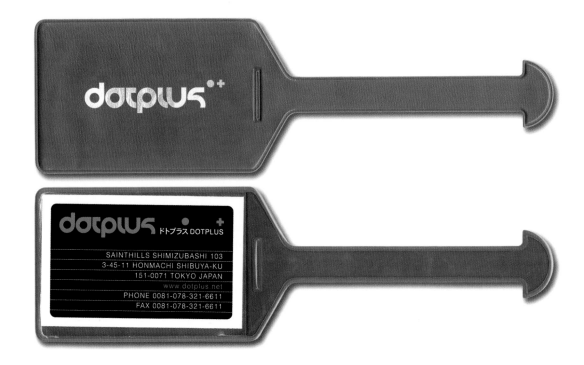

Basheer Design Books

Designer:
Eric Chan Design Co Ltd
Client:
Basheer Design Books

This card is designed for a
Design Books Shop in Hong
Kong. Both the shape and the
colour tone of the card is a
further development based
on its logo so as to remind
the recipient of the shop with
every single chance.

100 x 50 mm
Fancy Paper 270 gsm
PMS 440 U, 1505 U
Special colour printing,
die-cut

Joey Ho Design Ltd

Designer:
Eric Chan Design Co Ltd
Client:
Joey Ho Design Ltd

Client wanted to show two main elements through this name card: 'Enjoy Design' and be colourful. Hence, play around with typography is the main idea for this card. The 'EN' of the word 'ENJOY" is placed in a subtle way i.e. debossed on the top white

area so you can find both the client company's name 'Joey Ho Design Ltd' and also her required phrase 'enjoy design' on the card front. Designers also used four different fresh colours to make this set of cards more colourful.

100 x 50 mm
Fancy Paper 270 gsm
2 PMS
White stamping, deboss

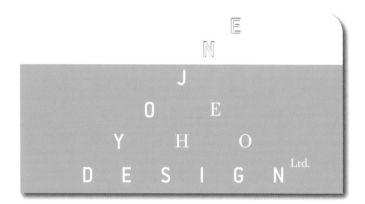

JOEY HO
Creative Director
B.A.A.S.(NUS)+M.Arch.(HKU)
何 宗 憲 建 築 思
香 港 大 學 建 築 學 碩 士
新 加 坡 大 學 建 築 學 文 學 士
UNIT 1601 – 1602 16/F
CAR PO COMMERCIAL BUILDING
18-20 LYNDHURST TERRACE CENTRAL hk
中 環 擺 花 街 1 8 – 2 0 號
嘉 寶 商 業 大 廈 16 樓 1601 – 1602 室
T 852 2850 8732 F 852 2850 8972 M 852 9836 8185
enjoy@joeyhodesign.com www.joeyhodesign.com

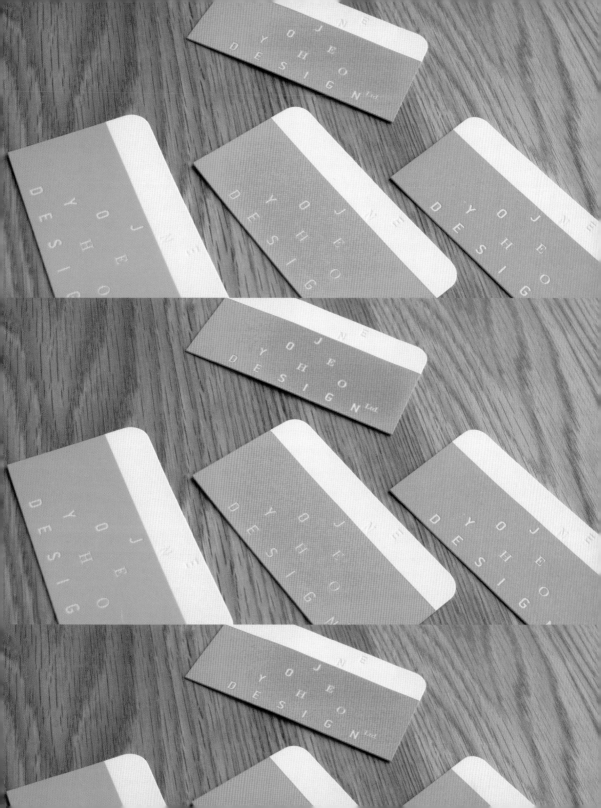

Prism+VisualAnalysis

Designer:
Prism+VisualAnalysis
Client:
Prism+VisualAnalysis

This card was designed to fold into a prism to remind people of its logo and ultimately enforce the company name. It is not only useful to the user, but also to who ever they receive it. It is often used to keep documents together or hold business cards in. When folded, it creates a useful pocket shape that makes it possible to attach to most printed materials such as books, invoices and flyers.

85 x 55 mm
n/a
PMS 213, 417
Emboss, die-cut

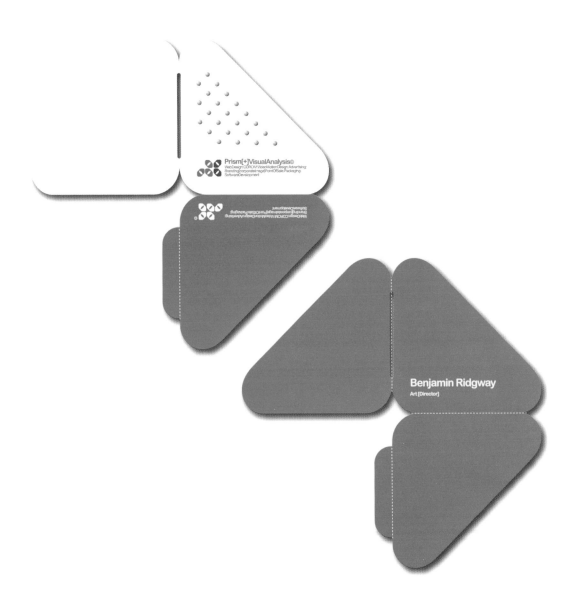

Talea

Designer:
Damián Di Patrizio
Client:
Talea

This is quite a different and useful design as a presentation card. First of all, the card has a completely new and original format. It is thinner and longer than the usual cards. This helps to remind it easily. Secondly, the card has

a stamp, like a brochure, that permits to aggregate some useful information about the company. The colours and images are elements from the company's logo.

100 x 30 mm (closed),
150 x 30 mm (opened)

Texturated paper
300 gsm

CMYK

Matt varnish

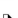

S A L U T E & B E N E S S E R E

SHIATSU
RIFLESSOLOGIA
MASSAGGI

V. LE MATTEOTTI 153
MILANO MARITTIMA
TEL. 0544 995499

t a l e a
centro benessere

V.LE MATTEOTTI 153
MILANO MARITTIMA
TEL. 0544 995499

SHIATSU
RIFLESSOLOGIA
MASSAGGI

V.LE MATTEOTTI 153
MILANO MARITTIMA
TEL. 0544 995499

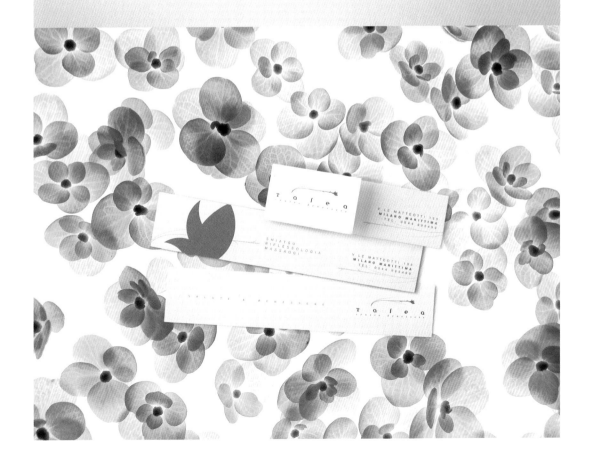

Ben Pieratt

Designer:
Fwis
Client:
Ben Pieratt

In response to the pricey vinyl toy market, the designer developed an ongoing series of free paper toys that anyone can download from the project's site. He simplified the concept down to its simplest form for his business card, while providing the recipient a mini-toy for their desk.

89 x 51 mm
Matt heavy stock
Red, black
Custom die and score

Asteria

Designer:
Asteria
Client:
Asteria

The business card is a match with the unique style of the identity of the company to create a fairytale imagery, which can also be seen throughout the artist's works. 'Asteria' means star shaped gemstone and shining diamond. It mixes fantasy, glamour and sensuous 'baby-dolls' styles. Figures are iconed with big starry-eyed characters displaying super cuteness. Purple is used to bring out a feeling of mystery. Besides, special printing effect and die-cut is a perfect match between the logo design and corporate nature.

90 x 55 mm
Matt card 300 gsm
CMYK
Die-cut, spot UV

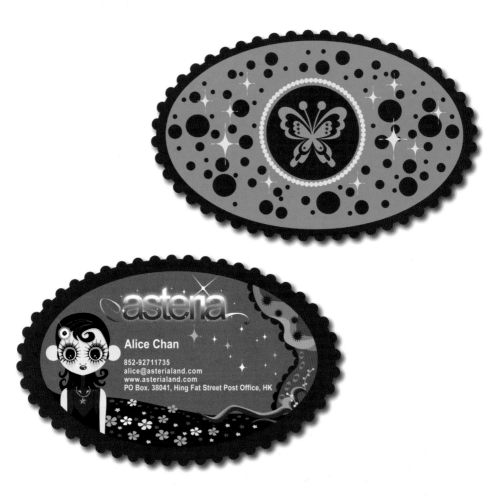

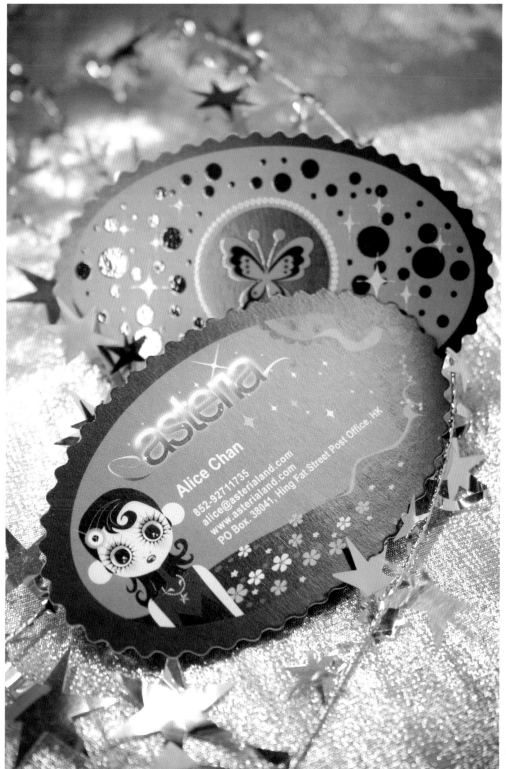

Kanister Records

Designer:
Viagrafik
Client:
Kanister Records

Using the main corporate green colour for all appearance of their products, diversity is actually an important aspect of the philosophy of Kanister Records. The green is not defined as a special colour but is allowed to appear in all its possible shadings.

The varying direction of the type Isonorm creates a technical image no matter on which side it stands. It also emphasizes the idea of a canister that can be filled with all kind of liquids.

88 x 55 mm
Semi coated 200 gsm paper
PMS 569
Die-cut

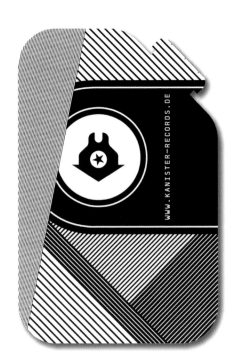

Picture

Designer:
Mark Boyce
Client:
Picture

A set of stickers is used to combine with the business cards which could create a personality that reflects each of the three founders both individually and as a professional organisaton. This set of stickers includes personal contact detail stickers, generic company stickers and large sheets of slogan or sign-off stickers. Purposely these sign-off stickers were

left blank to be completed by the founders before printing. These stickers would then be applied to printed sheets with images that is cut down into sizes of letterhead, postcard and business card. The logo is an acronym and is utilised in two distinct ways- firstly, big and bold, as a logo should be, and secondly as a sign-off, like a trademark symbol.

85 x 55 mm
Skye Uncoated 400 gsm
CMYK
Sticker sheet

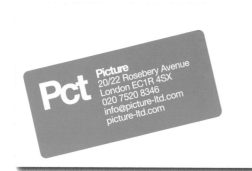

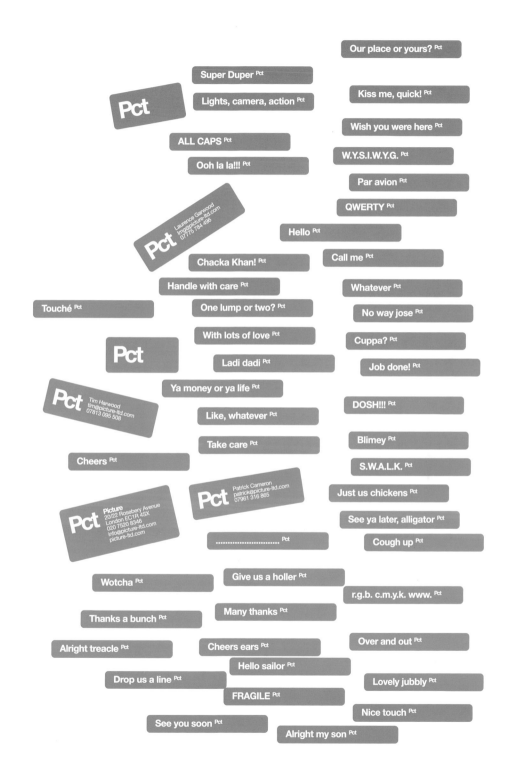

Emmi Salonen

Designer:
Emmi Salonen
Client:
Emmi Salonen

The designer of this card has
a fascination for all stationery
and believs that the more
unique the better it is. This is
why her designs are always
back to basics just like her
own business card, reas-
sembling a bit of informa-
tion typed on a corner of a
notepaper.

75 x 50 mm
White matt card
CMYK
One 5 mm hole punch

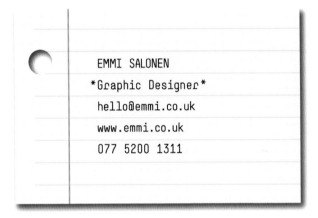

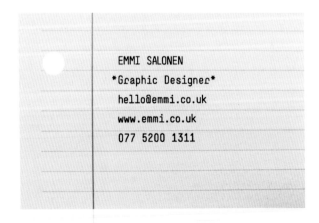

Alex Marshall

Designer:
Emmi Salonen
Client:
Alex Marshall

This business card designed
for a journalist has a real
folded right hand corner.
Such detail of design reflects
the habit of marking an inter-
esting page on a book or a
magazine by folding the cor-
ner. It tells you not to forget
this good piece of writing.

80 x 50 mm
White matt card
Process cyan, black
Folded top left hand
corner

Alex Marshall
Journalist
077 5316 7771
asmarshall@gmail.com

Fwis

Designer:
Fwis
Client:
Fwis

Very minimal design for this
business card with laser us-
age to burn the information
out, and it turns out to be a
not very simple idea .

89 x 51 mm
Matt heavy stock
n/a
Laser-burn

FWIS
Chris Papasadero { Principal
Lead Designer
Avant-Tard
215 SE Morrison #1034
Portland, OR 97214
fwis.com
cp@fwis.com
503.230.1741

FWIS
Graphic Designering
Ben Pieratt, Principal
215 SE Morrison #1034
Portland, OR 97214
fwis.com
ben@fwis.com
503.230.1741

avec

Designer:
Maiko Gubler
Client:
avec

Due to budget restrictions, the designer came up with a solution of combining a sticker and a business card in one. The peeled off logo can be applied to the diverse media of the artists represented by the agent.

85 x 55 mm
Transparent vinyl sticker
1/0, white
Screen print, kiss cut

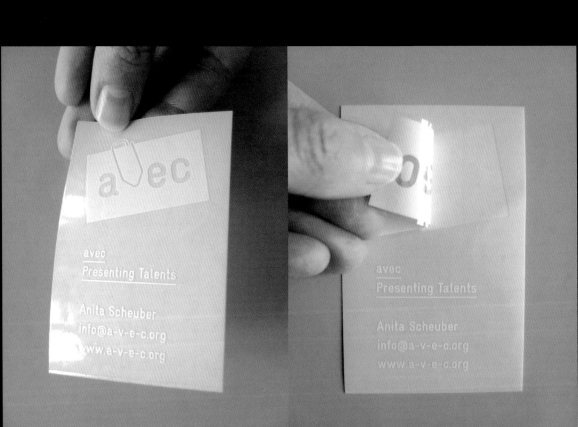

Roger Hendriks

Designer:
DesignArbeid
Client:
Roger Hendriks

This card is designed for a
business of software develop-
ment that links the administra-
tion system and the result
of the production machines.
'Fenêtre ' is a French word
that means 'window'. That
is why the word 'Fenêtre' is
lasered out of the card.

85 x 55 mm
n/a
Process cyan
Laser-cut

fenêtre

ir. Roger Hendriks
directeur

Saturnusstraat 40-96
2516 AH Den Haag

t 070 315 54 76
f 070 315 54 79

roger.hendriks@fenetre.nl
www.fenetre.nl

Ollystudio

Designer:
Ollystudio
Client:
Ollystudio

This business card is the most important part of the identity for Ollystudio. It is also the only piece of their identity that is given over in a one on one situation and as such is a potential conversation piece and a great way to break the ice with potential clients.

Therefore, they designed the card with a variety of colours and minimal information with foil blocking sressing on the company's name.

85 x 55 mm

GF Smith Colour Plan with Colt Skin finish

Pristine White, Ebony, Mandarin

Old gold foil block

Ollystudio

.co.uk

1st Floor Studio
2-8 Scrutton Street
London
EC2A 4RT

0871 208 0084
olly@
www.

Oliver Walker
Creative Director

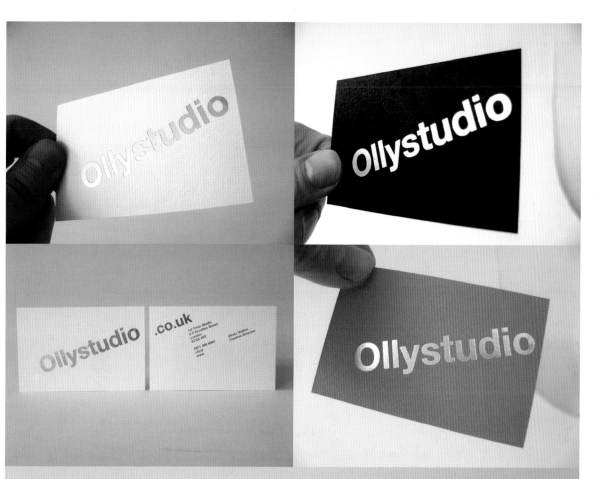

65 Media systems

Designer:
Mattisimo
Client:
65 Media systems

This business cards is designed for an interactive design boutique specializing in film-related websites located in Los Angeles. The challenge was apparently the '65' in client's name of '65 Media system' which has no actual reference. That is just the favourite number of the co-owners.

89 x 51 mm, 89 x 60 mm
Domtar Titanium Brite-white Smooth 175 lb Tag
n/a
Double hit floods

65 MEDIA

4051 GLENCOE AVE. MARINA DEL REY CA. 90292

65 MEDIA

65 MEDIA

MATTHEW SCHNEIDER

DESIGN DIRECTOR

PH-310-316-0766 FX-310-306-0677

MATTHEWS@65MEDIA.COM

65 MEDIA

MATTHEW SCHNEIDER
DESIGN DIRECTOR

PH-310-316-0766 FX-310-306-0677
MATTHEWS@65MEDIA.COM

Mattisimo

Designer:
Mattisimo
Client:
Mattisimo

This business card is made
for the designer himself and
a simple solution was chosen:
foil stamping logotype in
helvetica 75 bold on beautiful
rich paper stock, in three
colours, and then hitting the
back of the card information
with a silver spot colour.

89 x 51 mm

Domtar Feltweave 80 lb,
Feltweave 100 lb

PMS uncoated

Foil stamp

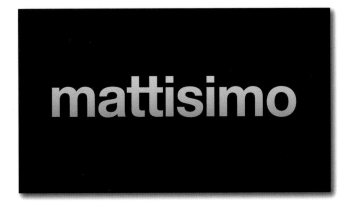

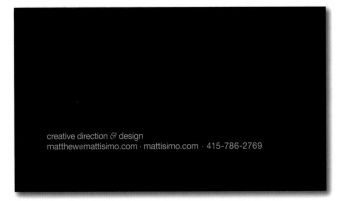

creative direction & design
matthew@mattisimo.com · mattisimo.com · 415-786-2769

mattisimo

creative direction & design
matthew@mattisimo.com · mattisimo.com · 415-786-2769

Shellmoonsite 2003

Designer:
Shellmoonsite
Client:
Shellmoonsite

This is an experiment about touch and smell. Engraving printing plus detail embossing effect for the Shellmoonsite logo on the rough surface of a White Woof Card gives s

sense of touch. Meanwhile, the perfumed card will lead you to read all the details.

88 x 48 mm

White Woof Card 300 gsm, tracing paper (card folder)

Black

Engrave, perfume

SHELLMOONSITE
シェルムーンサイト

小 门西

MLEE, MAN CHUNG LEE
DIRECTOR

HTTP://WWW.SHELLMOONSITE.COM
INFO@SHELLMOONSITE.COM

+ (852) 9426 6377

気付きの点がございましたら、お気軽にお申し出下さい。お客様が満足されるまで、何度でも無料で責任おもって、ご相談に応じさせていただきます。

シェルムーンサイト

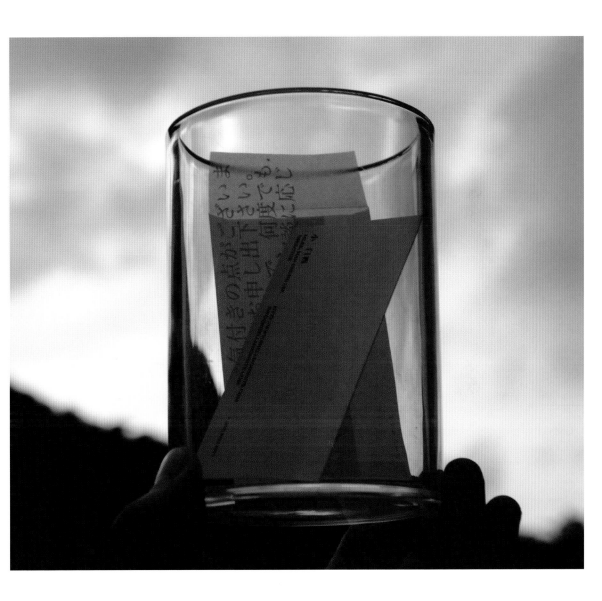

Shellmoonsite 2004

Designer:
Shellmoonsite
Client:
Shellmoonsite

This is an experiment about texture, layers and weight. By putting materials on the above in different orders, it creates different contrast, from smooth to rough, thin to thick, white to transparency, etc.

85 x 50 mm

Textured paper 120 gsm (card), PVC card, Onion paper (card wrapper), Eupo Paper 120 gsm (card folder)

PMS 448 U, 877 U, White, Black

Matt varnish, die-cut, hot stamping, emboss

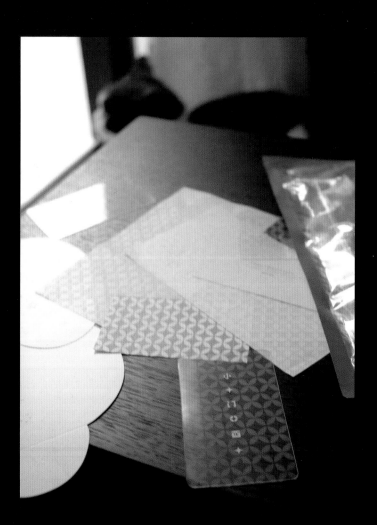

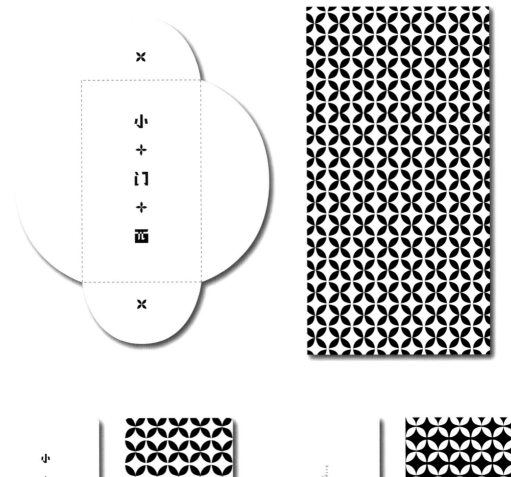

Escape Studios

Designer:
Stylo
Client:
Escape Studios

The designer was asked to up-
date the identity of a leading
training school in CGI and 3D
animation in Europe. As part
of their branding, the design-
er made the business cards
utilizing with the corporate
colour palette and devised

them by using silver foil to
pick out the relevant details.
Instead of going to be in 3D
or with illustrations, the
design is on a rather heavy
stock that helps keeping a
sophisticate and corporate
feel to the school.

85 x 55 mm
Challenger 400 gsm
PMS 405
Silver foil

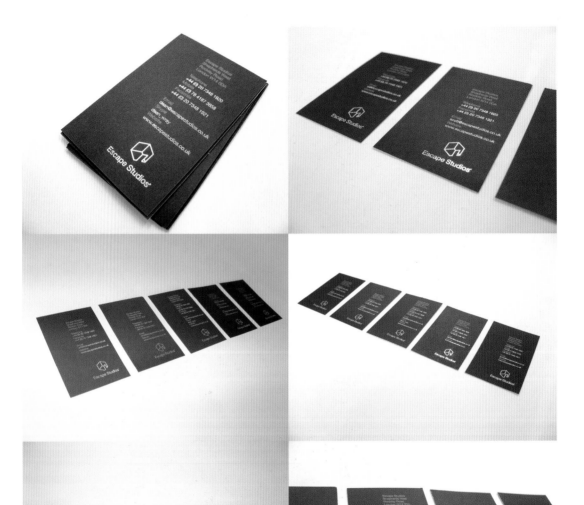

Ant-Zen

Designer:
BombTheDot
Client:
Ant-Zen

The boldness of the typog-
raphy, the colour, the simple
layout and the clear UV finish
of this business card reflect
the sophistication of the
company.

79 x 55 mm

Fedrigoni Sirio Black
480 gsm, Fedrigoni Sirio
Pearl 350 sm

Black, Graphite

Clear UV laquer

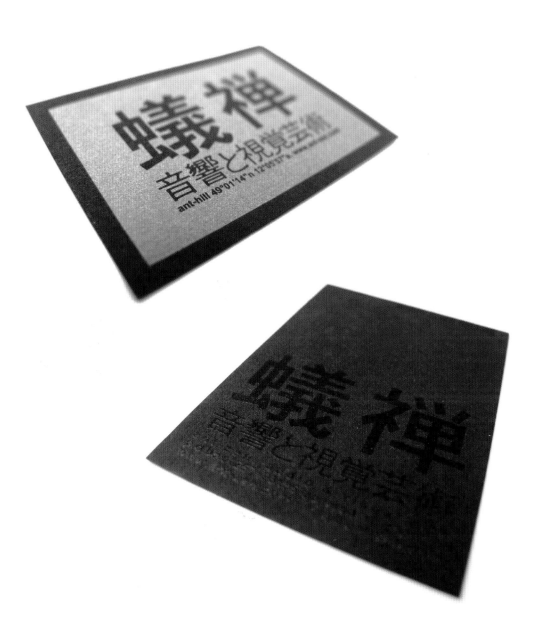

Turbin

Designer:
Lobby Design
Client:
Turbin

The designer realized the basics of the client's work were the contrast between black and white in pictures when they made such graphic identity. Therefore the designers gave the business card a matt white side while the other side is a glossy black with the logotype matt coated so as to emphasize on the contrast.

90 x 55 mm
Venicelux
n/a
Matt coated

CHRISTINA SÄRENFORS
TURBIN AB
DIREKT 021-15 16 92, MOBIL 070-887 57 58
E-MAIL kicki@turbin.se, www.turbin.se

Smedjegatan 7, 722 13 Västerås Rosengatan 5, 111 40 Stockholm
VXL 021-15 16 90, FAX 021-15 16 99 VXL 08-545 286 40, FAX 08-411 86 30

sketch napkin

Designer:
Warmrain
Client:
sketch

The story is about a couple having dinner at a restaurant. A waitress gave the man a napkin with a telephone number written on its corner. His wife was convinced and she was witnessing the seduction of her husband. She then left the table to pursue the waitress and proceeded to berate her for being so

forward. As the waitress explained, the telephone number is, in fact, that of the venue. This is a true story and has remained a talking point since sketch napkin's opening. Clearly it is the stuff of which urban myths are made.

200 x 200 mm
Tissue paper 250 gsm card
n/a
n/a

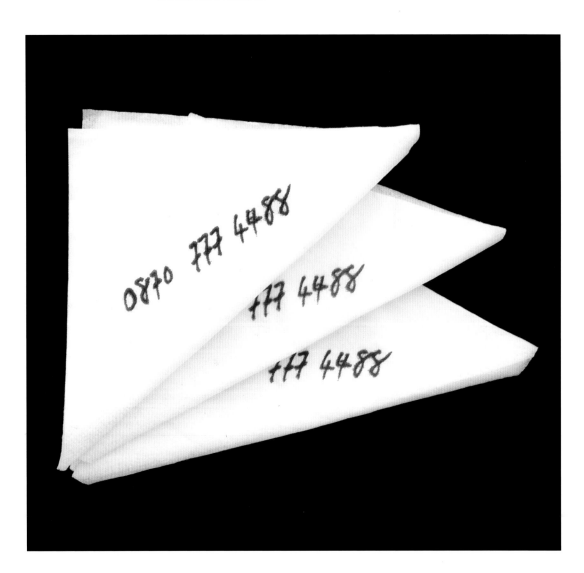

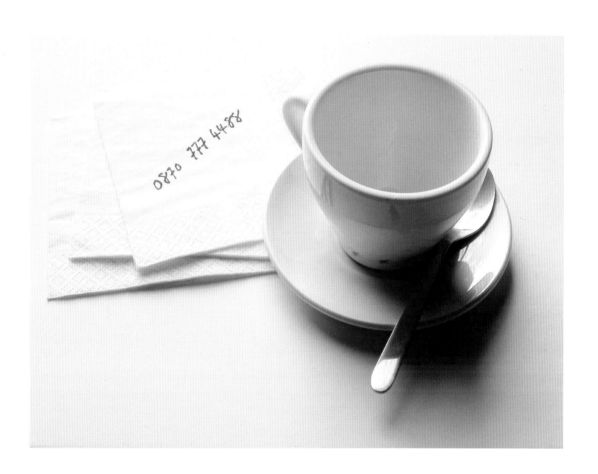

sketch

Designer:
Warmrain
Client:
sketch

These designs used wallpaper
to tell a story of décor, beauty
and charm - key aesthetic
elements in the venue. The
material was a surprisingly
inexpensive way to create
bespoke business cards. Each
card is unique and the cards

are printed directly onto
wallpaper ensuring that each
card is slightly different.

85 x 50 mm

Wallpaper Sandwiching
250 gsm card

n/a

n/a

SINEAD MALLOZZI

General Manager

direct tel: +44 (0)870 770 65 57
fax: +44 (0)207 629 16 84
sineadm@sketch.uk.com

sketch 9 Conduit St London W1S 2XG

LOUISA MOUELLEF
Guest Relations

Direct tel: +44(0)870 770 65 26
Fax: +44(0)207 629 16 84
Mobile: +44(0)777 573 75 33

loulsam@sketch.uk.com

Sketch 9 Conduit Street London W1S 2XG
www.sketch.uk.com

Guest r...

Direct tel: +44...
Fax: +44(0)2...
Mobile: +44(0)777 573...

loulsam@sketch.uk.com

Sketch 9 Conduit Street London W1S 2XG
www.sketch.uk.com

who's who
作品提供者

300million

A multi-disciplinary design company based in London, 300million creates brilliant, engaging solutions for clients of all sizes from blue chip to chippies.

Asteria

The brand is founded by Alice Chan who is an illustrator and graphic designer based in Hong Kong. Alice is active in design and illustration work for advertisements, editorials, comics, fashion, stationery, toys, and websites. She is now working for corporate, product and editorial clients from around the world. Her current clients are from Japan, USA, France, England, Germany, Finland and Hong Kong. They include: Canon, Anna Sui, Colette, Sakamoto, Sun Hoseki, Ito Yokado, Triiads, Pictoplasma, Die Gestalten Verlag, Web Design Index, Page One the designer's bookshop, Yakuta, Toy2R, IdN magazine, Clutter Magazine, Milk magazine, etc.

Andrew Demianyk

A freelance designer working in every aspect of the design industry from branding to illustration to advertising, Demianyk believes that ideas should be at the core of every piece of work and the central factor in determining its outcome. Without the idea at its heart, the piece is meaningless- aesthetics is only half of the answer. A good idea can be applied anywhere and everywhere.

Aurastate

Nineteen-year-old Jeremy Dowd has blue eyes and is passionate about high fives. Currently residing in Ontario, Canada, where he freelances and works under his design studio, Aurastate. Influences such as music, humor, fashion, and nature can be found throughout his work while doing art direction, graphic design, illustration, photography, and motion graphics.

Base

A studio specializing in creative direction and brand development, with offices in Brussels, New York, Barcelona, Madrid, and Paris.

Beautiful

Beautiful is a graphic design and illustration studio of Kerry Roper based in London. Kerry's work combines traditional illustration with photography and typography. He has worked for some of the world's top advertising agencies in art direction, illustration and typography.

Ben Loiz

Currently lives in Los Angeles, CA., Loiz's work has been exhibited internationally and featured in a number of books and news stand publications. Besides exhibitions and his product line NeeNoon, which he runs with his wife Reneé, he also works with a diverse group of clients including Stones Throw Records, Neiman Marcus, Save The Children Foundation, Sanrio/Hello Kitty, 2K by Gingham and Coca-Cola developing distinctive projects that range from print and brand identity to products and packaging.

BENG

Jan Willem van den Ban and Bastiaan de Wolff met at Total Design (now Total Identity), where they worked on large to extra large identity projects. Jan Willem continued to work for Intro in London for a couple of years. In there, he dug his way into new media, working on interactive projects for the likes of British Airways, Ricky Martin and Metallica. In the meantime, Bastiaan explored the boundaries between design, leading creative sessions and project management. With the idea 'Better and more fun!' in mind, Jan willem and Bastiaan reunited and formed Beng in 1998. They serve clients with outspoken communication concepts combined with fresh and powerful design. Beng now focuses on campaigns and identities.

Benoy Ltd. (Daniel Elsea, Charlotte Chan)

Founded in 1947 in the United Kingdom, Benoy Architects have now grown to be and is regarded as one of the world's leading retail architectural design and urban regeneration firms. With over 200 staff currently working in offices in the UK and Hong Kong, the firm is working on design schemes across the world, the United Kingdom, Hong Kong, China, Egypt, Greece, Italy, India, Malaysia, Poland, Portugal, Saudi Arabia, Spain, the Ukraine and Singapore.

Bleed

A graphic design agency based in Oslo, Norway. It was established in June 2000 by five individuals with background in graphic design, advertising and technology. Today Bleed counts 12 employees and stands out both nationally and internationally as a creative design agency that challenges the borders between commercial and art projects. Bleed believes that design must be based on creative ideas to stand out and that identity, function and values make the design work. Based on these values, Bleed applies graphic design as a communication tool and develops innovative design solutions for all channels.

BombTheDot

BombTheDot started in 1999 as design collective of four designers and photographers. The company's main focus is on graphic designs for CD, vinyl and DVD releases as well as concepts and management for prints and packaging.

Build

Founded by Michael C. Place, who was born in North Yorkshire, England in 1969 and studied at Newcastle College. He first worked in London with Trevor Jackson at Bite It! and then the Designers Republic (tDR) in Sheffield. His work includes record designs for Champion Records, Gee Street Records, R&S Records, Satoshi Tomiie, Warp Records and Sun Electric. He has produced the Wipeout series for PlayStation and the book 3D>2D Adventures In + Out of Architecture. In 2001, he returned from traveling and started 'Build' in London. It specializes mainly in design for print.

Buzzsaw Studios Inc.

A design studio that creates a buzz that drives profit to customer's brand. They help their customer to make their company profitable. Forget all the generic agency drivel, what's special is how they get there. They create tools, some traditional, some not so traditional, and their process involves the continual discovering, defining, and refining of each element of the brand - securing its strategic position and its ability to take advantage of the marketing benefits each media channel provides. They help their

customers to discover their unique position and tell the world who they are.

Page 76-79

C100

A Munich based design studio working for both national and international clients. It offers expertise in conception, creative direction and realization of print, web and art projects.

Page 32

CheekySweetGraphics

Founded by Thibault Choquel, whom, after studying firm's communication, worked on several multimedia projects as a web designer in France for a year. He then decided to move to Copenhagen, Denmark in 2002, where he was employed by the Roskilde Music Festival as a senior designer and team leader. Back in France in 2003, he worked for several communication firms as a senior designer. In 2004, he decided to work freelance. Today the experience continues as he got associated with Nicolas Dhennin to form Studio Poana.

Page 172-173

Chris Bilheimer

Chris Bilheimer, a Georgia-based designer and photographer, is a full-time art director for R.E.M. and he freelances predominantly in the music industry.

Page 124-125

Colorola

Colorola is a downtown LA studio of graphic artist and illustrator, Stuart Patterson. Known chiefly for his sexy illustration, Naked Music covers, or his work for Wallpaper magazine, Stuart has also enjoyed working with a wide array of international publications including Cosmopolitan, InStyle, Marie Claire, Stuff, Maxim, Esquire, Newsweek, FHM, Time Out London, and Flaunt. Other corporate clients include BMW, Burton Snowboards, Carolina Herrera, Bluefly, Alize, Moet et Chandon, Swatch, Master-Card, American Express, Penguin Books, Little Brown, Stila Cosmetics and TV Land.

Page 280-283

Cuban Council

A small interactive agency, Cuban Council specializes in creating superb solutions for web and print. Their main office is located in sunny San Francisco, but they provide services for clients all over the world. Their areas of expertise range from UI, application and graphic design to iconography, multimedia authoring and complex back-end development. As a group, they take great pride in developing solutions that are fun, usable, technically challenging, visually exciting and quirky.

Page 178-179

Da TeamBronx

Tim Tsui, a figure artist and illustrator based in Hong Kong who founded Da Team-Bronx, is active in designs for magazines and advertisements. He participated in the "Toyzworld Exhibition" and was invited as a speaker in a Conference that was held at Colette Paris. His clients include Royal Elastics, Tower Records, MTV, Colette, CSL and Milk magazine.

Page 120-121

Damian Di Patrizio

Born on the 22 October 1978 in Buenos Aires, Argentina, Damián Di Patrizio began his design career in 1999 working for the advertising agency Brokers DDB in Córdoba, where he worked for some agencies of the local circuit. After that, being invited by the creative director of Sonar, Patrizio went to Italy to work on the studio's art direction for firms such as Adobe, ABB and Matrox. In 2005, the Barcelona's design studio Frontiera Diligent asked Patrizio to head the art direction and work for firms such as Lendan, Sabadell Bank and Caixa Catalunya. Patrizio has won prizes from Diente ´05, Aspid Iberoamerican, Website of the Day in Taxi Awards, Gold on American Design Awards, and the Milano´s Contemporary Photography Museum. His work has been featured in publications such as 1000 Favourite Websites, Ensalada Mixta, Visual Magazine and Blur Ediciones.

Page 240-241, 302-303

Deanne Cheuk

Labeled as one of the top 50 creatives in the world ranged by The Face magazine; 'a leader' by Flaunt Magazine; and 'the fashion world's darling of the moment' by the Canadian National Post, Cheuk's clients are as diverse as Tokion Magazine, Urban Outfitters, and Levi's Strauss. She regularly compiles the graphic 'zine of inspiration' Neomu.

Page 162-165

Design People Studio

Based in Madrid Spain, Design People are founded by Alex and Maria. Alex has studied architecture and publicity. Maria first studied fashion design, then taught drawing and illustration. They have been designing together since 1990, firstly as NoLimit and since last year as Design People. They specialize in Corporate Design, producing emotive and highly acclaimed work for customers around the globe.

Page 68-71

DesignArbeid

A collaboration between Ruben Abels and Adam Oostenbrink, DesignArbeid was founded in 1998. Based in Amsterdam, The Netherlands, they work for any client who leaves room for conceptual development before starting the design.

Page 74-75, 199, 319

Designklinik

Designklinik is a design company based in Germany. It works on different areas of design and communication projects and shows its sympathy through visual language.

Page 279

Designland

A small multi-disciplinary design and illustration studio founded by Katherine Chadwick and Andrew Budge. With work ranging from the hand-generated to the digital, covering all points in between, Designland crafts thoughtful, concise and relevant communications for a wide range of clients, large and small.

Page 166-167, 200-201

Dimaquina

A Brazilian design collective created with the intention to make innovative, defying and stimulating work. They value the creative process, where clients participate as co-authors. Design to them is not just a plain result, but a search for a unique experience; solutions that can, at the same time, inform and seduce. They believe in art as a device and that collaboration can lead to outstanding work.

Page 147

Dopepope

Joe Lucchese, a.k.a Dopepope, is a New York City artist specializing in bizarre character design and his own brand of illustrative graphics he calls 'Experimental Aesthetics'. An illustrator since childhood, he swerved his talents into the world of digital photo retouching and effects, as well as graphic design. Dopepope lends his fantastic imagery to magazines, record companies, collaborations, and gallery shows as often as possible.

Page 222-223

Emiliano Rodríguez Ruiz de Gauna

Emiliano Rodríguez is a freelance graphic designer and photographer specialized in web design. He is currently working for companies and agencies from all around the world.

Page 186-187

Emmi Salonen

Originally from Finland, Emmi Salonen moved to the UK in 1996. She graduated from University of Brighton in 2001 with a BA Hons in Graphic Design. Straight after, she moved to Italy to work at Fabrica, Benetton's controversial young designers' melt pot. After a year, she was back in London where she worked a couple of years until moving to New York in 2004. There she was with Karlssonwilker, a small company known for its wit clever designs. Earlier in 2005 she relocated again, and is now working for her studio in East London.

Page 314-315

Enric Aguilera Asociados

A creative studio began in 1986 with the goal of providing creative services based on art direction and graphic design. This has enabled them to participate in projects for major consumer brands and to take part in the creativity of campaigns for the best agencies in Spain. Their experience has positioned them as one of the few communication studios that can take on a campaign, creatively and effectively, from the outset and follow through with the development of a corporate entity or a packaging design.

Page 25, 158-159, 194-198

envision+

Founded in 2001 by Brian Switzer and Esther Mildenberger, Envision+ is a design network of partners that are international in experience, thinking, and range. They are devoted to ideas and design that provoke thought, interaction, and smiles. Envision+ specializes in branding, interaction design and editorial design. Their projects cross languages, borders and disciplines. They love complex problems, close exchange and results that everyone is proud of. Their clients include Ferrari, Nestlé, Birkhäuser, avedition, as well as other corporate and cultural institutions.

Page 192-193

Eric Chan Design Co. Ltd.

Born in Hong Kong, Chan has worked in Hill & Knowlton (Asia) Ltd, Leo Burnett and Bates Hong Kong after graduating from Hong Kong Polytechnic and The First Institute of Art & Design in 1981. In 1991, in order to concentrate his interest in graphic design, he founded Eric Chan Design Co. Ltd. and has received more than 200 Hong Kong and international awards for the past years, including HKDA Gold Award, MEDIA Graphics Awards Poster Gold Award (Cultural), IdN Visual Image Gold Award, USA Communication Arts, New York Art Directors Club and Japan Applied Typography Visual Identity Best of the Best.

Page 224-227, 294-297

FEZ Design

Founded by Hafez Janssens, Fez Design is an independent design studio based in San Francisco, CA. Fez Design works on projects ranging from brand identity, collateral, packaging design, and product development & design. Hafez has a Persian and Belgian background, and takes a special interest in combining the European and Persian influences into his personal work. He is currently working on typographic studies with the Arabic characters. He has worked with Paul Tsang, a boutique studio in New York, and frog design, which are his two greatest influences, each bringing their unique design sensibilities. One of his greatest strengths in design is understanding and using materials and processes to create unique and interesting solutions.

Page 66-67

Form®

An award-winning graphic design consultancy based in London, Form® was established by Paul West and Paula Benson in 1991. Their background focused on creating campaigns for many high profile bands in the music industry, working as art directors and designers of record sleeves, logos, POS and merchandise. Over the years their client list has expanded dramatically and in addition to the music work, they now receive regular commissions for identity and branding from book, brochure and DVD packaging design; advertising campaigns; websites; and moving image projects. To date, Form® clients have covered the areas of music, sport, fashion, furniture, architecture, interiors, events, TV, film, video, publishing, marketing and PR. They welcome challenges from all areas where clients require an inspiring and creative approach – they don't like to be pigeonholed!

Page 56-57

Frost Design

Founded in London and now based in Sydney, Frost Design is an interdisciplinary creative studio of 25 people. Working on anything from postage stamps to the built environment, the studio's collective skill and experience allows it to work seamlessly across a variety of media for a diverse range of international clients. Central to Frost's philosophy is the value and power of the Big Idea – and the difference it can make to a business, large or small, when correctly executed. From small art projects to multinational brand identities, each and every project is treated individually and afforded the same care and attention.

Page 58-59, 236-237

Furi Furi Company

Established in 1998, Furi Furi Company is a design team based in Tokyo that has expanded worldwide. Furi Furi covers every aspect of design from consulting and planning to media promotions, combining their unique Manga aesthetics with a generous helping of adult madness. Their famous characters break through all language barriers and appeal to a broad audience, not only within pop culture. Well-respected right across the board, in merchandising, advertising, toy design and other media, their ability to style Japanimation characters with amazing precision and inner logic, emotion and motivation, has secured them a key role in the creation of computer game characters, be it for Sega, Nintendo or Sony.

Page 208-209

Fwis

"We'll Put Our Best Brains On It™" is their motto.

Grandpeople

Founded in 2001, while all members were still students at the Bergen National Academy of The Arts in Norway. Since then they have been able to work with a lot of different clients that allow them to really explore the fields of design and illustration. In 2006, the willingness to experiment and play is still the single most important motivation for their work, and perhaps the hallmark of their designs.

I.Do Graphic

Formed in 2005 by three young designers from Malaysia, I.Do Graphic is an alternative and radical graphic design studio.

Joe Scerri Design

A Swiss-based design studio specializing in design, brand identity, corporate design and web design. Second to what effective visual communication must perform, they believe that good design also has a role: To invigorate, to inspire, to touch, to excite, to surprise, to move and to liven the usually bleak surroundings that it sits in.

Jules David Design

Founded by Julien Rademaker, Jules David Design specializes in identity design. Rademaker graduated from The Royal Academy of Fine Arts in The Hague in the year 2000. After five years of working as a designer and art director, he started his own company in 2005.

Julian Morey Studio

A London based designer and art director. As a protégé of Peter Saville Associates he contributed to designs for New Order, Factory Records and The Haçienda. Working independently, his clients have included Diesel Jeans, Environ Records, Giorgio Armani, KesselsKramer, and Vogue. In 1999 he founded Club-21 as an outlet for his diverse collection of contemporary typefaces. Frequently profiled by the design press they have been incorporated into advertising for the likes of Nike and stamp designs for the Dutch PTT. Recently he established Editions Eklektic as an outlet for personal work expressed through the form of silk-screen prints.

Kern02

A graphic design studio based in Antwerp, Belgium, Kern02 specializes in corporate identity and publishing. They integrate personality, positioning, and social role in their corporate identity designs with other values they believe in. They work with an extended conceptual and strategic treatment, in which they always search for the essential by working step by step and thinking logically. Their clients are very much involved at the different steps they take in the design process. Working this way Kern02 creates an added value for each client.

Kinetic

Their creed is to break the barriers that hinder marketing communication and to explore the creative and conceptual limits of their projects. They are driven by the passionate belief that creativity can be transformed into arresting creatives that stop people in their tracks. Their design and advertising arm enables a web campaign to be extended into the other platforms of traditional advertising and marketing and vice versa, always without losing sight of the key messages and the brand image. After all, Kinetic takes their work and their clients' welfare very seriously. And while they champion creativity, they have always ensured that their work functions well for their clients. That means they are not some flash in the pan outfit, and in which has never stopped them from having the fun that they have in the things they do.

Klear Operation

A graphic design studio in Thailand that creates work happily for customers. They hope that people who use their products will be happy too.

Kummer & Herrman

A medium size agency founded in 1998 by Jeroen Kummer and Arthur Herrman. Both partners have had their education at the Utrecht School of the Arts. Arthur Herrman is also a teacher in Graphic Design and Typography at the Utrecht School of the Arts. Their work is characterized by a clear and powerful language with special emphasis on typography. Elemental ideas serve as starting point for their designs from which translations of ideas follow with a strong conceptual attitude and motivation in relation to the content. This perception reveals itself in the design for print and 'time based media' for cultural and non-profit organisations, as well as for national organizations.

Layfield

Stephen Layfield, who founded Layfield design company, is one of Australia's leading designers. He was recently awarded Australia's top graphic design award - The AGDA Pinnacle. He has also won numerous international awards for his design work.

Lobby Design

Creating communication based on strong ideas, Lobby Design also creates good and long lasting relations between people and companies. They have experiences from clients in all sort of different industries, such as the publishing house Forma Publishing Group, the fashion house H&M, the matchmaking company Match.com, the cultural magazine LET and the organization against bullying named Friends. Lobby Design was awarded "Sweden's Best Design Studio" in the communication newspaper Resumé and Easyresearch yearly client survey in January 2006.

Made

A design studio from Oslo, Norway, Made consists of three healthy and bright individuals. Their clients often hire them to do design and art Direction. Sometimes they do it at night, sometimes blindfolded, sometimes backwards and sometimes one more time with feeling.

Maiko Gubler

Originally from Switzerland, and now based in Berlin, Gubler used to assist Fork Unstable Media as an art director. She also co-founded the collective ALRT! She currently designs motion graphics, 3d illustration, identity and web site.

Mark Boyce

Born in London, England in 1972, Boyce studied typography at the London College of Printing. Since graduating he has worked for several design agencies, designed and art directed a substantial and varied range of work. He designs mainly for print but is also active in interactive design, retail and exhibition environments, and art direction for photography and moving image.

Mattisimo

An independent design studio in Brooklyn New York, founded by Matthew Schneider. He takes on projects ranging from brand research and identity, printed application and interactive and interaction design, with a special interest in industrial design and development. Schneider graduated from the Minneapolis College of Art and Design 1996. He moved to San Francisco afterwards and worked as lead designer for Studio 77. He then worked in San Francisco as Art Director for Anderson and Lembke, and Saatchi from 1997-98. A year later, he moved to New York to pursue career as Associate Creative Director Tribal DDB. In 2001, he moved back to San Francisco to be part of AKQA. He also has worked for Method, and freelanced for a variety of shops in Los Angeles. In 2004, Schneider again moved to New York, to be a lead Creative for Firstborn Multimedia. He has then worked as freelance for RGA, CreateThe, FCB and formed personal studio. Currently, he resides in Park Slope, Brooklyn.

MEWE Design Alliance

MEWE Design Alliance is a graphic design company from Beijing, China.

Michael Perry

Currently working as a designer for Urban Outfitters in Philadelphia, and doodling away night and day, Michael Perry creates new typefaces and sundry graphics that inevitably evolve into his new work, exercising the great belief that the generating of piles is the sincerest form of creative process. He has shown his work around the world, from the booming metropolis of London to Minneapolis to the homegrown expanses of Kansas. His website, www.mid-westisbest.com, has been lauded and recognized in many places.

Milkxhake

A new Hong Kong based design studio founded by three designers in 2002, specializing in graphic and interactive designs. The founders started from a design project when they studied Digital Graphic Communication at Hong Kong Baptist University. Their name 'Milkxhake' not only means a glass of drink, it also symbolizes the spirit of 'mixing', which is expressed through their logo.

Mwmcreative

A young and innovative graphic and screen-based design studio based in London. It was set up early in 2004 by two MA Communication Design CSM friends Maria da Gandra and Maaike van Neck.

NuDesign

A design studio founded by Achilles Greminger, who is an illustrator and graphic designer based in Zurich, Switzerland.

Nuno Martins

Born in 1979 in Oporto, Portugal, today Nuno Martins still lives and works in the place where he grows. He graduated in Communication Design from Faculdade de Belas Artes do Porto in 2003 and had studied at Willem de Kooning Academie - Hooge-school in Rotterdam, Netherlands.

Ollystudio

As a London-based creative agency, Ollystudio has evolved into a leading design studio since its inception six years ago. Oliver Walker, the founder brings his fifteen years experience with high profile designs, to a team of creatives who work in these disciplines. Ollystudio has a history of creating adventurous solutions that also communicate with clear messages. In creating close working relationships with clients, Ollystudio ensures a partnership dedicated to reaching a strong concept and a successful result. They take the latest technology to manipulate photography and illustration and create unique images for clients and help define their brands to the visually-aware customers; They utilize typography, design skills and design processes and create work in all of the areas including advertising, books, brochures, web sites, in-store, POS and exhibition design.

one-two.org

A project created by Raphael Muntwyler, who lives and works in Lucerne, Switzerland. He was first educated as a carpenter and he finished a degree in graphic design at the School of Art and Design in Lucerne in 2000. Muntwyler has collaborated with Stephan Mueller aka Pronto in Berlin. Since 2001 he has been self employed as graphic designer and freelancer for clients such as BOA Cultural Center and McKinivan Moos Inc.

Parent

They design and art direct for print, web and brand identity.

Park Studio

A London based graphic design studio founded by Linda Lundin and Nina Nägel in 2002. It is the place to come to for a solution which is friendly but sharp, challenging and always on brand, whether it is for an identity, publications, retail or exhibition graphics. They experiment and question to create the most original result keeping their clients one step ahead of the competition.

Passvite (Filipe Mesquita, Pedro Serrão)

Filipe Mesquita and Pedro Serrão have been working together since 2003. They created a series of experimental and commercial projects such as: Passvite (an exhibition and development of an acting community to systematic facts, themes, problems of the everyday), by02 (commercials creative services), Águas Furtadas (Portuguese design shop), shortcut to unknown (personal and experimental work of Filipe Mesquite) and Antek (Pedro Serrão's personal work). In partnership or individually their work have been in some exhibitions, books and magazines such as Din magazine, Musabook, Rojo, Nlf book,etc.

Page 128-129, 148-149

Philippe Archontakis Design

A design studio specializes in branding and corporate ID that is founded by Philippe Archontakis. After working three years as an art director for Cesart, being a partner for three years at Logient and eight years as the founder and partner at Blue+Associates, Archontakis is now playing the field on his own as freelance art director.

Page 64-65

Prism+VisualAnalysis

A web and print design agency operating in the UK, Prism+ Visual Analysis specializes in conceptual design and creates strong visual communication material both offline and online. They are currently three years old and have been working with a varied client base from local music labels to bigger corporate clients and solicitor firms.

Page 298-301

RDYA

Ricardo Drab and Associates was founded in 1996 with energy, intuition and talent. It is a design studio that acts as a communication and art company, combining advertising strategies, design and marketing. Their clients give them the freedom to create and they work to reach their objectives. Their task is to create a particular language for each brand, an essence that runs through the products and messages of a company, which can be immediately identified by the public.

Page 86-89, 170-171, 274-275

Rinzen

An Australian design and art collective, Rinzen is best known for the collaborative approach of its five members, forming as a result of their visual and audio remix project, RMX. Rinzen's large-scale artwork has been installed in Tokyo's Zero Gate and Copenhagen's Hotel Fox, their posters and album covers exhibited at the Louvre and their visuals incorporated into the shows of electronic musicians such as Kid606. Members of the group are currently based in Sydney, Brisbane and Berlin.

Page 286-287

Rina Miele

Since the first time considering design as a career, Miele's goal has always been able to tell a little story about herself, in which she works really hard. Being offspring to a designer, she always made art, but never gave any thought to design as a profession. Since then she has shown everyone how hard she can work. Some of her clients included Pantone, VH1, CondéNast Publications like Glamour, Allure, Vogue, Lucky and Rockstar Games.

Page 214-215

Roanne Adams

A 25-year-old graphic designer living in New York City, Roanne Adams works for the international brand consultancy, Wolff Olins. Adams received a BFA in Communication Design from Parsons School of Design. At Wolff Olins she has worked on brands like Fila, Product Red, Citibank, New York City and most recently OshKosh, and The New Museum. Admas has also worked for the design firm Honest, collaborated with the design/art collectives Surface to Air and Lansing-Dreiden. Aside from her day job, she does freelance design.

Page 210-211

Root Idea

A multimedia graphic design company that provides services from brand identity, sales promotion, packaging, display to exhibition and multimedia graphics design. Root Idea's mission is to bring strategic solution, innovation to their clients in order to build up an outstanding identity and strengthen competitiveness in the market. They believe that design needs to keep an aesthetics and logicality in a balanced state of mind. Their guiding principle of all their decision and action making is not to think about beauty, but how to solve the problem rationally and logically. However, when they found that the finished solution is not beautiful, they know something is wrong.

Page 142-143

Rumbero Design

Xavier Encinas, a.k.a. Rumbero Design, is a young French Art Director working as freelance for records labels, Modern art galleries, streets artist, and corporate industries. He is part of the French designers collective, Unchi Leisure Center, and he also creates The My Brand Project.

Page 118-119

Satellite Design

A San Francisco based studio founded in 2000 by two principals with very different backgrounds- one designer and one copywriter, Satellite Design are print-oriented, specializing in identity, print collateral and packaging. Their fundamental difference lies at the heart of their approach to communicating solutions. They work with some of the world's largest and most visible brands and some tiny start-ups that are still defining their markets, products and identity.

Page 216-217

Shellmoonsite

Man Chung Lee, a.k.a. Shellmoonsite, was born in Hong Kong in 1976. He studied Multimedia and Maya in the Vancouver Film School, where he graduated in 1999. He began to work as a web designer shortly thereafter. In 2001 Lee joined the design force for IdN magazine, and started his career as a graphic and book designer. From April 2004 to July 2005, he was the Art Director of Hong Kong culture and art magazine, Cream. Lee is now the Art Director of the creator's lifestyle magazine, RMM. In 2003, Lee conceived, organized and promoted a few exhibitions, such as 'WE' exhibition held in Cattle Depot, Hong Kong Artists Village; 'A2' exhibition in Basheer bookshop, Hong Kong; 'Artists' exhibition in Newburgh, Hong Kong, etc. He is also a contributor to the Japanese creative e-zine www.shift.jp.org. His works fall in many other different media, such as NEUT—006, Tokyo Remapping, SonyStyle x Levi's Campaign, Lomography fisheyes camera, etc.

Page 212-213, 326-333

Segura Inc.

Founded by Carlos Segura in 1991, Segura Inc. is a multi-faceted design and communications firm that specializes in print, collateral and new media communications. Prior to establishing Segura, Carlos had worked as an art director for many advertising giants such as Young & Rubicam, Ketchum, HCM Marsteler and Bayer Bess Vanderwacker. Besides focusing on their best profession i.e. graphic design, printed advertising, corporate identities and other new media; the company would do any types of creative design through whatever medium is allowed, delivering messages with a distinctive sense of style and simplicity.

Page 73

so+ba

Founded by Alex [So]nderegger and Susanna [Ba]er in 2001, so+ba is a dynamic creative design agency based in one of the most exciting Asian metropolitans – Kyodo, Tokyo, Japan. Although Sonderegger was born in Cameroon, he and Baer are both Swiss by birth, who have been working in Tokyo since eight years ago. With experiences in design and advertising in Switzerland and Japan, as well as a good understanding of the two very different cultures, cross-cultural communication is one of the strength and the focus of so+ba. Their work is like a ping-pong match, or two cooks who try to make one delicious visual dish. When beginning to work on new projects they examine the product or company, collect, hunt, gather visuals and develop various strategies. In a further step they compile and distill them into one visual language. As a result, the conclusion very often is form follows function.

Page 130-133

Spoken

Graduated from University College Northampton, Patrick Casey has been running Spoken for about 2 years. Many of his clients have been found through networking everyone that he comes across. As a born creative, Casey loves to rework and manipulate type through different formats. He is still a young designer who has a lot to learn about design. To achieve this, he will open his eyes and heart to the world, act like a sponge and use his entire life as research.

Page 92, 136-137

...,staat

A creation-driven agency founded in 2000, ...,staat's work is 2-, 3- and 4-dimensional with a highly conceptual and strategic basis. Focusing on concept, communication, design and experiences, they create brands, campaigns, books, interiors, events or whatever challenges them. They do not pretend to know it all, but they do believe they can apply their vision and creativity on every subject, resulting in refreshing, unexpected ideas and outcomes. By dedicating themselves with positive and inspiring energy they find the essence, develop the concept and shine out in execution.

...,staat stands for clarity and working with short lines of communication. Existing of a strong basis of 14 people, they work with passion on creation and realization. With great access to a flexible network of freelancers, they are able to bring in specific skills when necessary. They are pushing their limits and those of the brands to reach unexpected higher grounds. The deliverables always match the briefed objectives, but rarely the briefed deliverables.

Page 33, 126-127, 258-261, 264-265, 268-269, 278

Stiletto

Co-founded by Julie Hirschfeld and Stefanie Barth, Stiletto NYC is a design studio based in New York and Milan, which specializes in motion, live-action and print projects. Their clients are both local and international, including MTV, Nike, the German music television channel VIVA & VIVAPlus, the Gap, RCA Records, HBO, Sundance Channel, HKM films, Samsung, Res magazine and several small boutiques in Europe and America. They have been featured in The Face, Wallpaper, I.D. and in 'Restart: New Systems in Graphic Design' published by Universe. Their motion graphics for MTV had won two Art Director's Club awards.

Page 28-31, 34-41, 122-123

Studio Output

Formed in 2002 by three partners, Studio Output is a company which specializes in graphic design and art direction. Clients span the arts, fashion, broadcasting, leisure and music industries, and include BBC Radio One, Ministry of Sound and Arts Council England. Studio Output aim to help their clients to communicate with clarity and power. To do this they employ people who relish the challenge of creative thought,

and thrive on the responsibility of handling their own clients. An open and honest working approach helps to foster friendly and long-lasting client relationships.

Page 93-95, 284-285

Stylo

A creative design consultancy that works for both public and private clients on a variety of projects in various disciplines including corporate identity, print, internet, e-commerce, moving image and sound design.

Page 54, 334

SWIGG Studio

A multi-disciplined design firm founded in 2004 by Stephanie Wenzel, Swigg Studio is located in Brooklyn, NY. Swigg Studio provides graphic solutions for a multitude of design challenges including identities/logos, print materials: brochures, catalogs, editorial layout, environmental signage, web and motion graphics, typography development and fashion graphics. Stephanie's work has been shown internationally in the 'Neighbourhood' exhibition at the Pictoplasma Conference in Berlin, the Sneaker Pimps World Tour, the Riviera Gallery in Brooklyn as well as in the graphic design publications Novum and Items Magazine.

Page 108-109, 150

The Consult

An independent graphic design agency based in the UK. Their focus is developing insightful and memorable communication that works. They engage in an exploration of thought and process in order to create inspiring concepts and beautifully styled design.

Page 276-277

Tnop™ & ®bePOS|+|VE

A design studio founded by Tnop Wangsillapakun, a Chicago-based designer who received his Bachelor of Fine Art in visual communication arts from Rangsit University, Bangkok in 1993. He started working as a graphic designer at J. Walter Thompson, Bangkok. Two years later, he joined TBWA Bangkok as an art director. In 1996, he studied in graphic design at Savannah College of Art and Design, Georgia, the uNited States and from there, he received his Master degree in 1998. He then moved

to Chicago to work at Segura Inc. His works have been featured in books and renowned magazines inside and outside of the U.S. In 2000, he started ®bePOS|+|VE design in Bangkok with his friends. He left Segura Inc. in 2006 to focus on his studios in both Chicago and Bangkok.

Page 254-255, 262-263

tomoby

tomoby is a London based design studio founded by Tom Leach, a young English designer. Tom graduated from The Surrey Institute of Art & Design over two years ago and has since been working with some of the top design agencies in London. He has developed a more mature understanding of graphic design, typography and print in the past year when working with Luminous. And recently he has moved into a sector to create and explore brand experience, interaction and environments.

Page 270

Trollbäck+Company

A bicoastal creative studio committed to develop innovative visual and branding solutions. Rooted in a strong European design sensibility, the young multi-disciplinary company works across a variety of media from film titles and trailers to TV commercials, environmental and architectural installations, network branding, outdoor advertising, magazine and book design. Their design and production studios are on Fifth Avenue and Venice Beach.

Page 62-63

Underline Studio

A design partnership with a singular goal of creating great design, Underline Studio is based in Toronto, Canada. The partnership is the inspired collaboration of Claire Dawson and Fidel Peña. Met as colleagues in the 1990s, they directed a number of high profile international branding and promotional campaigns. At Underline Studio, they have continued the record of design excellence, this explains why Underline has established itself as a specialist in clean, evocative and intelligent design within a short time.

Page 98-99, 182-183

undoboy

Believes that design brings happiness, undoboy loves and hates design.

Page 55

Uniform Sweden

A name created by Andreas Pihlström with his design and audio works. At the age of 18, Pihlström started to work at the Swedish advertising agency Gazoline as a designer. Two years later, he relocated to New York and launched Gazoline NY. He also worked for a number of design agencies there, such as Syrup, Piranha and Artribe. In 2001 he moved back to Stockholm and started up the design agency N'JIN Theory. Later his focus turned onto audio and he opened his own project music studio, launching the Swedish office of UK based company, Sonar Audio.

Page 176-177

Viagrafik

An art & design studio founded in late 2003, Viagrafik consists of Leo Volland, André Nossek, Robert Schwartz, Tim Bollinger, Till Heim and Lars Herzig. It is a professional design studio located in Wiesbaden, Germany, which offers a wide range of services. On one hand they specialize in print design such as logo design, corporate identities, illustration, font type design, book and catalog design, interior design and web design; on the other hand, they are offering motion and animation design. Viagrafik is also an art studio. Everyone of them has a background in graffiti or street art. They always try to combine their artistic skills with their design skills. They also participate in exhibitions, thus they share a great diversity in their artistic visions in which they combine it within their projects. They love to work free.

Page 140-141, 308-309

viction:design workshop

viction:design workshop was founded by Victor Cheung in 2001 in Hong Kong. Their workshop provides a broad range of design services to maximize the true potential of their clients, building sophisticated and innovative solutions that enable them to develop deeper and more personalized relationships with their customers.

Page 60-61

Warmrain

A bespoke communications company who creates truly memorable events, installations, branding and graphics by engaging people's senses and emotions. Warmrain develops projects that get under the skin and into the heart of a client's message.

Now in their seventh year their strength lies in defining the essence of a project and bringing it to life by create visual stories of substance and wit.

Page 48-49, 338-341

WE RECOMMEND

A design company working mainly on visual identities, WE RECOMMEND's design approach is based on a fusion of Swedish and Danish design in which they create contemporary and innovative solutions rooted in the traditional craftsmanship of design. Their services include graphic design, corporate identity, product identity, art direction, packaging design, editorial design, digital design and motion graphics.

Page 271

Yucca Studio

A multi-disciplinary creative boutique working with a strong desire to create the best design and user experience possible. They have stayed independent, focused and believed in a future crafted out by passion. Their holistic approach emphasizes on critical thinking and aesthetic research, by applying simplified complexity into visual solutions and interactive media. They believe first and foremost that they are communicators, and that enables them to deliver their clients' message across any communications platform.

Page 244-247

Zion Graphics

A multi-faceted design agency based in Stockholm Sweden, Zion Graphics was founded by Ricky Tillblad in 2002. Zion's work crosses over vast disciplines include: corporate identity, fashion, interactive media, packaging and print. Their clients are J. Lindeberg, Sony BMG, Universal Music, MTV, EMI Music, Pee&Poo, Peak Performance and more.

Page 100-103, 105, 116-117